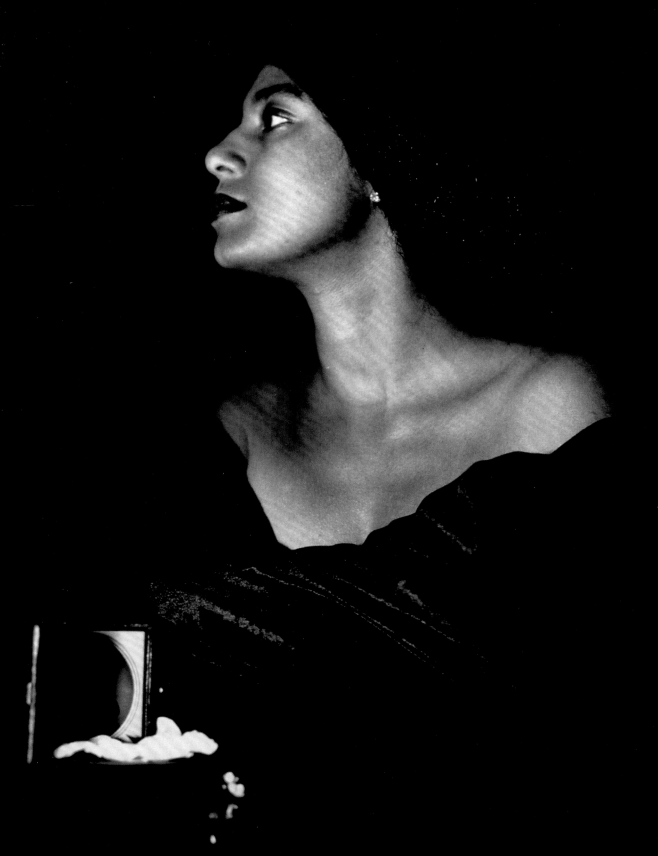

SEDUCED BY ART
PHOTOGRAPHY PAST AND PRESENT

HOPE KINGSLEY
WITH CONTRIBUTIONS BY CHRISTOPHER RIOPELLE

NATIONAL GALLERY COMPANY, LONDON
DISTRIBUTED BY YALE UNIVERSITY PRESS

DIRECTOR'S FOREWORD

Many of the museums and galleries with great collections of European art that are regarded as sister institutions of the National Gallery, notably the National Gallery of Art in Washington, the Musée d'Orsay in Paris, the Metropolitan Museum in New York and the Getty Museum in Los Angeles, include photographs, as well as paintings. In recent years we have realised that we should give more attention to photography. Such a conviction coincided happily with a new interest in the Gallery's first Director and his remarkable wife, Sir Charles and Lady Eastlake. The latter (as Elizabeth Rigby) was not only a participant (as a model) but an exceptionally intelligent commentator on the new art form.

Photography began to influence painters almost as soon as painting began to inspire photographers. It was with an idea of illustrating some of the reciprocal influences – involving Pre-Raphaelitism, Symbolism and Surrealism, for example – that the National Gallery first approached Michael Wilson. He not only offered to help but recommended Hope Kingsley to us as an exhibition curator. Her highly original exhibition proposal concentrates on the start of the complex relationship between photography and painting and connects that episode with the situation today. It was not what we had expected, but it was even more appropriate as an exhibition for us.

Both the exhibition and this book do much more than introduce the public to stylistic and technical developments in contemporary photography that owe much to Old Master paintings and the work of pioneer photographers in the mid-nineteenth century. We are also forced to ask unexpected questions about the ambition and potential of both art forms. And we recognise that we may be doing this at a turning point in the history of Western art, at a moment when fiction has become as respectable as truth, and narrative as important as documentation for the photographer, and when the pursuit of beauty and the ideal are no longer confined to photographs of high society and Hollywood stars. Suddenly, indeed, much that was once disparaged as academic, much that had to be avoided by anyone aspiring to be a 'modern' artist, has become central to the work of the most creative and innovative photographers today. *Seduced by Art*, therefore, is a particularly timely exhibition.

We are grateful to Michael and Jane Wilson, Hope Kingsley, Marta Braun and the numerous trusts and individuals who have kindly lent their support to the exhibition.

What is the connection between the history of painting, the earliest decades of photography and work by some of the most innovative photographers active today? *Seduced by Art: Photography Past and Present* is a three-way project linking contemporary photography with two sets of Old Masters, those of four centuries of fine art and those of the first three decades of photography. This book argues that historical art was an engine for early photographic innovation, and that both these precedents inspire present-day photography.

Photography is now widely acknowledged as an art with pictorial legitimacy and a place at the table alongside the other graphic arts. The Royal Academy of Arts, London, welcomes the submission of photographs to its Summer Exhibition, while public art institutions such as the Victoria and Albert Museum, London, incorporate photographic departments, with curators and dedicated galleries. The art market follows this lead, and auction houses and private galleries present photographs alongside pieces in other media. Prices for photographs are rising steadily, and top works sell for more than two million pounds.[1] Market value is one type of affirmation, but a more important endorsement is reflected in exhibitions such as the 2011 Royal Academy show 'Degas and the Ballet: Picturing Movement', which presented Edgar Degas's photographic studies alongside his paintings and drawings. Other projects have turned the tables: mid-nineteenth-century photography is often shown with Pre-Raphaelite painting, while exhibitions of twentieth-century art increasingly include photographs alongside works in other media by the same artists. Some shows have matched present-day artists with their historical inspirations. Notably, the National Gallery's 2000 exhibition 'Encounters: New Art from Old' commissioned Jeff Wall's photographic response to George Stubbs's *Whistlejacket* (painted around 1762).

Photography's history now covers 180 years, but when the medium was invented, its practitioners began from scratch. Was it any wonder that their images would resemble the pictures that preceded them? While those early photographers explored new visual territories, they also drew their inspiration from a diverse art-historical past that included classical sculpture, seventeenth-century Dutch still life and Renaissance re-creations of scenes from antiquity.

In this book, the artistic aims, visual styles and technical approaches shared by early and recent photographers are compared through thematic chapters on the genres of fine art and photography: history pictures and tableaux,

portraiture, figure studies, still life and landscape. Interspersing the chapters are interviews with six current practitioners, most of whom visited the National Gallery to walk through the rooms and talk about the relationships between their work and historical art.

HISTORICAL RICHES

The connection with art history enriches photography's vocabulary, and it is a productive kind of retrospection for a practitioner like Maisie Broadhead, who borrows freely from past art. Her diverse media include jewellery in precious stones and metals, which are built into *Keep Them Sweet* (fig. 2), an allegory that re-creates a seventeenth-century Baroque painting – Simon Vouet's *La Richesse* (fig. 1). The photographic illusion is rich; each figure, each tint is sympathetically reimagined from Vouet's original design.

Vouet's painting was made for Louis XIII, whose 'riches' were symbolised as material (jewels and objets d'art), intellectual (an open book) and, above and beyond all, spiritual (the infant who gestures at the heavens). Broadhead reinvents the emblems in personal terms: the winged figure is her sister, whose little daughter offers a bracelet made by Broadhead, whose own baby son is the divine child in blue. The objects are updated as charming anachronisms, both ordinary and sensory – a nappy on the standing child and a bracelet whose bright beads are silver and sugar. Broadhead casts her jewels to please both grown-ups and children; such a trinket 'keeps them sweet' in more ways than one.

Broadhead's appropriation of art-historical elements is an acknowledged contemporary approach. It is also found in nineteenth-century photography: Victorians such as Julia Margaret Cameron collected cultural references with an enthusiasm that rivals our own postmodern scavenging. Cameron's *A Study of the Cenci* (fig. 3) is a pastiche of a number of models: historical

Below, fig. 1
Simon Vouet, *An Allegory of Wealth* (*La Richesse*), about 1635. Oil on canvas, 170 × 124 cm. Musée du Louvre, Paris.

Opposite, fig. 2
Maisie Broadhead, *Keep Them Sweet*, 2010. Digital C-type print, 145 × 106·5 cm. Represented by Sarah Myerscough Fine Art, London.

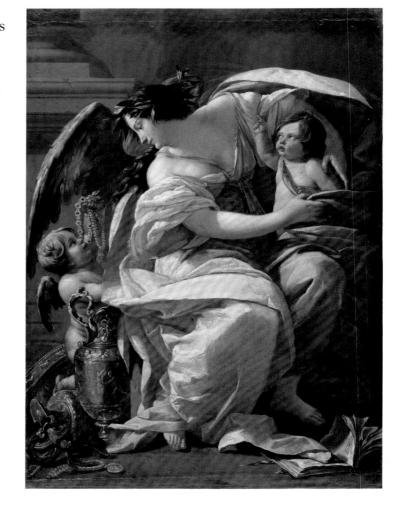

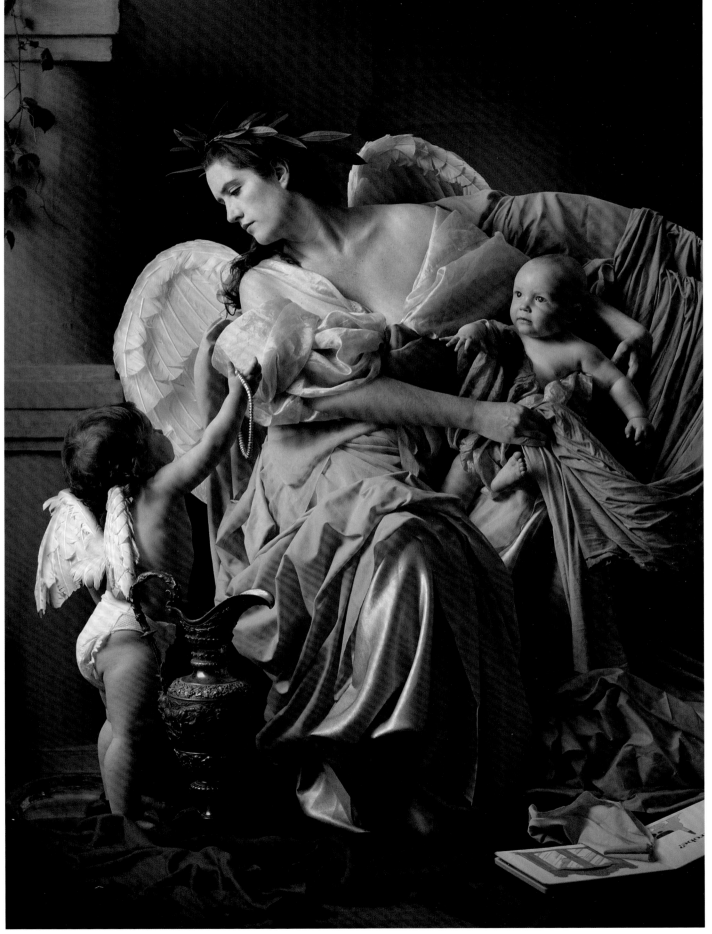

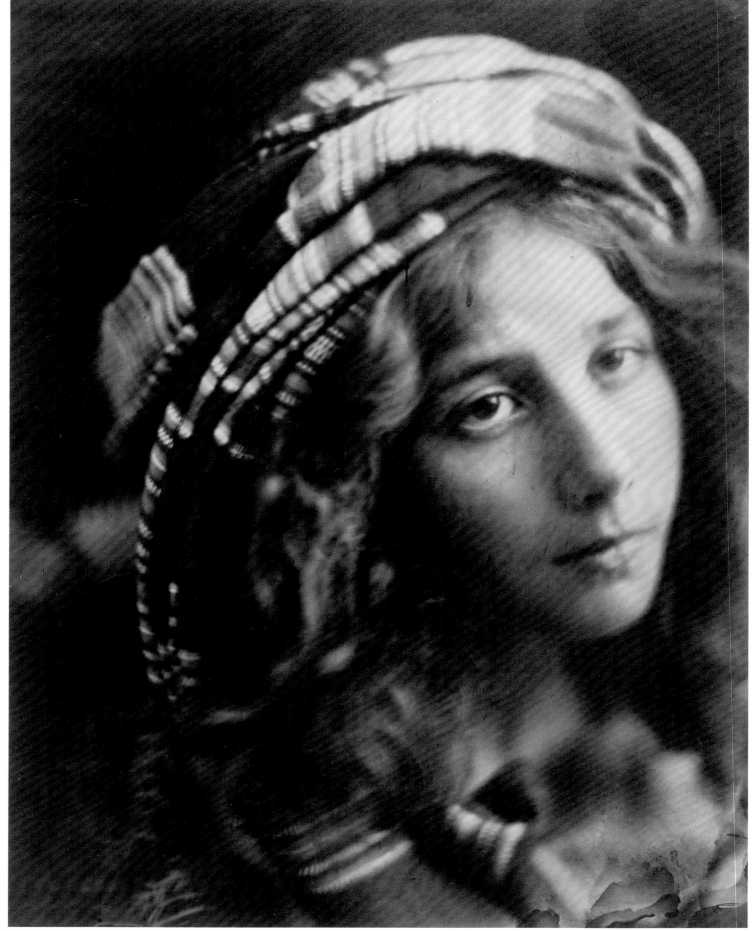

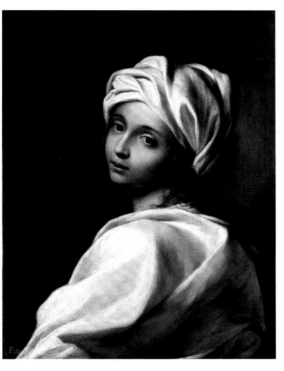

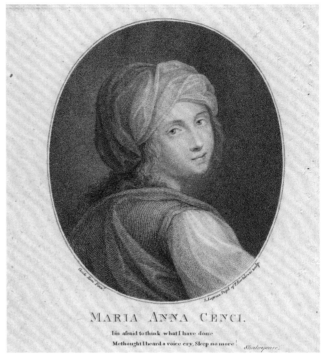

accounts of an ill-fated woman of sixteenth-century Italy,[2] a seventeenth-century painting (fig. 4), an 1819 play by the poet Percy Bysshe Shelley and Charles Dickens's bewitched description of the painting in *Pictures from Italy* (1846).[3] Clearly, that tragic and sensational story of incest and murder resonated over several centuries.

Ultimately, it is likely that Cameron worked from an art reproduction; her Cenci faces right, oriented like the engraving published in London in 1794 (fig. 5).[4] She imitated a print that was based on a painting, but, of course, she used yet another process. Compared with a photographer, the painter of Beatrice Cenci had many means at his or her artistic disposal: execution (brushwork), composition, colour, the management of light and dark and an ability to emphasise the important areas of the subject and suppress extraneous detail (also available to the engraver). Cameron's closest approximation to execution was the adjustment of focus to produce hard or soft outlines, emphasising some portions of the image while subduing others. Her framing of the picture equates to composition, while modelling was based on light and shadow. Colour was a problem; it was beyond the capability of monochrome photography, and early blue-sensitive photographic materials skewed colour rendition. Blues looked almost white, while reds, oranges and even yellows

photographed darker than they appeared to the eye. Cameron had to anticipate how the colours of the striped scarf would photograph in light and dark tones, and she composed a swirl of fabric to echo the tilt of the head, the curve of the chin, and give movement and volume to the subject. In the hand and eye of an inspired practitioner like Cameron, photography could make a virtue out of its early limitations; what could not be marked with colour was made bold with tone.

PHOTOGRAPHY'S INVENTION

These old and new photographs belong to a medium fewer than 200 years old. Photography's arrival in 1839 was less a discovery than the outcome of a century of photochemical experimentation, and it had at least two acknowledged inventors: Louis-Jacques-Mandé Daguerre in France and William Henry Fox Talbot in England.[5] Daguerre's process, the daguerreotype, produced a detailed photographic image as a fine layer of mercury-silver particles on the polished surface of a silver-plated sheet of copper.[6] These were unique objects – one exposure produced one plate. And they were a commercial success; within three years, daguerreotype portraits were being produced in capital cities across Europe (fig. 38, p. 61).

Talbot's method used a solution of light-sensitive silver salts applied to paper. His photographs were reproducible, for multiple positive prints could be made from one negative.[7] Talbot's paper photographs did not match the precision of the daguerreotype or its profitability, but the prints were appreciated for their artistic qualities, which were compared to drawing and printmaking, as we will see in chapter two.

Photographic technology moved on quickly. In the 1850s, collodion glass plate negatives and albumen-coated printing papers were introduced and lenses improved, enhancing image quality and expanding photography's subjects and applications.[8] By the end of the nineteenth century, gelatin silver bromide became, and remains, the standard for analogue photographs (even colour

Fig. 6
David Octavius Hill and Robert Adamson, *Elizabeth Rigby* (later, Elizabeth, Lady Eastlake) *with umbrella*, about 1843–47. Salted paper print, 19·5 × 14 cm. National Gallery of Canada, Ottawa.

prints depend on these constituents).[9] Each innovation had its own practical and visual characteristics and many co-existed. Rarely did one approach completely displace its predecessor, and thus an expanding creative and technical vocabulary was ensured. Periodically, old methods have been reinstated: for example, paper negatives were revived in the 1890s along with early printing processes. They resurfaced in the late 1970s as part of a general interest in mixed media. Most recently, digital photography's predictable perfection has provoked the renaissance of artisanal wet darkroom practice.

Through many permutations, photography has been valued as an imaging system with extraordinary powers to record the surface facts of the world. Did that splendid reckoning of material reality have the attributes of art? From the very beginning, practitioners and critics began to think carefully about the relationships between photography and other arts.

THE PHOTOGRAPHIC ARTIST

'Of all the delusions which possess the human breast, few are so intractable as those about art.'[10] In 1857, Elizabeth Eastlake was in a perfect position to make this wry comment about the debates on art and photography. As the wife of Sir Charles Eastlake, Director of the National Gallery, she saw the scrum of the London art world at first hand. She had a ringside seat at another arena, that of the eighteen-year-old art-science, photography. Fourteen years earlier, as Elizabeth Rigby, she had been well acquainted with photographers David Octavius Hill and Robert Adamson; she was the most photographed of all their sitters (fig. 6).[11] In London, she and her husband were part of the photographic scene, for, in 1853, he became the first president of the Photographic Society of London,[12] a key venue for exhibitions. It was also an important forum in a remarkably rich time when photographs were first exhibited and discussed as works of visual art. Four years later, Elizabeth Eastlake made an important contribution with an astute essay on the artistic and technical capacities of photography. It remains relevant today.[13]

Photography arrived at a time of unprecedented access to art. In London, the 1850s were boom years, beginning with the Great Exhibition of 1851 and extending to the reorganisation of the National Gallery in 1855. As a public gallery with free entry, the National Gallery was a crucial artistic resource. When, in 1869, Henry Peach Robinson published *Pictorial Effect*

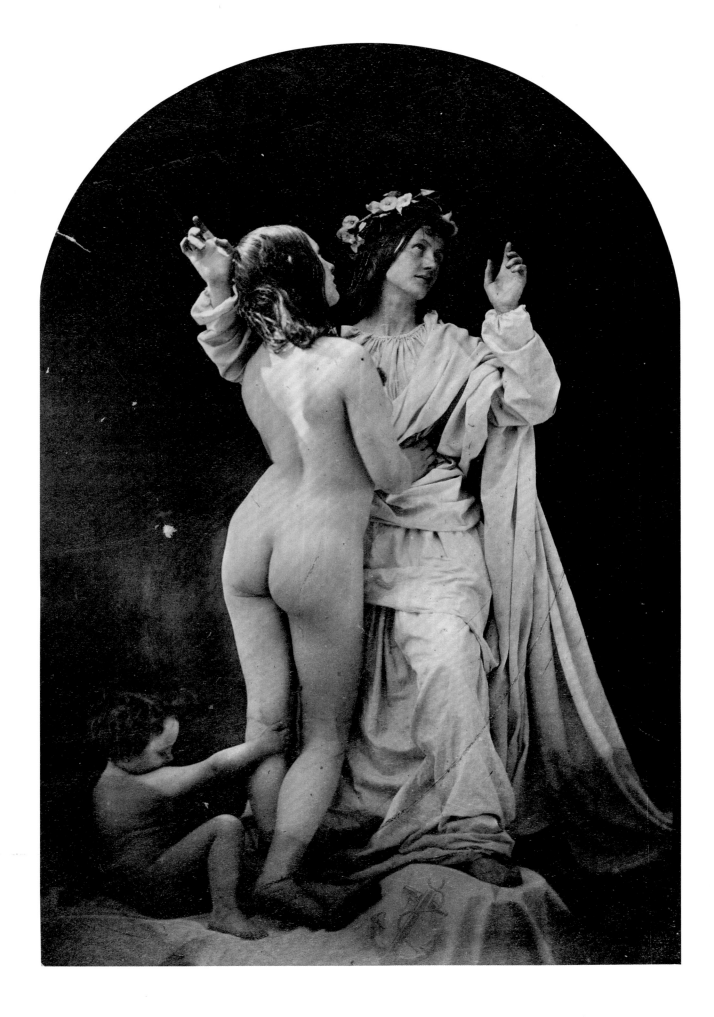

Fig. 7
Oscar Gustav Rejlander,
Untitled (allegorical study),
about 1857. Gold-toned
albumen print, 18·5 ×
12·5 cm. Wilson Centre
for Photography.

in Photography, the first comprehensive book on the art of photography, his inspirations were found at the National Gallery. For a new medium aspiring to pictorial legitimacy, the best source was art whose value was proven and admired. Van Dyck and Turner formed Robinson's central lessons and his artistic roll-call encompassed Rubens, Rembrandt, Caravaggio, Titian, Tintoretto, Veronese and Raphael.[14] These works remain an inspiration; for contemporary practitioners like Jorma Puranen, Ori Gersht, Maisie Broadhead, Tom Hunter and Rineke Dijkstra, the National Gallery is a regular detour.

Through such lessons and comparisons, photographers have wrestled with the most fundamental question: can photography be taken seriously as an interpretative medium and be accorded the kind of cultural weight allocated to fine art? Photographs present the particulars of the world; they cannot match a painting's synthesis of observation and imagination. In one of the first meetings of the Photographic Society of London, photographer John Leighton complained that photographs were 'at present too literal to compete with works of art' and missed the opportunity to 'elevate the imagination'.[15] This idea pre-dated the invention of photography, for in 1786, Joshua Reynolds argued that a camera obscura produced only a 'cold prosaic narration or description', missing the influence of a 'poetical mind'.[16] If photography were a mechanical method, then it would lack consciousness, excluding the subjectivity and intellect required for a work of art.

Yet, if the art was in the idea, then the medium was of little account, as Oscar Gustav Rejlander observed in 1866:

> If my maid of all work, after I have posed myself before the looking-glass, takes off the cap of the lens when I cough, and replaces it at my grunt, has she taken the picture? She thinks 'she did it'.[17]

Rejlander's little joke was a dig at the assumption that anyone – including a housemaid – could take a photograph. A photographer was more than a camera operator; it was the idea that made the photograph. Rejlander's images are threaded with ideas, art and storytelling, as in his unnamed study (fig. 7), which is a variant of another Rejlander photograph portraying the Greek myth of Iphigenia and her salvation from sacrifice.

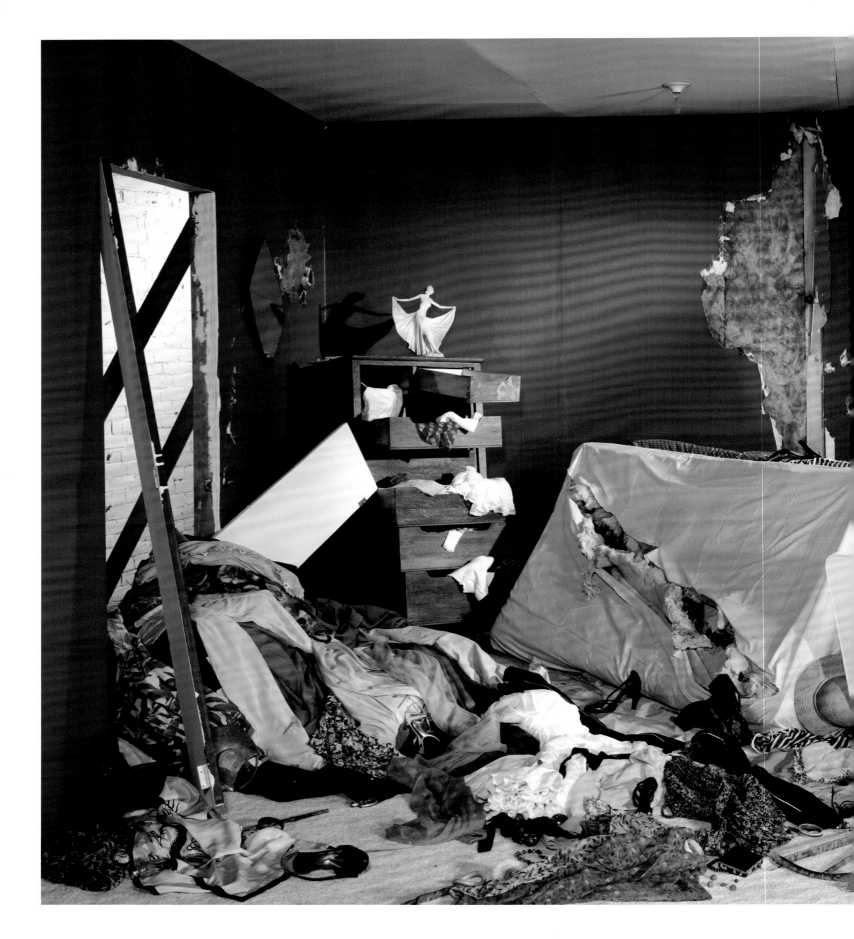

Fig. 8
Jeff Wall, *The Destroyed Room*, 1978, printed 1987. Cibachrome transparency in fluorescent lightbox, 158·8 × 229 cm. National Gallery of Canada, Ottawa.

A FAMOUS PAINTING AND A HIGH-HEELED SHOE

Fig. 9
**Ferdinand-Victor-Eugène
Delacroix**, *The Death of
Sardanapalus (La Mort de
Sardanapale)*, 1827. Oil on
canvas, 392 × 496 cm. Musée
du Louvre, Paris.

Rejlander's photographs depicted subjects that were prevalent in academic art. His challenge was to find a persuasive way to present those themes in a new medium, and the success or failure of his ambition will be considered in chapter three of this book. Today, photography is a recognised and valued art with a wide variety of subject matter and approaches. Can its pictorial language include historical art?

Jeff Wall's first foray into art history was a large-scale colour photograph, *The Destroyed Room* (fig. 8), inspired by Ferdinand-Victor-Eugène Delacroix's famous painting *The Death of Sardanapalus* (fig. 9). Wall re-creates the diagonal sweep of Delacroix's composition in wrecked furniture and scattered clothes, while a woman's high-heeled shoe, poised in the centre of the scene, stands in for the central figure of Sardanapalus's slave. Delacroix's canvas shows the beginning of a violent event, vividly peopled with the throes of life and death. Wall presents the aftermath of destruction; the scene is still and the protagonists are absent.

Work such as *The Destroyed Room* quotes historical art without directly imitating it. Within this book, that intention is important, for comparisons between works of art should be more than imitative. This is not a child's game of 'spot the difference', rather an argument for shared causes and effects, aesthetic decisions at the surface and philosophical connections beneath.

Wall has spoken of wanting to 'make pictures in the traditional way', describing his work as an attempt to 'recuperate the past – the great art of the museums'.[18] His photographs strongly correlate with the forms and subjects of fine art. But should a new medium have its own pictorial codes? Many have thought so and, in the twentieth century, practitioners and critics rejected what was believed to be photography's parasitic dependence on fine-art models. The old discussions about art were fruitless, elitist and, most importantly, untrue to photography's fundamental documentary impetus.

One could propose that photography was always an also-ran among the traditional visual arts, and that documentary is a way to deal productively with the medium's inadequacy as an imaginative art form. If it cannot be authentically expressive, then it should be authentically objective. Photography must celebrate its inherent strengths instead of compensating for its weaknesses by imitating painting through tricks and manipulations. By insisting on photography's unique properties, practitioners presented it as a worthy visual

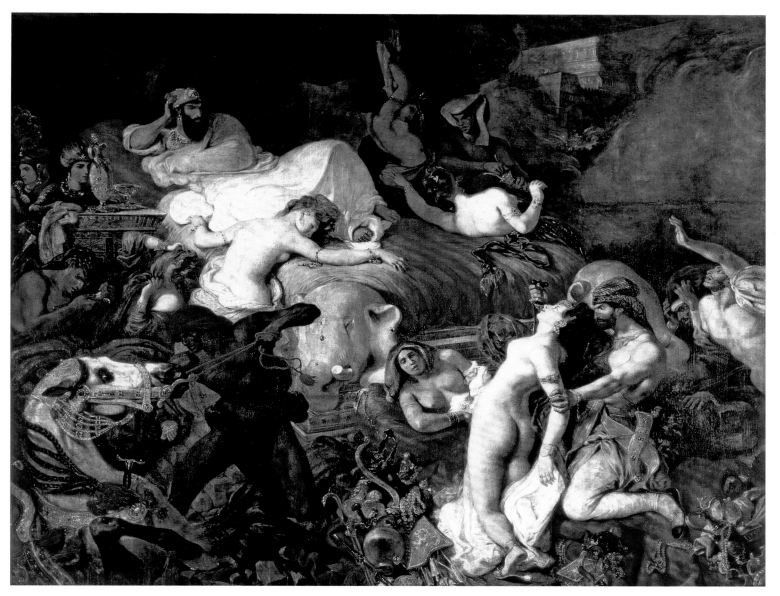

Fig. 10
Tom Hunter, *Death of Coltelli*, 2009. C-type print, 122 × 152 cm. Wilson Centre for Photography.

form distinct from fine art. But autonomy brought isolation, and Jeff Wall has described the 'photo ghetto' of the 1960s and 1970s as a self-contained world of galleries and publications devoted exclusively to the medium.[19]

The segregation has waned, in part through the work of artists such as Wall and Tom Hunter, whose pictures operate on a theatrical level that pushes back against the tendency towards a resolute ordinariness of subject. Hunter's *Death of Coltelli* (fig. 10) represents Delacroix's central Sardanapalus figure in a contemporary setting. In Hunter's work, the ordinary lives of his East London neighbours include extraordinary events – murder, rape, mugging, suicide – and they are pictured in the spectacular terms of large, full-colour photographs. As Colin Wiggins has noted, this is consistent with historical art: 'Extreme violence and physical abuse abound on the walls of the National Gallery and other comparable collections'. He adds that 'the patina of time and the High Art context renders it no longer shocking'.[20] Yet, Hunter's photographs are closer in time, and photography's undeniable realism puts us on edge.

In Hunter and Wall's photographs, as in Delacroix's painting, colour lends a beauty to the pictures at odds with the grim subject matter. Today, we may not notice colour, for it is the default mode of contemporary photography. However, colour is a relatively recent presence in the medium. In the nineteenth century, it was not integral to the photographic process but was added to monochrome images as hand-tinting. The results were clearly artificial, and some believed that colouring photographs undermined their authenticity. In 1860, the *British Journal of Photography* questioned the 'morality' of hand-colouring, explaining that it 'destroys the assumed absolute truthfulness of the original'.[21] This attitude persisted long into the twentieth century and black-and-white images remained the creative ideal. Colour photographs were associated with commercial work, with advertising budgets subsidising their technical complexity and cost. Colour was contaminated by vulgar consumerism and lacked artistic legitimacy until New York's Museum of Modern Art began exhibiting colour photography in the mid-1970s.[22]

In Sarah Jones's *The Drawing Studio (I)* (fig. 11), colour is the animating element, an echo of the artist's model remaining in the lush violet of her wrap. Jones trained in theatre, and her photograph resembles a set in which the performer has exited stage right. This is a place for us to imagine the absent model, encouraged by the dimensions of the piece, which accommodates the viewer's real scale. Jones's photograph shares with Jeff Wall's work a

comprehensive picture plane that enfolds the viewer in the scene. Large pictures are participatory – they thrust the image out into the spectator's perceptual space. The scale suggests that what we see is more than just a picture on a wall; it is a window on to a 'real' scene. Wall made a purposeful use of this in 1978, when *The Destroyed Room* (fig. 8) was presented as a nearly life-size transparency mounted behind the window of a Vancouver gallery's street frontage.[23] It was an unconventional window display, replacing a neat arrangement of merchandise with a chaotic tumble of goods in the wreckage of a room. When the photograph was acquired by the National Gallery of Canada in 1979, it moved into a setting where the art-historical references were more insistent. This early integration of photography into a public art gallery set the stage for the medium's ever-closer relationship with fine art.

Jeff Wall has described his large colour photographs as a means to 'participate with a critical effect in the most up-to-date spectacularity' and, along with his reference to 'the great art of the museums', this suggests that he is inspired by the tableaux of historical art.[24] In such ways, artists renew old modes and themes in the currency of their time. The subjects do not change from one medium or century to the next; we are still compelled by the stories in tableaux and celebrate the beauties of a still life. But the context alters, as does the technology, and for each genre, we find ourselves faced with the same question: what can photography do relative to what has been done in fine art? How does it fit itself into what is old, what is new, what is accepted by the establishment and what suits an experimental medium? The juxtaposition of media and time periods challenges our perceptions of the status of photography and the qualities we look for in a 'photographic' work of art.

Among a multitude of photographers, *Seduced by Art* focuses on artists who pay attention to historical picture making, whether painted or photographed. There are exceptional practitioners in past and present centuries. But are they exceptions? Even the small coterie of early photographers came from a world about which we know a great deal, and they are indicative of widely discussed ideas.[25] They also characterise innovation. It is important to remember that everything looks new in its own time, and that Julia Margaret Cameron stands equally with Jeff Wall as a revolutionary image-maker. Their works lead us into an enlivened appreciation of art's history and today's new possibilities.

Fig. 11
Sarah Jones, *The Drawing Studio (I)*, 2008. C-type print mounted on aluminium, 122 × 152 cm. Courtesy the Artist and Maureen Paley, London.

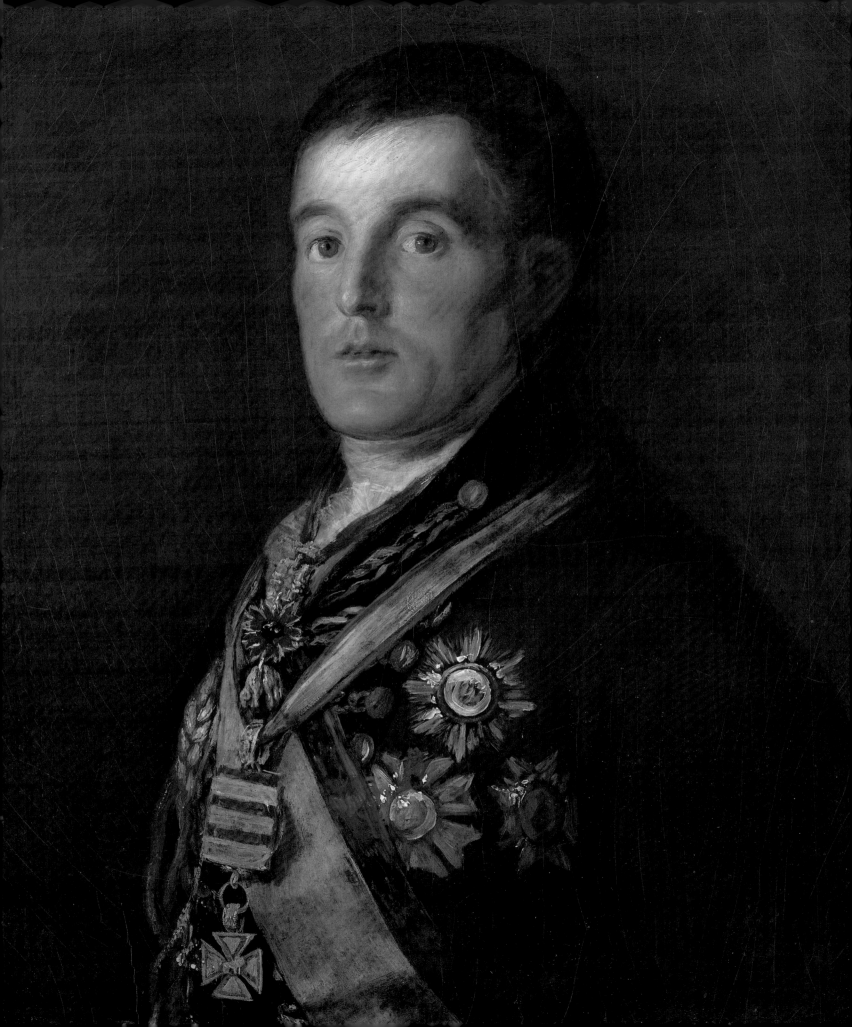

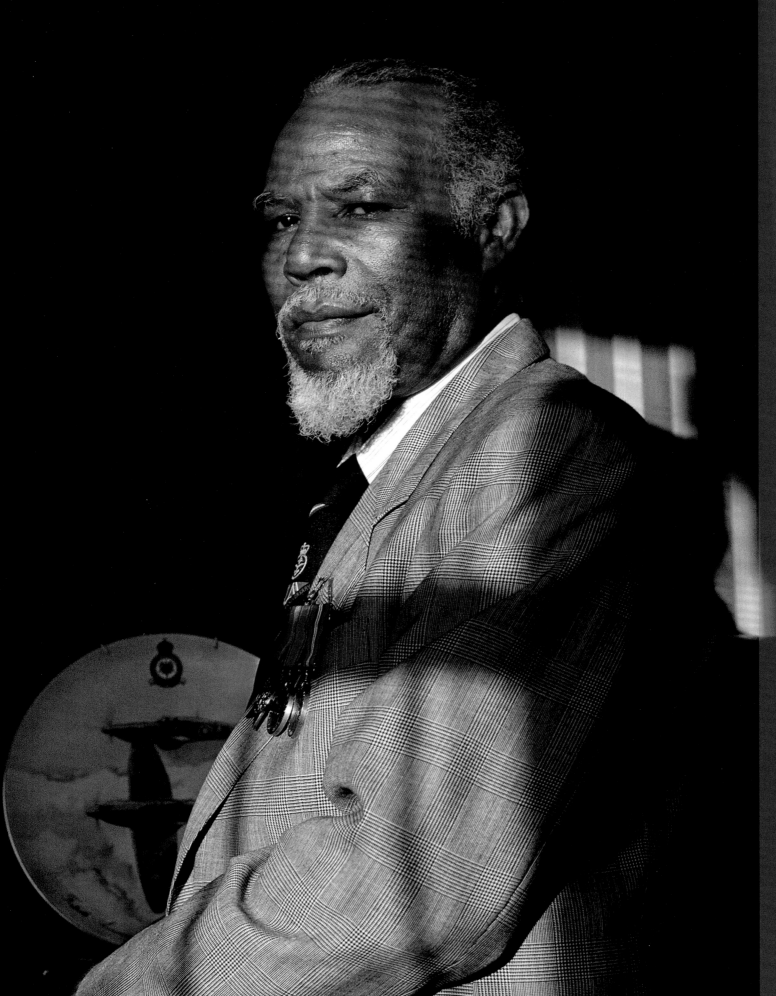

Photography is part of our own cultural moment, but it also arises from artistic traditions that long pre-date it. Photography's debt to fine-art conventions is more than imitation or homage; the past is adapted to inspire the present. This is Historicism: whether in architecture, the decorative arts or photography, it describes the revival of the content, materials and techniques of historical forms. Historicism has been a recurrent force in culture, validating new art in the conventional terms of the old. In this way, it is usually understood as the antithesis of Modernism, whose ethos was a break with precedent and whose motivation was a search for new modes of expression. Yet, Historicism is still in play today; nineteenth-century eclecticism is mirrored in our own magpie postmodern culture, which recycles historical approaches alongside the latest pop trends.

In the Victorian era, history was what made art new, as a greater professionalism in archaeology and anthropology gave artists a more accurate understanding of the past. Photographically illustrated publications invigorated art history, providing a diversity of sources from the classical prototypes of Greece and Rome, through the Italian Renaissance and on into the Baroque. The biggest reproductive project of the time took place at the National Gallery, where Leonida Caldesi photographed more than 320 paintings, published in 1873 as *Pictures by the Old Masters in The National Gallery*.[1]

REIMAGINING THE GREAT SUBJECTS OF ART

Historical art still resonates with contemporary practitioners. Layers of past and present are described in Thomas Struth's *National Gallery 1* (fig. 12). This is a picture within a picture: a photograph of a gallery that encloses an altarpiece, which in turn frames an illusionistic sixteenth-century space that seems to be a window through the wall. Struth's monocular camera lens flattens these pictorial layers into a single scene.[2] The different worlds are connected by their protagonists – the modern gallery-goers in front of a revered work of art, their clothes and poses echoing the red-, green- and blue-draped apostles surrounding the figure of Christ. Do these elements combine to make an allegory? The pictorial elements portray reverence and inattention, belief and doubt. Cima's subject is doubting Thomas; does Thomas Struth doubt the truthfulness of the photographic image? None of this is real; all of it is a picture, part of which was painted more than four hundred years ago and is now encompassed in a photograph made in 1989.

Is an interest in the artistic past reactionary? We have inherited prejudices from the late nineteenth century, when the grand religious set pieces and allegorical history paintings demanded by traditional patrons – the Church, the aristocracy and the State – were giving way to colloquial subjects for a secular market. By the end of the century, a reverence for historical art began to be seen as a refuge for those who did not understand or appreciate art's advance. This suspicion of high-art

Fig. 12
Thomas Struth, *National Gallery 1, London, 1989*, 1989. C-type print on Perspex support, 183·5 × 199·5 × 4·9 cm (framed). Tate, London.

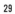
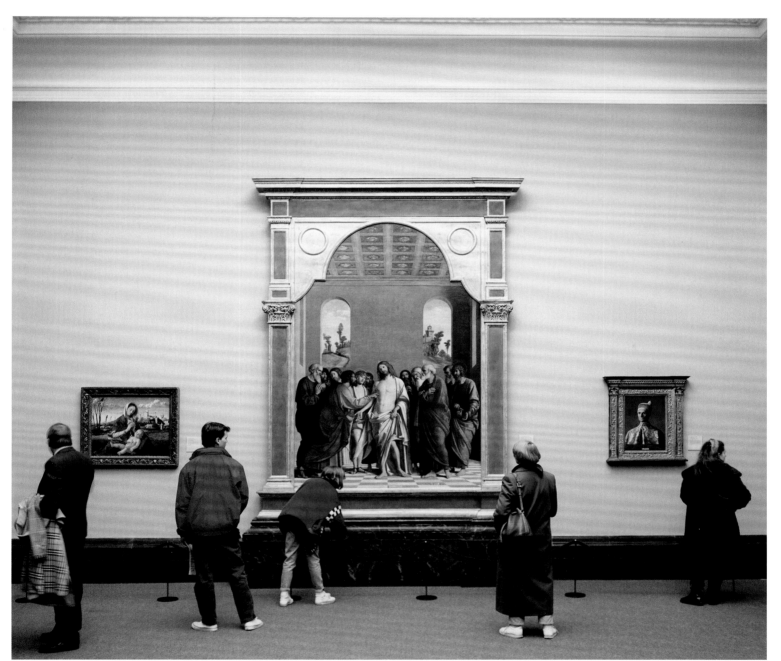

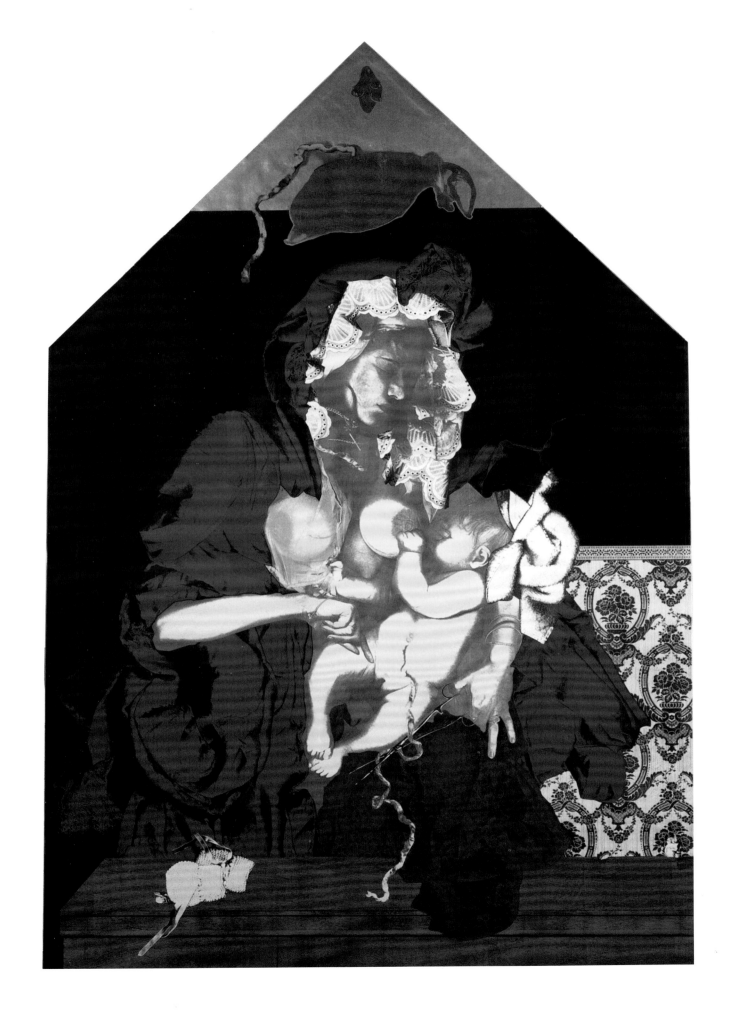

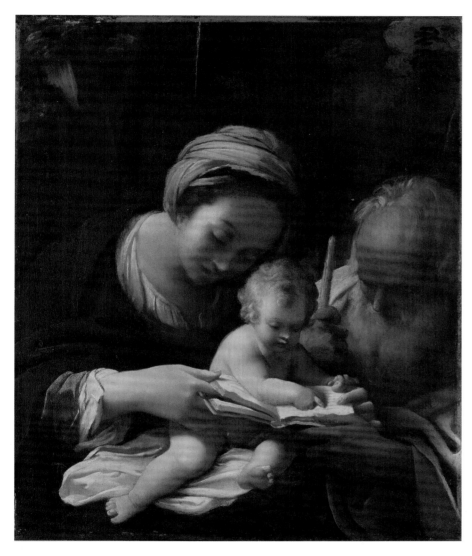

Opposite, fig. 13
Helen Chadwick, *One Flesh*,
1985. Collage of photocopies
on paper, 160 × 107 cm.
Victoria and Albert Museum,
London.

Above, fig. 14
Bartolomeo Schedoni,
*The Holy Family with the
Virgin teaching the Child to
Read*, about 1613–15. Oil
on wood, 33·6 × 28·2 cm.
On loan from the Personal
Representatives of Sir Denis
Mahon CH CBE FBA.

sources persists today, and part of Helen
Chadwick's provocation in *One Flesh* (fig. 13)
was in remaking an old-fashioned Old Master
subject (fig. 14) with modern media.

Chadwick pieced together a Madonna and
child from photocopies of real objects – and
bodies – placed directly on the glass platen
of the copier. She tinted the prints with the
vibrant colours of a medieval manuscript
and combined the sections into a collage that
was mounted within a simplified version
of a traditional arched altarpiece.[3] Just as
Chadwick's technology marries old and new
forms from collage to xerography, her imagery
unites old and new readings of a nativity,
from the traditionally draped Madonna to the
modern surgical clamps for her baby girl's
umbilical cord.

Chadwick used photography as a medium
that stood apart from the hierarchies of
what was seen as the traditional and elitist
world of painting and sculpture. In the 1970s
and 1980s, that was an opportunity,[4] and it
remains so today. But early photographers
did not contravene the values of fine
art; there was too large a gap between
photography's aspirations and its place in the
art world. Academic art endorsed invented,
synthetic pictures of high-art subjects, but
photography was limited to bald reality.
Could a mechanical medium address the big
subjects of art? As the *Athenaeum* wrote in
1856: 'Machinery can copy science, – can
catch shadows, and keep them when caught;
– but it takes a human heart to conceive the

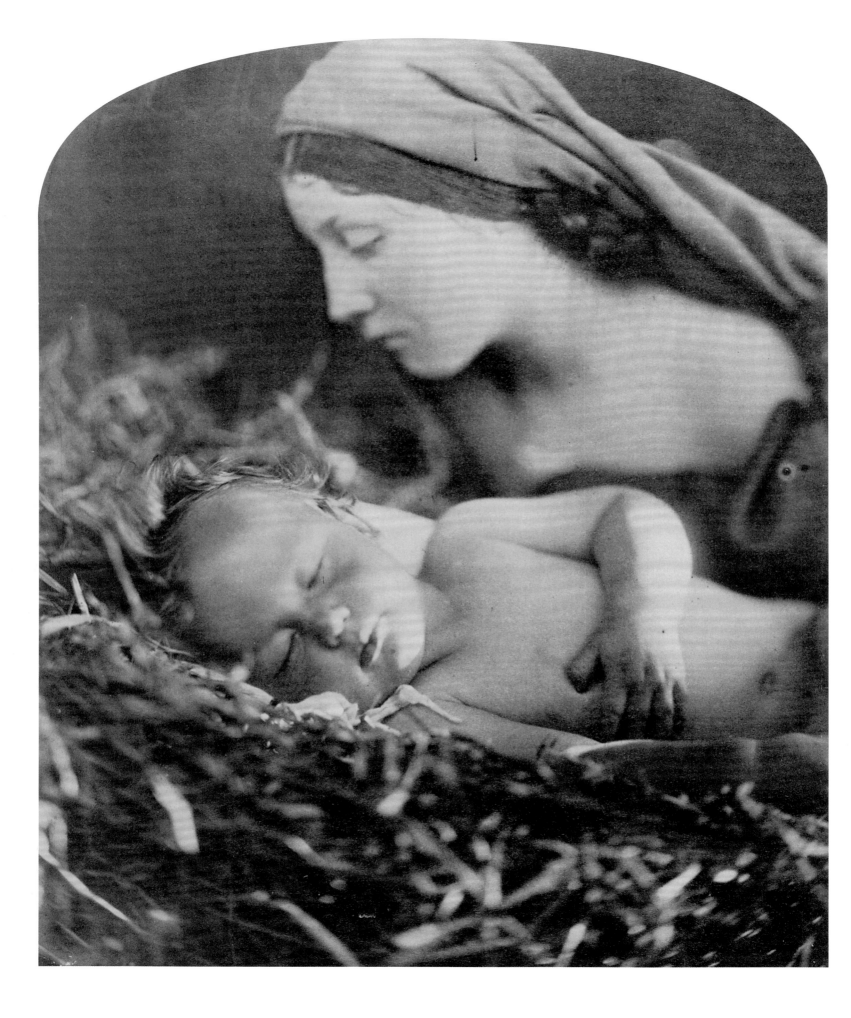

Opposite, fig. 15
Julia Margaret Cameron,
Light and Love, 1865.
Albumen print, 26 ×
21·6 cm. Wilson Centre
for Photography.

Right, fig. 16
Correggio, *The Madonna of
the Basket*, about 1524. Oil
on wood, 33·7 × 25·1 cm. The
National Gallery, London.

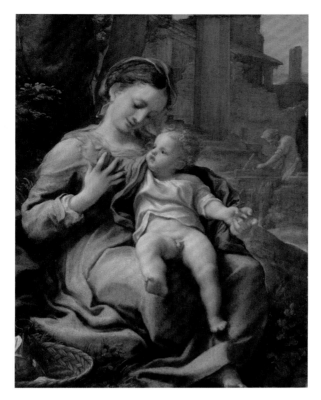

transfiguration, and a human brain to plan
the Last Judgement'.[5] This might have been a
positive challenge to photographers like Julia
Margaret Cameron, whose graceful studies
re-envisioned traditional religious subjects.
In *Light and Love* (fig. 15), the figures have
a fresh naturalness that is complemented
by subtle tones and soft outlines. The result
compares well with Correggio, who was cited
in reviews of Cameron's photographs. In 1867,
founding editor of the *Intellectual Observer*[6]
Henry James Slack praised Cameron's work as
corresponding with 'the method of drawing
employed by the great Italian artists',
resembling 'a sketch by Correggio'.[7]

REPRODUCING ART

Correggio's *The Madonna of the Basket* (fig. 16)
would have been well known to Cameron and
her reviewer, for it had been in the National
Gallery since 1825. Cameron had seen many
works of art in her travels across Europe.

However, most of her photographs were made
at her home on the Isle of Wight, and the
range of her sources and the care with which
she re-created Old Master works indicates
that she had more to go on than a good visual
memory. In the mid-nineteenth century, art
reproductions were proliferating as engravings
and, increasingly, as photographs.

Works of art were photographed very
early; William Henry Fox Talbot included a
photograph of a fifteenth-century drawing in
his publication *The Pencil of Nature* (1844–
46), and described it thus: 'Fac-similes [sic]
can be made from original sketches of the
old masters, and thus they may be preserved
from loss, and multiplied to any extent'.[8]
Photography revolutionised reproductive
media; its objective transcriptions supplanted
hand-engraved interpretations of works of
art. Furthermore, photographic images had a
continuous tonal gradation, improving on the
line engravings that were the ordinary staple
of art reproductions.[9]

Photographic reproductions were also
relatively affordable. A good engraving could
take weeks, months and sometimes years
to produce, while a photographic exposure
was a matter of seconds, and a print run
required little more than a decent spell of
daylight (until the advent of artificial light,
photographic publishers stockpiled their
products in the summertime). Photography's
signal disadvantage lay in the rendering of
colour; the engraver could translate colour into
the appropriate monochrome tones, whereas

34

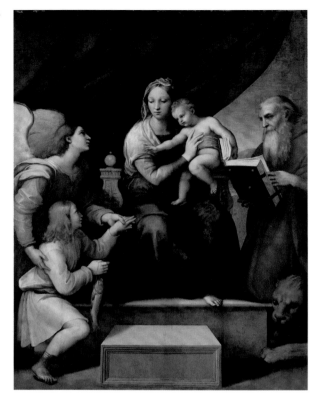

less profitable photographic endeavours. By the middle of the nineteenth century, photographic art reproductions were widely circulated, and Cameron's mentor, artist George Frederic Watts, advised her to use them as lessons in picture making:

> There are a few rules to be laid down, but they will not carry you far. I should advise you to get some Photographs from prints after the greatest masters.[10]

If those reproductions were useful as an artistic aid, then perhaps there was also a market for

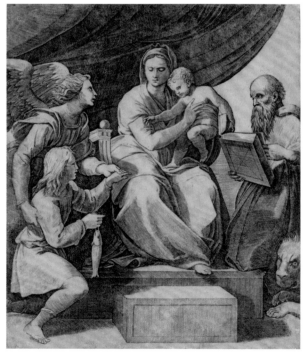

Left, fig. 17
Raphael, *The Madonna of the Fish (The Madonna with the Archangel Gabriel and St Jerome)*, 1513–14. Oil on wood, transferred on to canvas, 215 × 158 cm. Museo Nacional del Prado, Madrid.

Below, fig. 18
Marco da Ravenna (after Raphael), *The Madonna of the Fish (Madonna del Pesce)*, about 1517–20. Engraving, 26·2 × 21·6 cm. The British Museum, London.

Opposite, fig. 19
Roger Fenton (after Raphael), *Madonna and Child*, 1854–58. Photographic art reproduction as albumen print, 36·3 × 26·5 cm. The Royal Photographic Society Collection at the National Media Museum, Bradford.

nineteenth-century photographic materials distorted colour values. Thus, to make an art reproduction of Raphael's *The Madonna of the Fish* (fig. 17), Roger Fenton photographed an engraving in which the conversion to monochrome had already been made (figs 18 and 19). The same circumstance applies to Fenton's reproduction of George Lance's '*Comus*' (p. 153, fig. 112).

For a number of photographers like Fenton, art reproductions were a steady commercial enterprise, subsidising more creative but

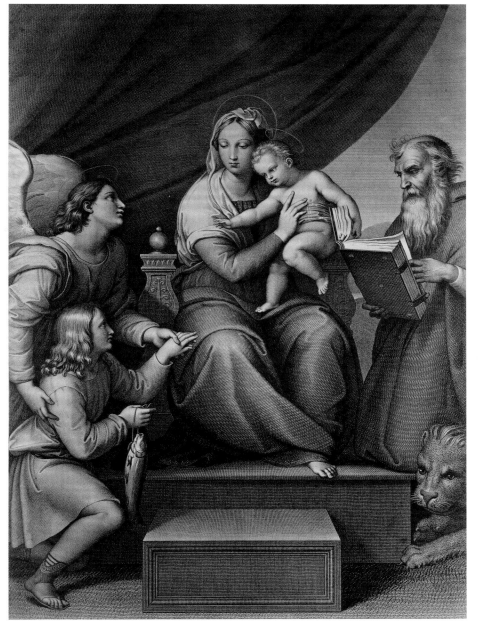

the photographs they inspired. Cameron made a number of studies after famous works of art, including *La Madonna Riposata* ('Resting in Hope', 1864, a variant of *Light and Love*, fig. 15).[11] She sold such works to Henry Cole, the first director of the South Kensington Museum (now the Victoria and Albert Museum), and her photographs were integrated into the museum collections as high-quality reference material.[12] Cameron reprinted some of the subjects at a reduced size, suggesting that she was aiming at a commercial market.[13] She also joined the Arundel Society, founded in 1848 by Charles Eastlake, among others, which published reproductions of historical art to encourage its appreciation and preservation.[14] By the mid-1850s, photographic reproductions were central to the society's publications; between 1856 and 1878, it produced more than 30 volumes illustrated with albumen prints, carbon prints and photomechanical prints.[15]

O. G. Rejlander's studio business included photographic studies after well-known works of art. In *Non Angeli sed Angli* (fig. 20),[16] he re-created the pose, tonal gradations and lighting of the cherubs in Raphael's *The Sistine Madonna* (about 1513–14). He probably adopted those elements from one of the many reproductions (fig. 21) that were likely his only access to a painting that had resided in Dresden since 1754. Rejlander's result was successful enough to be widely exhibited and printed for sale in different sizes. The photograph captured a natural beauty that was praised by contemporary reviews; one

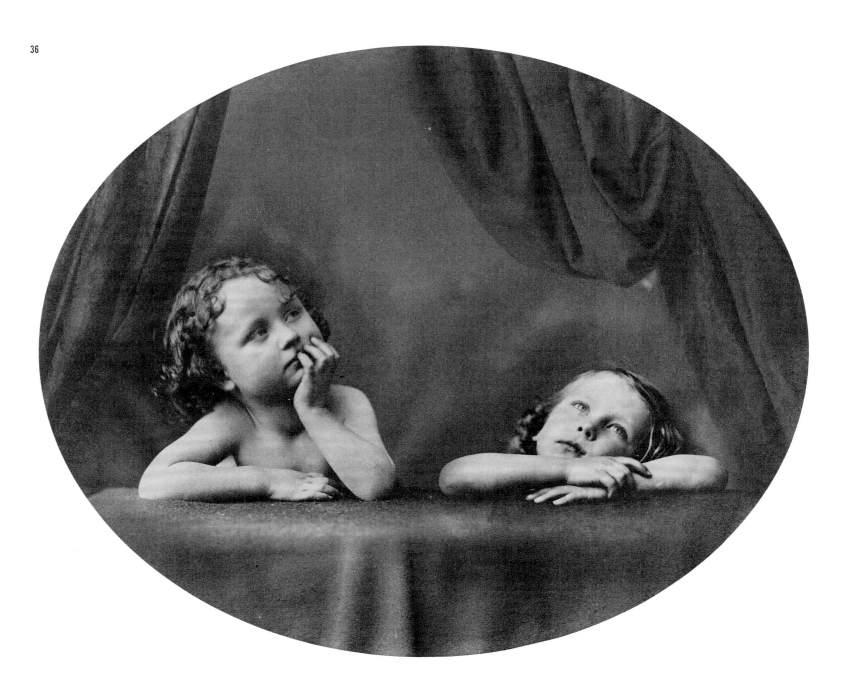

Fig. 20
Oscar Gustav Rejlander,
Non Angeli sed Angli, 1857.
Albumen print, 16·2 ×
19·3 cm (oval). The Royal
Collection, Windsor.

Fig. 21
**William Holl the Younger
(after Raphael)**, *The Sistine
Madonna* (*Madonna di San
Sisto*), 1822–71. Engraving
on paper, 30·5 × 23 cm. The
British Museum, London.

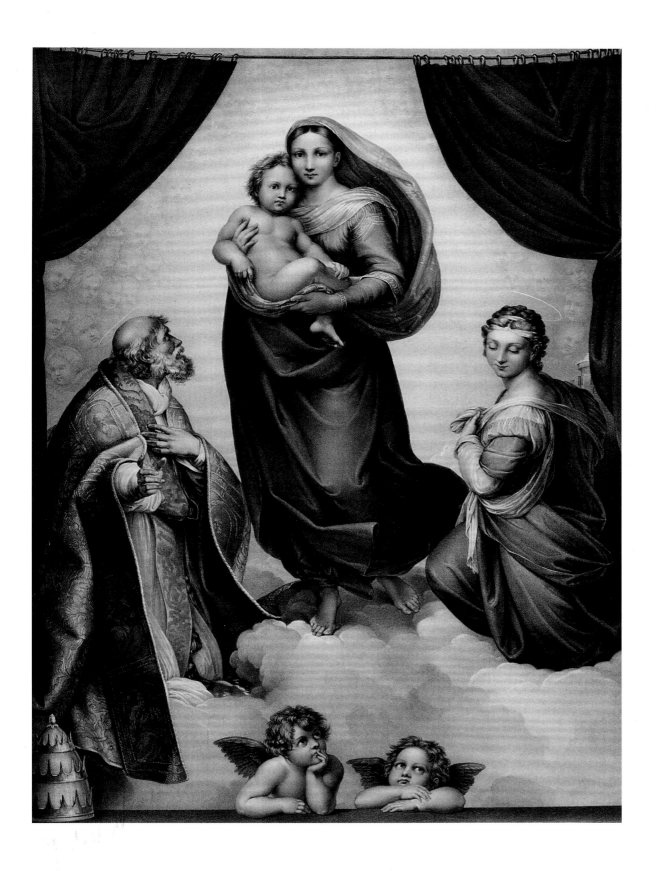

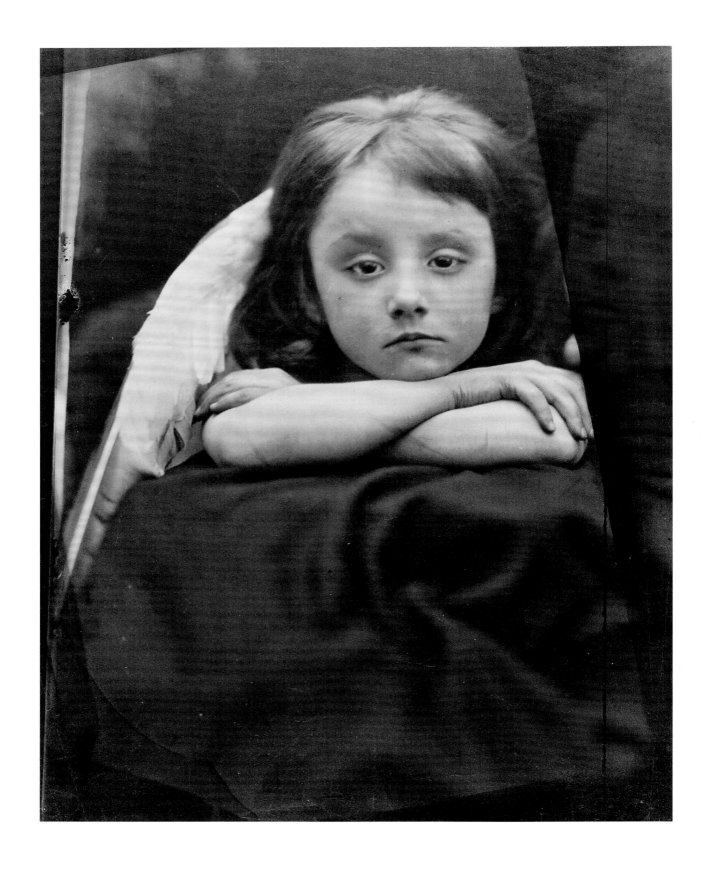

Fig. 22
Julia Margaret Cameron,
I Wait, 1872. Gold-toned
albumen print, 26·7 ×
21·6 cm. Wilson Centre
for Photography.

account claimed that Rejlander 'tests Raphael by nature and beats him hollow…the visitor could at once recognise how the cherubim of the photographer gave the go-by to [snubbed] those of the painter.'[17] Cameron's *I Wait* (fig. 22) is less formal, and the freshness of the pose appeals to a modern eye. But it was a study; Cameron's finished exhibition photographs show more stylised angels. This is not a work of art-historical scholarship, but a charming picture made by a practitioner who knew Old Master art well, and her audience shared her knowledge and her taste.

MEETING THE ART OF THE PAST

In Rejlander and Cameron's time, photographs as studies and reproductions addressed a constituency that knew and valued historical art, often through those very images. Our access to art is enhanced by modern photographic art reproductions that are freely available in full colour and high resolution.[18] However, does this marvellous resource skew our understanding of historical art? We see the images not the objects. Photographs reduce diverse artefacts to equivalent representations, effacing the material qualities of the originals. That issue is part of the project that Jorma Puranen calls *Shadows, reflections*.

Puranen approaches the art of the past head on, photographing each work as an object whose characteristics – the marks of the painter's brush, the sheen of paint and varnish, the topography of the panel or canvas beneath – are detailed in the glancing light of the camera's exposure. As Puranen explains:

I photographed disturbing reflections on the surface of paintings. These reflections arouse in the viewer some kind of feeling of vulnerability, which is created by the tensions between the moment and permanence, between a flash of light and patina that is centuries old.[19]

We are accustomed to seeing artworks in the even brightness of digital imaging or well-lit galleries. But Puranen's pictures show a reflective veil of light that slides across the photographic surface to reveal something but not everything. We see the picture partially, and must imagine the rest. Such visual ambiguity is intriguing; the details are implied, tempting us to look more closely. We approach the image both psychologically and aesthetically, as has long been part of our enjoyment of art. In the 1840s, Charles Eastlake argued that indistinctness in painting had its uses, giving greater latitude to the imagination: 'when vision is imperfectly addressed…imagination takes its place'.[20] In Puranen's works, our imaginations are fully engaged.

In Puranen's photograph of Goya's *Duke of Wellington* (fig. 24), the subject peers out through the light, and there is a feeling that the sitter, long lost to us except as an image, is resurrected as an apparition from within the picture. Puranen speaks of 'the possibility of presence' in the portrait: 'I thought that what I

was doing was in fact like knocking on the frame of a painting and asking, "Is anyone there?" or saying, "Wake up, I know you're there."[21]

This is not a portrait in the conventional photographic sense of a real sitter in front of the camera lens. Instead, there are two subjects: the long-ago person and the painted representation. Here is a double past, one lived, one painted, and a double present of paint and canvas and of light-sensitive particles and dyes suspended within a gelatin binder on photographic paper.

Puranen's work is made from Francisco de Goya's famous portrait of the Duke of Wellington (fig. 23), whose legacy includes Dave Lewis's *Mr. Hector Stanley Watson* (fig. 25). Watson turns to look at the camera, much as Wellington turned towards Goya, and the light picks up his medals, simpler by far than the ornaments on the Duke's jacket. Instead of a sash, Watson wears an RAF tie, for in the Second World War he was one of almost 7000 West Indian volunteers to the RAF.[22] Goya portrays Wellington against a plain background – the Duke is important enough to be the picture in its entirety. In Lewis's photograph, Watson is picked out by a band of light that removes him from the ordinary surroundings of his living room and gives him gravitas. Lewis honours a different kind of heroism; unlike the Duke of Wellington, Watson and his compatriots at the West Indian Ex-Servicemen's and Women's Association were not professional soldiers but

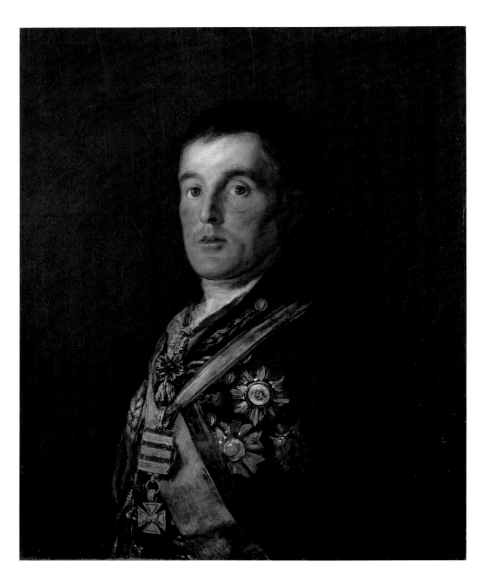

Above, fig. 23
Francisco de Goya, *The Duke of Wellington*, 1812–14. Oil on mahogany, 64·3 × 52·4 cm. The National Gallery, London.

Opposite, fig. 24
Jorma Puranen, *Shadows and Reflections (after Goya)*, 2011. C-type print mounted on Plexiglas, 98 × 78 cm. Jorma Puranen, courtesy Purdy Hicks Gallery, London.

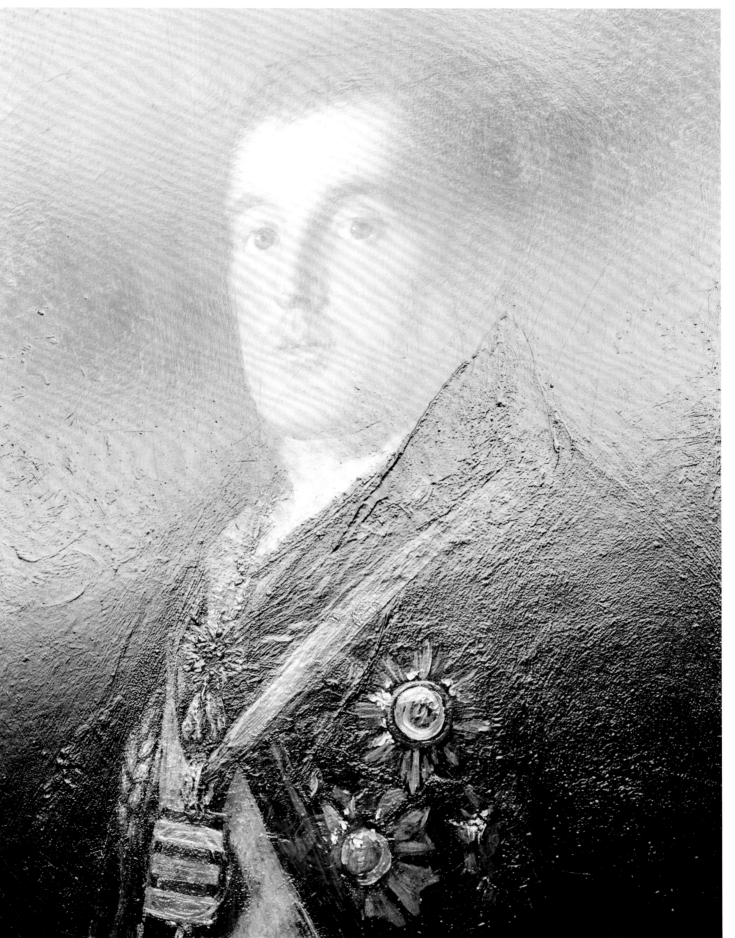

ordinary people. This is what photography can do: commemorate the people whose contributions to history will never be marked by a grand oil painting.

While photographs are obviously more realistic than their painted equivalents, they too are constructed portrayals. The anonymous daguerreotype portrait of a junior naval officer (fig. 26) shows a studied pose. The gold-toned plate is enhanced with applied gilt on the sitter's belt buckle and sabre, while his face and hands are hand-tinted with powdered pigment to cover the pallid grey of the mercury-silver image with a more pleasing flesh tone.[23]

Roger Fenton's photographs from the Crimean War were also carefully composed. Fenton had studied painting, and that training is evident in the *Cooking House of the 8th Hussars* (fig. 27), in which an apparently natural group of British officers and enlisted men is arranged for a long exposure time.[24] Fenton's large plate camera helped him to see the underlying formal structure of the scene, for it presented the image upside down on the ground-glass viewing screen. There is a similar sensibility in Simon Norfolk's thoughtful posing of the Media Operations Team in Helmand Province (fig. 28), made with a large-format field camera based on a nineteenth-century design. Norfolk also modified his photographs to match nineteenth-century materials. The exposures were digitally adjusted to replicate the photosensitivity of collodion glass plate

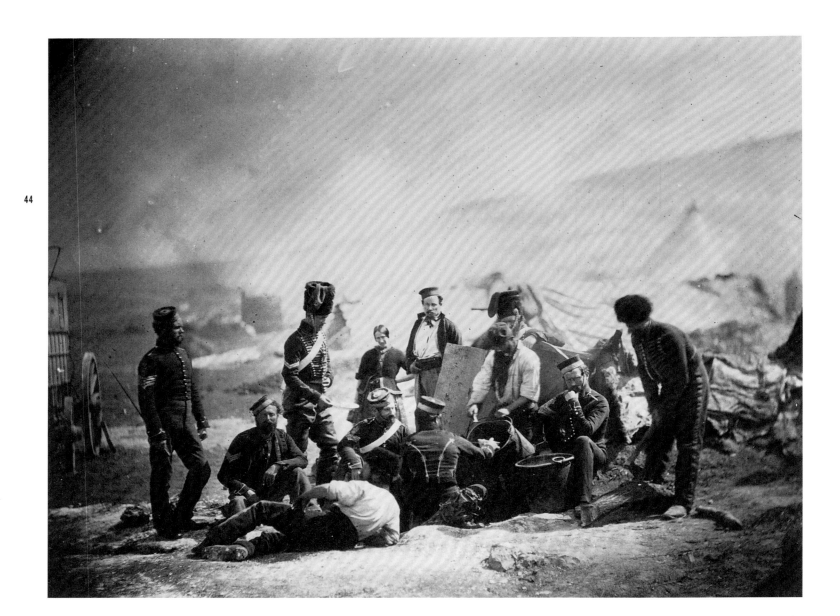

Opposite, fig. 27
Roger Fenton, *Cooking House of the 8th Hussars*, about 1855. Gold-toned salted paper print, 15·5 × 20 cm. Wilson Centre for Photography.

Below, fig. 28
Simon Norfolk, *British Army Media Operations Team including a Combat Camera Unit, Camp Bastion, Helmand*, 2011. Digital archival pigment print, 36·7 × 48·8 cm. Wilson Centre for Photography.

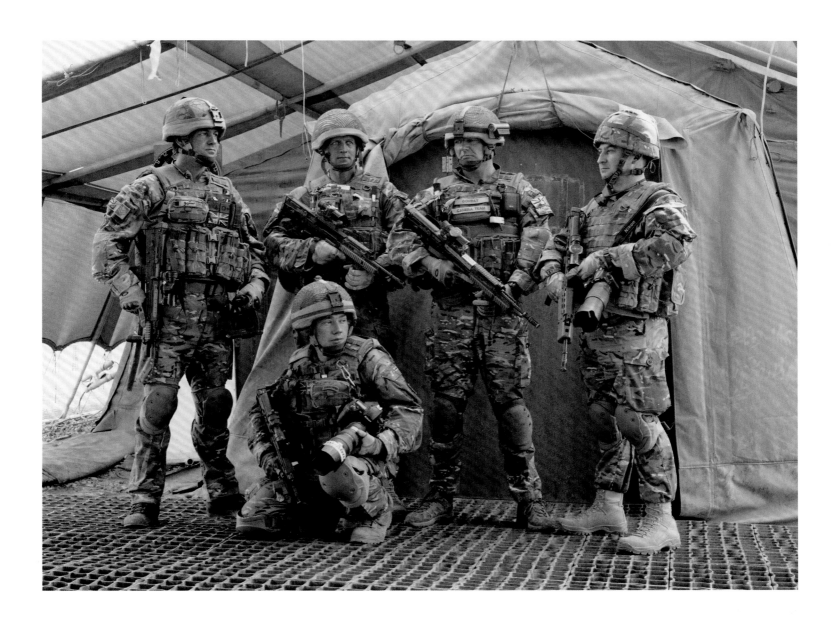

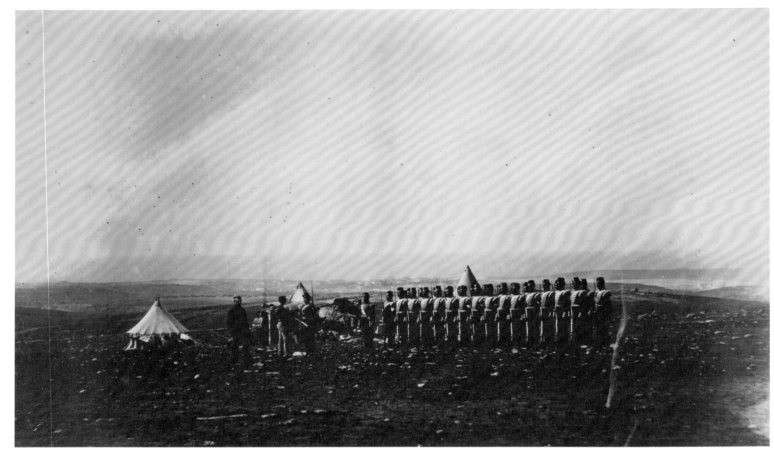

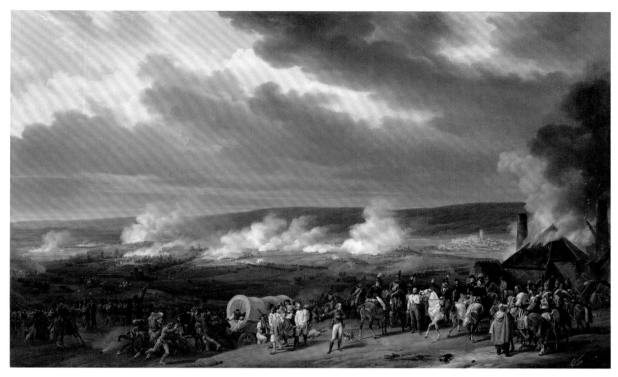

Opposite, fig. 29
Roger Fenton, *Lieutenant-General Sir John Campbell and the remains of the Light Company of the 38th (1st Staffordshire) Regiment of Foot*, 1855. Gold-toned salted paper print, 14·6 × 24·7 cm. Wilson Centre for Photography.

Right, fig. 30
Emile-Jean-Horace Vernet, *Battle of Jemappes*, 1821, from the group 'Four Battle Scenes', 1821–26. Oil on canvas, 177·2 × 288·3 cm. The National Gallery, London.

negatives, and the images were printed in aubergine-brown hues with ivory highlights, like the original albumen silver prints. Norfolk's project was inspired by John Burke's late-1870s photographs of the British invasion prior to the Second Anglo-Afghan War of 1878–80, and he modified the modern photographs in homage to the earlier work.[25]

PICTURING HISTORY

Luc Delahaye insists on his autonomy from art-historical sources; his catalyst is the unshakeable relevance of real events. The photograph *US Bombing on Taliban Positions* (fig. 31) was made while Delahaye was working as a photojournalist within Magnum, the photographers' cooperative agency. But the expansive, carefully presented scene operates on us like a grand history painting. The view of an unseen American B-52 plane bombing Taliban positions in Afghanistan has

the breadth and scale of Emile-Jean-Horace Vernet's *Battle of Jemappes* (fig. 30).

Vernet spells out the battle; one can follow the narrative from foreground to far distance; all is revealed. In contrast to the chaotic scrabble of an infantry battle, Delahaye's photograph shows just the silent smoke of the bombing. This is a faraway view of events, its vastness scaled down by distance and the empty tranquillity of the foreground. The picture is reticent, a contrast to the images of war in today's media. We see so much of the scene, but we actually see nothing at all beyond a puff of smoke.

The composition of Roger Fenton's Crimean battlefield (fig. 29) bridges the two approaches above. The line of soldiers against a spare background is neither as pared down as Delahaye's photograph, nor as didactic as Vernet's painting. It would have been carefully worked out in advance, the perfect line of troops, the oblique light picking out

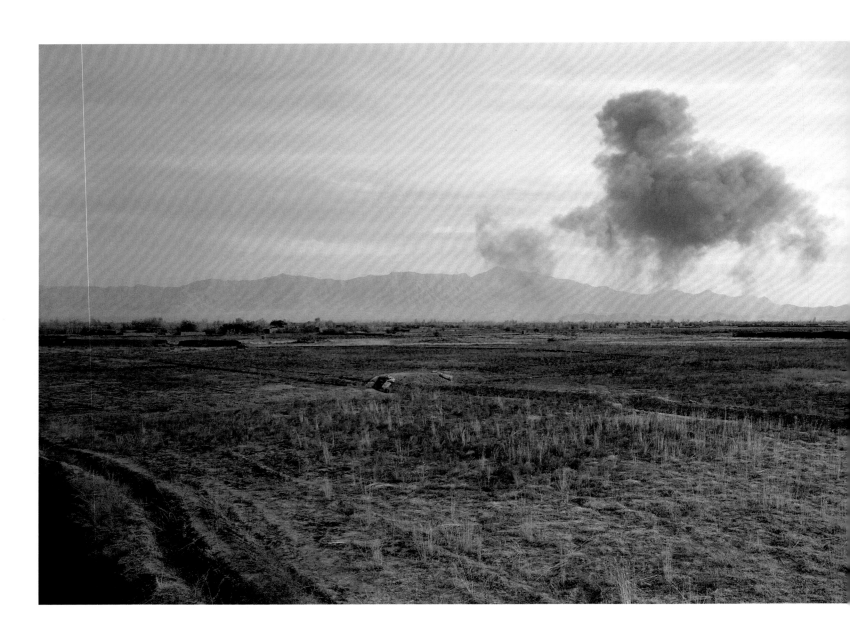

each chest, each leg, ranked like a row of their Enfield rifle cartridges against the plateau of Sevastopol. The title of the photograph is indicative of the attrition: more than half the regiment were casualties of the war and Sir John Campbell would be killed later that year.

Delahaye began his big panoramic photographs in 2001 upon leaving *Newsweek* magazine, to which he was a regular contributor. The large-scale photographs from Afghanistan were joined by images of other global events, from the 2003 Security Council meeting on the Iraq War to the 132nd Ordinary Meeting of the Organization of the Petroleum Exporting Countries (OPEC) in Vienna in 2004 (fig. 32). The works developed as he further disengaged from photojournalism, resigning from Magnum in 2004. Delahaye also changed his working practice, taking up larger cameras to open the field of view beyond the small format of a typical hand-held press camera. The tightly focused instant of the usual photojournalistic image – *this event, here and now* – expands into a panoramic scene that suggests extended time.

Although large images can present much more visual information, Delahaye's pictures are simply composed and intelligible. This comes in part from the eye of a journalist who has learned to distil the essence of a place or event. The scale also produces an openness that encourages the viewer to move into the scene. At the size of the works (typically two to three metres wide), we are enveloped

Fig. 31
Luc Delahaye, *US Bombing on Taliban Positions*, 2001. C-type print, 112·2 × 238·6 cm. Courtesy Luc Delahaye and Galerie Nathalie Obadia.

by the place, pulled in, on to that plain in Afghanistan. The photographed view is eye level; we are standing in Delahaye's place as he originally stood there. This is intentional. It promotes what he calls a physical rapport between himself and the event, the resulting work and the eventual viewer of that work.

Vernet and Delahaye's pictures are made for the art world, and their large scale has the same purpose; they are works for display in an exhibition hall, not in the print or online press. These are not utilitarian documents, but neither are they simply pictures with a set of pictorial codes to be read by an informed, middle-class, art-world audience. Delahaye's photographs, like Vernet's great historical tableaux, are a means of communicating the narratives and ethical questions of world events.

The distant viewpoint in the Afghanistan panorama (fig. 31) is a purposeful contrast to the heroic proximity of Robert Capa-style reportage, where immediacy guarantees authenticity. Delahaye's visual restraint is a choice; he has been close enough for many years. He refuses to use the emotional hooks that he associates with photojournalism, that reportorial tug on the sleeve. Often, he says, the reality of the event is more terrible, more absurd or more ordinary than the media portrays, and he is sceptical about his ability to do justice to such uncomfortable or contradictory truths.

Although the form and content of Delahaye's photographs are similar to history paintings,

Fig. 32
Luc Delahaye, *132nd Ordinary Meeting of the Conference*, 2004. Digital C-type print, 138·7 × 300 cm. Wilson Centre for Photography.

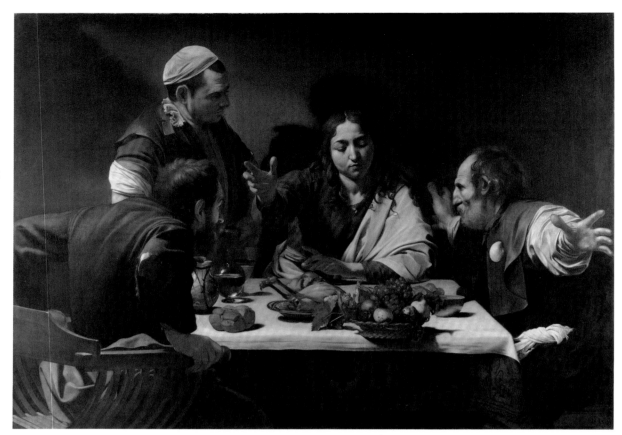

Left, fig. 33
Michelangelo Merisi da Caravaggio, *The Supper at Emmaus*, 1601. Oil and tempera on canvas, 141 × 196·2 cm. The National Gallery, London.

Opposite, fig. 34
Luc Delahaye, *Taliban*, 2001. C-type print, 111 × 237 cm. Wilson Centre for Photography.

the pictures do not intentionally refer to art history, as Delahaye says: 'it's true that one can see resemblances and that these could be mistaken for quotations, or allusions, to certain types of paintings'.[26] But, he believes that the resemblance to painting is the result of common artistic motifs.

To focus on Delahaye's photographs as art objects is to miss part of their meaning. They are telling stories, as in the original French term for 'history painting', *la peinture d'histoire* (where *histoire* has a dual sense of both history and narrative). Effective storytelling demands expression and drama, and these key components of art are found in Delahaye's spectacular tableau, *132nd Ordinary Meeting of the Conference* (fig. 32). In this fluid scene of strikingly Baroque chiaroscuro, the gestures of the OPEC delegates and

reporters communicate an emotional register reminiscent of Caravaggio (fig. 33). Delahaye builds the narrative pace by stitching the scene together as a digital composite. He is unapologetic about this synthesis; it allows the picture to exist.

Delahaye does not specifically refer to these art-historical models, but his work operates on a theatrical level that amplifies the historical power of the event depicted. In *Taliban* (fig. 34), the fallen soldier's position is reminiscent of the figure of Christ in a pietà, a Muslim stand-in for a famous religious figuration. Perhaps we re-envision this man as a Christ-like sacrifice, or perhaps the political poles of good and evil are simply cancelled out by the pathos of a dead body. The different approaches of painter and photographer may also meet, as Delahaye says:

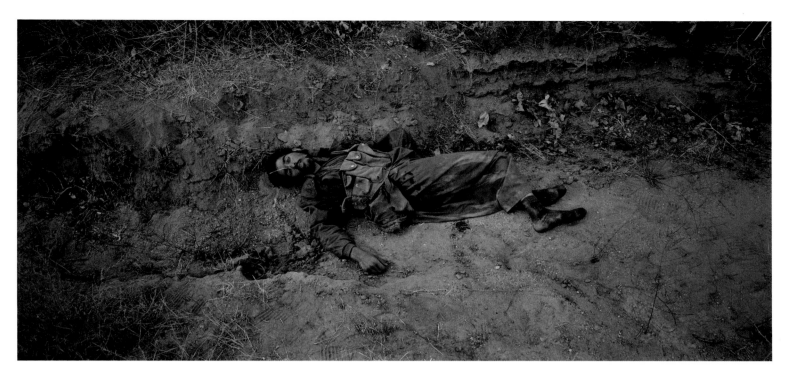

Take the Renaissance painter who painted Christ, the entombment: he wasn't a witness to the event and had to do it from a model who he made pose in a certain fashion, from his own observation of life; then take a war photographer who photographs a soldier or civilian, wounded or dead, in a certain position. The art historian will later say that the photograph is inspired by the painting, but what we actually see is that the paths of the photographer, who took reality as a subject, and of the painter, who took reality as a model, are crossing somewhere.[27]

Delahaye's words are both a critique and an opportunity. He points to a superficial use of shared cultural references that is as much visual resemblance – our brains' love of pattern-making – as valid art-historical comparison. Artistic models may short-circuit our ability to engage directly with a work;

the sources are so familiar. Yet, pictorial archetypes are also signifiers of something bigger, a literal and metaphorical framing for our reaction to a work of art. And, in finding a point of convergence between the painter's and the photographer's responses to reality, Delahaye offers us the possibility that pictures, whether painted or photographed, might share something fundamental and inspiring in representing our experience of the world.

HK *Take the Hill and Adamson portrait of Elizabeth Rigby, later Lady Eastlake [about 1845, fig. 43, p. 64]. The reason she rests her head on her hand is because she's trying to hold it still.* I struggle with that! Because of the kind of lighting I use, I keep saying [to my sitters] hold still, breathe in! But when they think someone's observing them, scrutinising their faces, then suddenly they get rigid and that makes them move.

CR *With the lighting you use people have to stay particularly still?* Well, it is continuous lighting. I don't use flash photography, so it is often similar to the way you'd light a film set. I wasn't trained as a photographer so my knowledge of the kit is limited to what I've learned through others, like my partner who is a film director. A lot of the techniques he's learned involve keeping a camera rolling, so it's continuous lighting that has an effect on the outcome, and a quality that flash and studio photographs often don't have.

Actually, that's where it has some connection to painting. The paintings here [in the National Gallery] are notable for the quality of light, particularly the older Dutch paintings. When I'm staging a photograph and I reference paintings, some images are selected based on how easily they can be translated into a photograph. Others you take for the narrative rather than the quality of light because you want to do something with a story. You're not quite sure whether it will turn out to be a beautiful image or not. You just have to take that chance with some of them. It's amazing how you realise, when you are trying to re-create something, which painters were technically correct and which weren't.

When one person's being lit with one [light source], and the other person with [another], when you try and put multiple lights in a set they conflict. You can't really say well I'm only going to light you and not you.

HK *Whereas in a painting you can do that, you can stitch it together.* Which is the beauty of painting really; you can actually use your imagination and paint people how you want them to be as opposed to how they are.

HK *Continuous lighting must give you better opportunities for really looking at what happens.* You do most of it by eye. You stand at the point where the camera is and you can really see what you're going to get, and that's hugely important because I can spend half a day on one shot, trying different elements, but as soon as you put the lights on you know whether this is going to work, or whether this one's going to take a bit longer and you'll have to redo it. It's a great way of working, actually.

CR *Have you ever just abandoned a shot because it wasn't going to work?* No. I think I have a strong idea before I embark on most photographic journeys. I don't photograph terribly often, and I usually do it in a condensed period and try and do multiple shots. Because it's generally quite an expensive process, I plan for a few months to take a particular set of shots. I think I've got very good at being pretty sure of what I want in my head.

I like to use people and situations around me that I know. They're people that I have dinner with, and breakfast with, and sometimes change their nappies! I like the idea of elevating them to these scenarios, which might not seem to anyone else as particularly special connections, but to me they are. They're the things that I know better than anything else, better than education, better than any books you'll read.

CR *Why did you start taking photographs?* I began as a jeweller, and I was just not satisfied with how three-dimensional objects like jewellery were portrayed in pictures. This sounds like a crazy reason to start, but actually as makers not many people get to see your work. So many people do such beautiful things [but] a snapshot just doesn't do them justice. There was an element of thinking I'd love to do something that does the object justice. This way, I get to select things, I can jump all over the place, and I can feel like that's a perfectly legitimate pathway through a place like the National Gallery.

CR *Your work is full of detail, dare I say like Holbein's* **The Ambassadors** *[1533], which is an incredibly complicated political allegory chock-a-block with significant objects.* Well, that's what's wonderful when

'THE KNOWLEDGE I DON'T HAVE...ALLOWS ME TO DO THINGS, TO BE FREER AND TO HAVE FUN.'

55

the props are so poignant, so specific, when they tell you a very detailed bit of information that makes the whole picture read. I think that's something I always enjoy playing with, adding props that tell you a little bit more, give a little bit more detail, and inform you about who you are looking at and what the story is.

HK *Nineteenth-century art photographers were struggling with that because what they wanted to do photographically was what painters did, which is emphasise certain things, de-emphasise others, select the salient points. And yet the camera was representing everything more or less equally.* Yes, that's something you can do now with digital. It allows you to work in a way that is less [like a] photographer more [like a] director. You can take the raw image but you can fiddle with elements afterwards, which does give you the benefit of hindsight and allows you to work out whether something was really relevant or not. In a way it's more like painting than early photography. You get to pick and choose now, to have this control that you haven't had, which I think for storytelling purposes is great.

HK *Photographers have always debated whether photography can be art and whether what are thought of as elitist forms like allegory are beyond the pale, or just not relevant. And yet you're engaging with these forms, both in a visual sense and in an intellectual sense, in that you're interested in allegory.* Well, I think there's something very interesting about being in this time and not feeling the need to rebel against it, and actually just absorbing things and taking what you want. Again, not having this education through photography I suppose I missed out on those kinds of conversations, which has perhaps allowed me not to be stifled or to feel constricted. I suppose I've got a kind of naivety that allows me to do stuff without worrying about its complex history.

HK *Without looking over your shoulder.* I find sometimes your knowledge of something can hold you back from working. That's why I feel quite comfortable in this area, in this medium, and even doing bits of film. There's something in the water at the moment with this idea of

looking back. It's quite nice to go back and be flamboyant. Especially in a time such as now when everything's very sombre and austere. There's something quite exciting and fun about something that looks very elaborate.

CR *Among the photographers in this exhibition, you're just about the youngest. Do you think it's a generational thing?* Perhaps. The knowledge I don't have at the moment allows me to do things, to be freer and to have fun. I mean I'm really adamant that for years I struggled through art school and battled with the quality of the stuff, [conflicted] about whether I should actually just throw it in because I can't do it to the standard I think I should. Now I'm giving myself a break and saying, just do it because you enjoy it. It sounds very simple and unintelligent, but actually it does allow you to be free.

CR *Not so many years ago pleasure was a very dirty word in aesthetics.*
HK *As was beauty.* And I still think there's an element of that now. In my mind, it never occurred to me to break myself in order for something to be good. When my brain works the best is when I'm enjoying something. If you are trying to communicate endurance and a test of yourself and going to dark places, you almost have to be in that dark place to get that message across. But I suppose that's not an element of myself that I ever feel comfortable showing the world. That's not the bit of me that I want to express. It's got to come from somewhere else.

HK *I think that it is valuable that you didn't have to go running the gauntlet for photographic postmodern theory and all of that.* Well, everyone has a different way of working. Of course, sometimes the penny drops later on and suddenly everything falls into place, but it's sort of an ongoing education.... I'm finding it nicer working it out and gathering information as I go along.... It's important to have an understanding, but also to hold it back until perhaps you're critiquing it afterwards. Once it's there, it's there; you've done it.

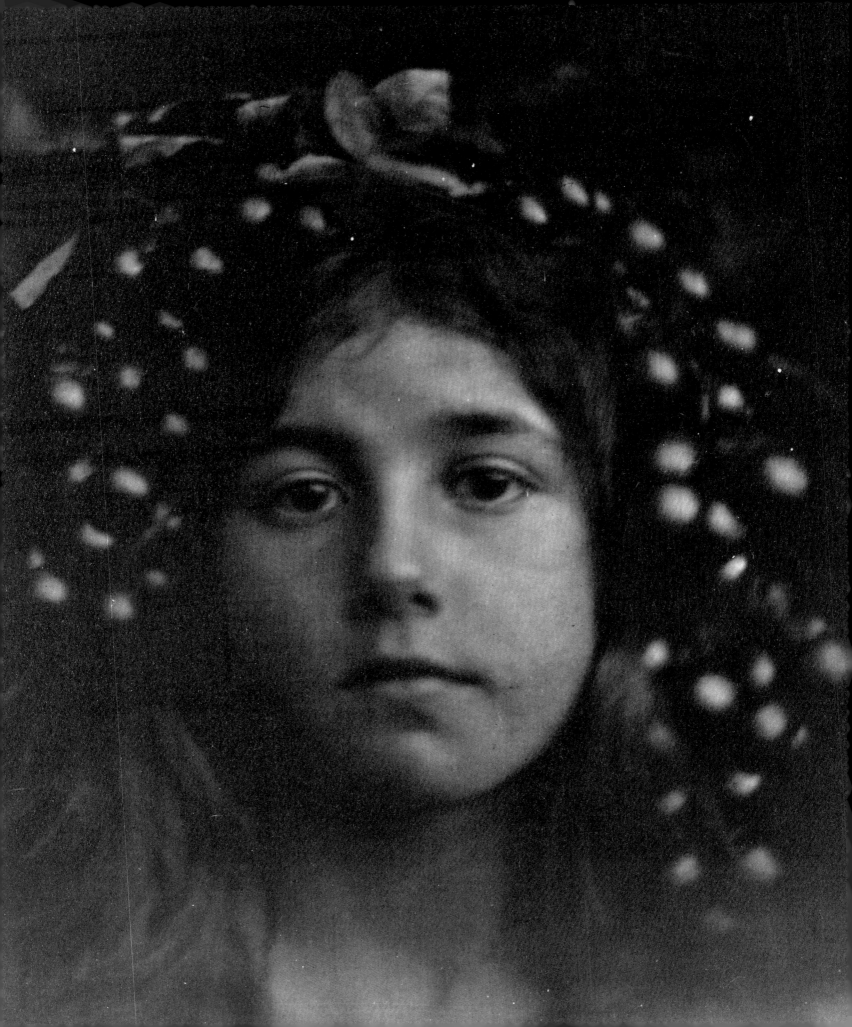

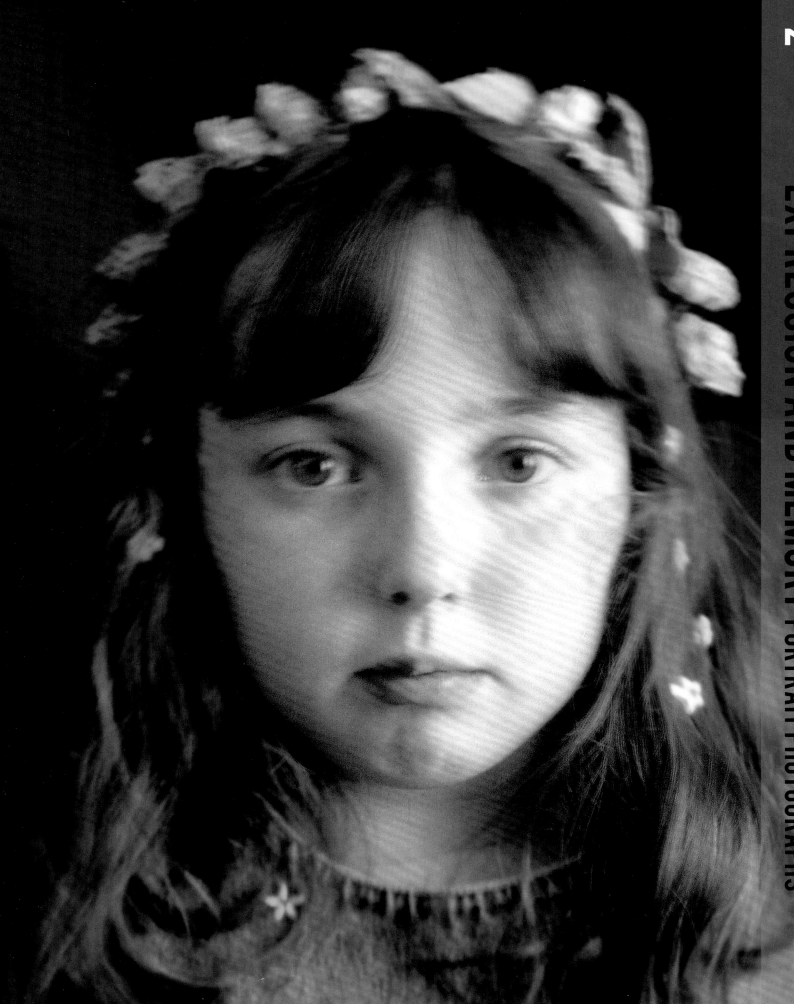

Below, fig. 35
Nadar (Gaspard-Félix Tournachon), *Sarah Bernhardt*, about 1864. Later gelatin silver bromide glass plate negative, 27 × 21 cm. Médiathèque de l'Architecture et du Patrimoine, Paris.

In 1989, while the photographic community marked the 150th anniversary of photography's invention, a Scottish poet and artist made nine allegorical portraits of creative black women.[1] Maud Sulter photographed each sitter as one of the muses of classical antiquity, and cast herself as Calliope, the muse of epic poetry (fig. 36). A small cased photograph, probably a daguerreotype, represents Calliope's emblem, her writing tablet, for photography was Sulter's other medium of communication. Her pose and drapery were based on Nadar's mid-1860s portrait of the actress Sarah Bernhardt (fig. 35). The project was subversive: 'Zabat' was the name of a traditional African dance exalting women's strength, and the 'Zabat' photographs showed black women artists as a rejoinder to photography's 1989 anniversary, whose celebrants – photographers, writers and academics – were mostly male and all white.[2]

Sulter's inspirations included seventeenth-century portrait painting, such as Jan Lievens's portrait of the Dutch scholar, poet and artist Anna Maria van Schurman (fig. 37). Van Schurman is also portrayed with the emblems of her vocation: she holds a book, perhaps a compilation of her letters and poetry published the previous year. This portrait may well have been made to mark that achievement, just as *Calliope* marked the publication of Sulter's book of poetry also entitled *Zabat*.[3] Sulter felt that there were too few opportunities to commemorate women, writing of *Calliope*:

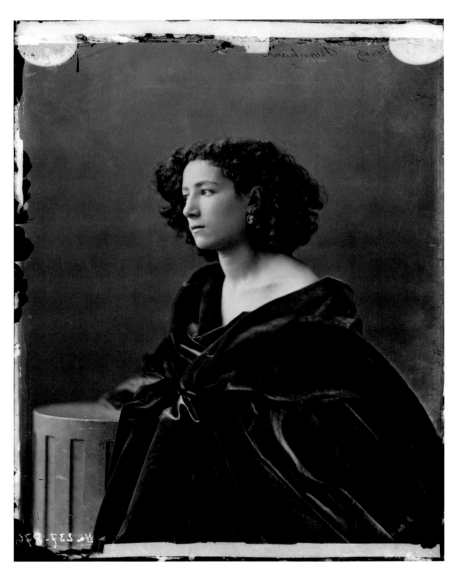

'If you're black and female the chance of one's poetry being attributed to one in later life is slim'.[4]

Opposite, fig. 36
Maud Sulter, *Calliope*, 1989, from the series 'Zabat', 1989. Cibachrome, 140 × 116 × 4·5 cm (framed). Victoria and Albert Museum, London.

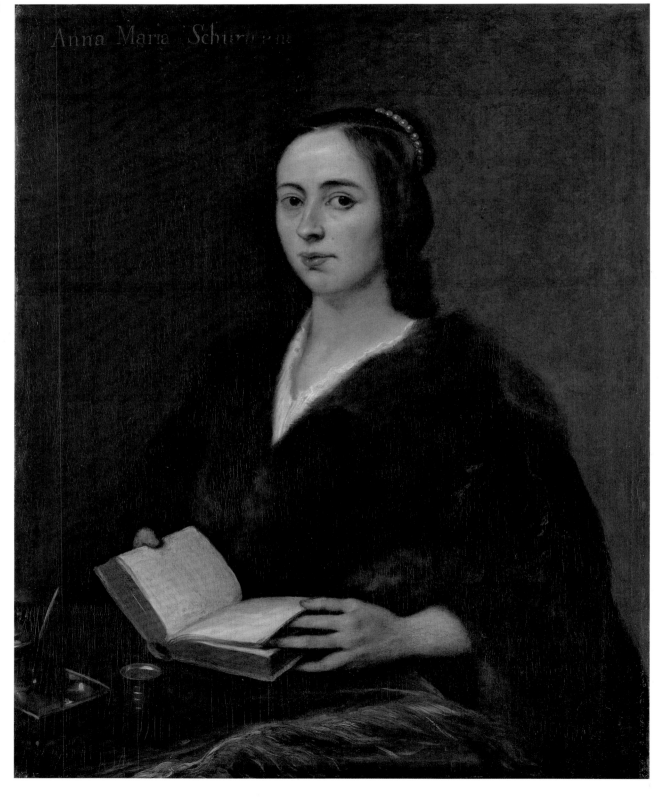

Sulter's portrait is an allegory. But straight, unadorned portraits are also part of art's history, and, in their first manifestation, photographed faces were extraordinary in and of themselves.[5] Even today, early portraits are compelling, as is this French daguerreotype of an unknown woman, gazing out so gravely from a distance of more than 150 years, cheek resting on hand to hold her head still for the long exposure (fig. 38).

In 1843, the poet Elizabeth Barrett (later, Browning) wrote of the profound impact of photographic portraits. She had recently seen examples of daguerreotypes and described them as 'like engravings — only exquisite and delicate beyond the work of graver'.[6] Barrett had the sense that those small works produced by the action of light showed 'the *very shadow of the person* lying there fixed forever!' She added that such pictures were 'the very sanctification of portraits'. 'I would rather have such a memorial of one I dearly loved, than the noblest Artist's work ever produced'.[7]

Barrett argued that her preference for the photographed portrait was not 'in respect (or disrespect) of *Art*, but for *Love's* sake'.[8] Portraits are often mementos, and early photographic portraits emulated the most popular type of keepsake: the painted miniature. Once costly and highly prized, the portrait miniature moved downwards on the social scale from the sixteenth-century aristocrats of Tudor England to the nineteenth-century urban middle classes,

Opposite, fig. 37
Jan Lievens, *Portrait of Anna Maria van Schurman*, 1649. Oil on canvas, 87 × 68·6 cm. The National Gallery, London.

Above, fig. 38
Unknown photographer, *Portrait of a woman*, 1854. Daguerreotype plate in glass surround, 18·2 × 14·8 cm. Wilson Centre for Photography.

 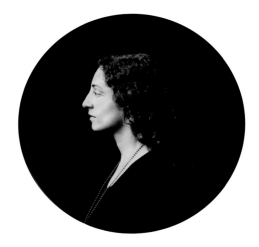

who were the customers for photographic portraits. Daguerreotypes imitated the elaborate presentation of painted miniatures; they were mounted in the same gilt surround within embossed cases hinged and clasped for portability.

The correlation between painted and photographic miniatures inspired Bettina von Zwehl's exquisite tondo photographs (figs 39 and 40).[9] She made them in 2011 while artist-in-residence at the Victoria and Albert Museum, London, whose fine collection of portrait miniatures was Von Zwehl's inspiration. Richard Gibson's portrait of a woman (fig. 41) compares well with the pose and framing of Von Zwehl's *Irini II*, which also echoes Gibson's miniature in the smooth, luminous skin tones.

Portraiture had a strong psychological pull, and this was a commercial opportunity; from its earliest years, photography was as much market as medium, and each improvement in technology expanded its mercantile reach. In the early 1850s, new glass plate negatives and smoothly coated albumen paper gave good definition, even

in a small image; from about 1854, that combination was used for diminutive photographic portraits made at the size of visiting cards and thus called *cartes-de-visite* (fig. 42).[10] Painted portraits had been an expensive, laborious undertaking; *cartes-de-visite* cost little by way of time, effort or money. Their affordability took portraiture to the masses, as art critic P. G. Hamerton declared in 1860: 'A poor soldier's wife can now get a more authentic miniature of her husband for one shilling, than a rich lady could have procured a century ago for a hundred pounds.'[11]

THE SPIRIT OF REMBRANDT REVIVED

The portrait of Elizabeth Rigby (later, Lady Eastlake, fig. 43) is an early paper print from a paper negative, and its rough, broad tones are the very opposite of albumen prints, which give a sharp, detailed likeness. In 1857, Elizabeth Eastlake noted the cost to photographic art: 'Every button is seen — piles of stratified flounces in the most accurate drawing are there, — what was at first only suggestion is now all careful making out, —

Above, figs 39 and 40
Bettina von Zwehl, *Irini (II and I)*, 2011. C-type prints, 5.8 cm (diameter). Bettina von Zwehl, courtesy Purdy Hicks Gallery, London.

Opposite, above, fig. 41
Richard Gibson, *Unknown woman, perhaps Elizabeth Capell, Countess of Carnarvon*, 1653–57. Watercolour on vellum put down on pasteboard, 7·4 × 6 cm (oval). Victoria and Albert Museum, London.

Opposite, below, fig. 42
Oscar Gustav Rejlander, *Mary Rejlander*, early 1860s. Albumen print as *carte-de-visite* mounted on card and inserted into album page with hand-painted surround, 14 × 9 cm (including surround). K & J Jacobson, UK.

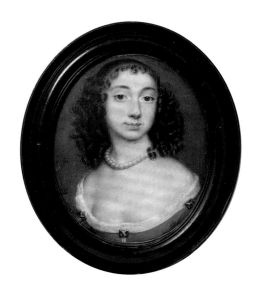

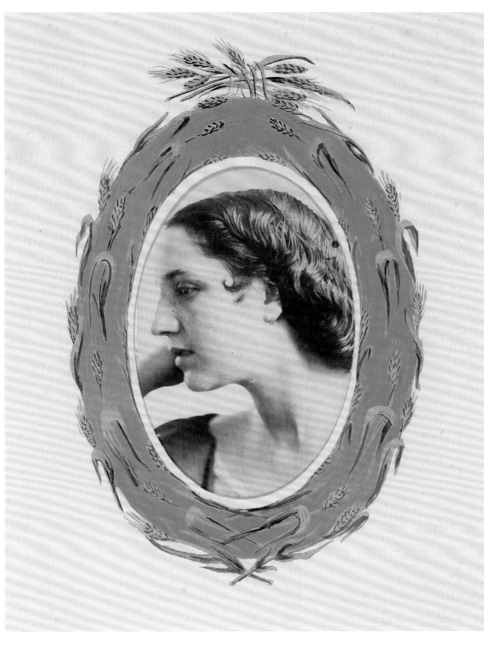

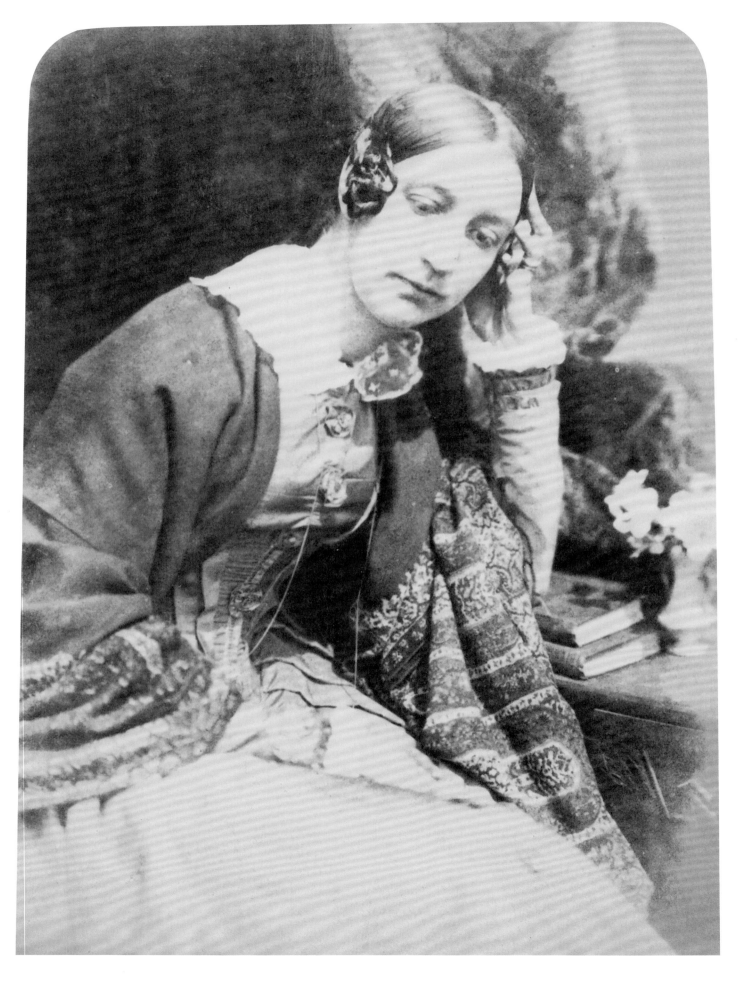

Opposite, fig. 43
David Octavius Hill and Robert Adamson, *Elizabeth Rigby* (later, Elizabeth, Lady Eastlake), about 1845. Salted paper print, 21 × 15·2 cm. Wilson Centre for Photography.

Right, fig. 44
Rembrandt, *An Elderly Man as Saint Paul*, probably 1659. Oil on canvas, 102 × 85·5 cm. The National Gallery, London.

Below, fig. 45
David Octavius Hill and Robert Adamson, *Thomas Kitchenham Staveley*, about 1844. Salted paper print, 20 × 15 cm. Wilson Centre for Photography.

but the likeness to Rembrandt and Reynolds is gone!'[12]

In works like the portrait of Elizabeth Rigby, David Octavius Hill and Robert Adamson took a different approach, and their debt to Rembrandt was clearly laid out by Eastlake, recalling her first glimpse of their photographs:

It is now more than fifteen years ago that specimens of a new and mysterious art were first exhibited to our wondering gaze. They consisted of a few heads of elderly gentlemen executed in a bistre-like colour upon paper. The heads were not above an inch long, they were little more than patches of broad light and shade, they showed no attempt to idealise or soften the harshness and accidents of a rather rugged style of physiognomy — on the contrary, the eyes were decidedly contracted, the mouths expanded, and the lines and wrinkles intensified. Nevertheless, we examined them with the keenest admiration, and felt that the spirit of Rembrandt had revived.[13]

Eastlake connected Rembrandt's naturalism with Hill and Adamson's unidealised photographs (figs 44 and 45). She suggested pictorial similarities; Rembrandt's use of chiaroscuro[14] was reproduced by the photographs' strong contrasts of light and shadow (which came from the bright daylight necessary for a short exposure time).

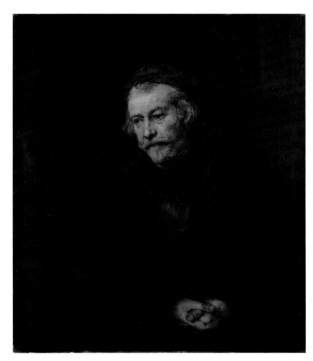

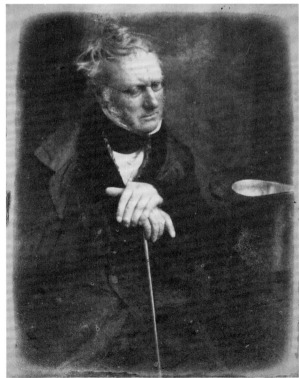

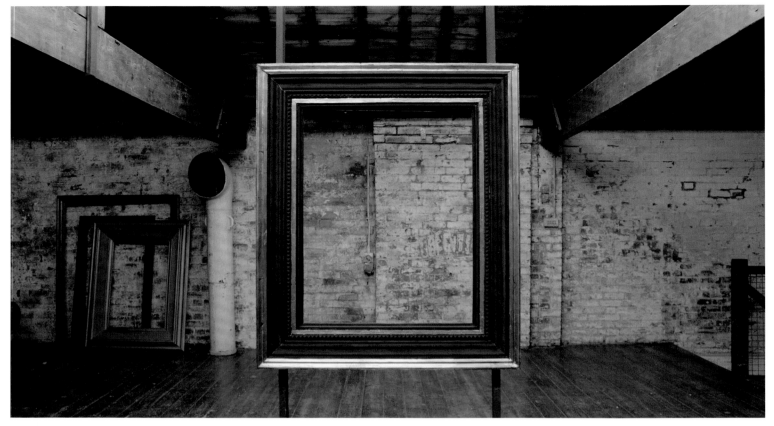

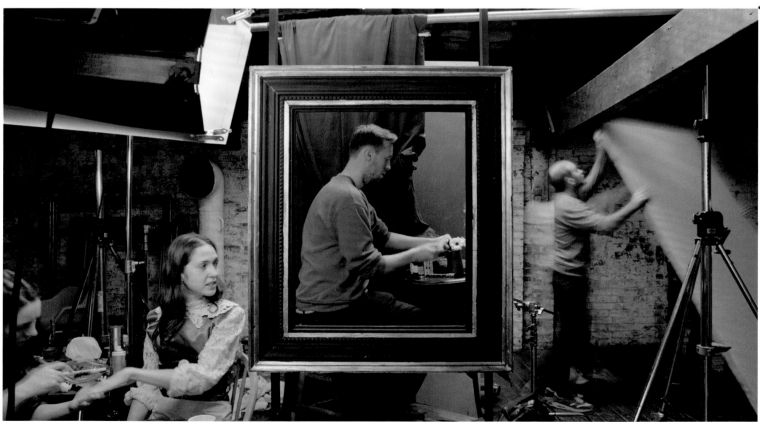

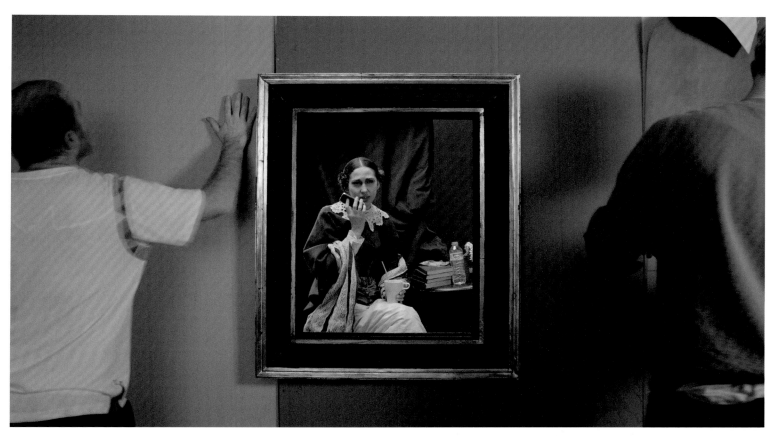

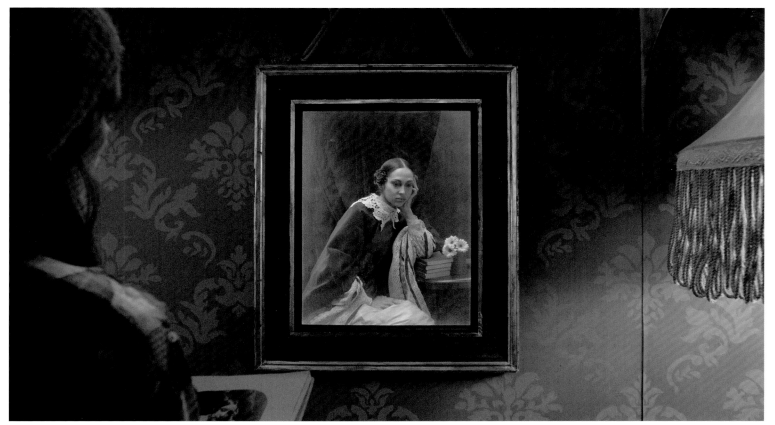

Fig. 46
**Maisie Broadhead and Jack
Cole**, Four stills from *An Ode
to Hill and Adamson*, 2012.
Film; 3 minutes. Lent by
Artist.

Rembrandt's rough execution was echoed in the graininess produced by the fibrous structure of the paper negative. Eastlake defended paper photographs from disparaging comparisons with the immaculate precision of daguerreotype images, claiming that the indistinct beauties of the paper prints piqued the imagination.

These works still attract us. Hill and Adamson's portraits of Elizabeth Rigby have inspired a 2011 time-based piece by Maisie Broadhead and Jack Cole. *An Ode to Hill and Adamson* (fig. 46) re-creates Rigby's portrait, showing how an apparently simple image evolves from a complex series of aesthetic decisions and technical elements. Broadhead's lively shoot sweeps us along to a sweetly poignant finish where past and present come together as 'Elizabeth' props her head on her hand to await the long exposure. As a coda, the real Elizabeth's documented flirtation with Hill is captured in a little wink.[15]

MORE LIKE OLD PICTURES THAN EVER: CAMERON AND WATTS
In 1857, a review of the latest exhibition of London's Photographic Society celebrated the beauties of monochrome photographs:

> Colour, with all its witcheries, is still too airy a Proteus to be easily captured and chained....Our works are but monochrome studies: now golden brown, anon of a rich, reddish sepia tone; now grey and lucid, presently almost of a black Indian ink lustre; but still, in one form

or another, monochromes, with all their merits and deficiencies, soft, beautifully modelled, rich-toned as Rembrandt, sweet and mellow as Correggio.[16]

Improvements in photographic chemistry meant that photographs could show a wide range of hues and tones.[17] The results were appreciated for their correspondence with the muted palettes of Old Master art (fig. 16, p. 33), providing the proper art-historical validation. In nineteenth-century photography, colour was notable by its absence, for apart from hand-tinting, photographs were monochromatic until the early 1900s. Colour was added to commercial photographs like studio portraits and stereo cards, but the effects could be crude and the new aniline dyes made matters worse.[18] Colour was criticised on a number of counts: it was not integral to the photographic process; it was associated with vulgar commercial photography; and its association with bright contemporary painting was problematic. Indeed, monochrome photography was proposed as a cure for the 'colour-fever' of contemporary art, as the *London Review* suggested in 1861: 'the public taste, vitiated by the gaudy productions of a large class of mediocre painters, who had run riot in colouring, needed some truthful guide to restore to it its pristine power of discrimination'.[19] The art in question was easily identified: Lyndon Smith was among many who warned that the 'true lover of nature' would find no pleasure in the 'gaudy

Fig. 47
George Frederic Watts, *Julia Margaret Cameron*, 1850–52. Oil on canvas, 61 × 50·8 cm. National Portrait Gallery, London.

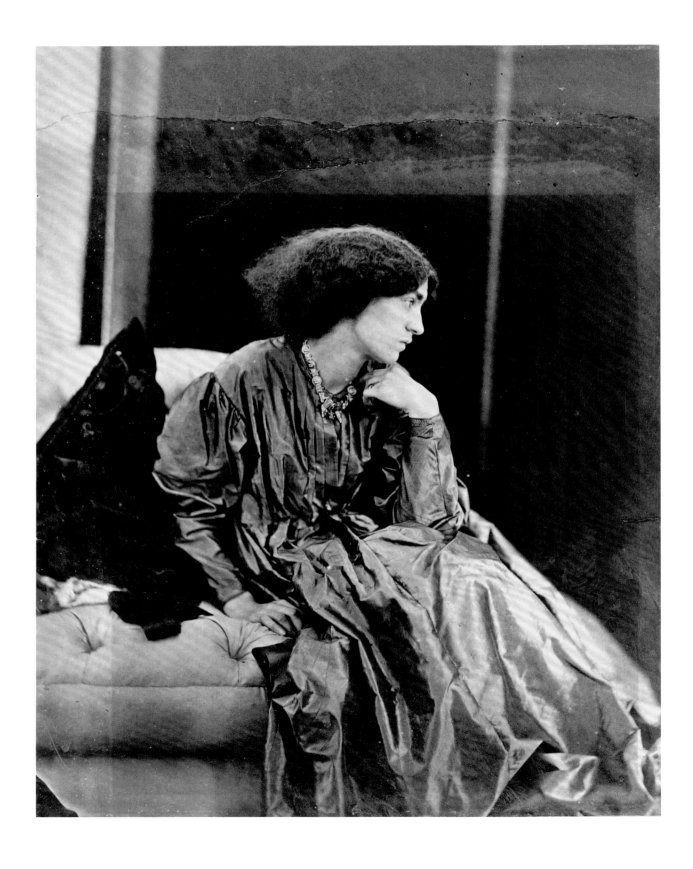

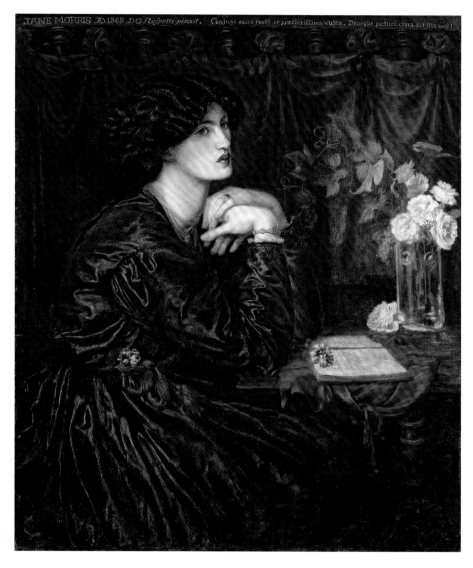

Opposite, fig. 48
John Robert Parsons, *Mrs William Morris posed by Dante Gabriel Rossetti*, 7 June 1865. Albumen photograph, 20·4 × 16 cm. Victoria and Albert Museum, London.

Above, fig. 49
Dante Gabriel Rossetti, *The Blue Silk Dress (Jane Morris)*, 1868. Oil on canvas, 110·5 × 90·2 cm. The Society of Antiquaries of London (Kelmscott Manor), Oxfordshire.

and meretricious colouring of the pre-Raphaelite'.[20]

The Pre-Raphaelite Brotherhood was founded in 1848 by three young British painters – Dante Gabriel Rossetti, William Holman Hunt and John Everett Millais – who embraced the detailed execution and bright colours of medieval art.[21] Rossetti's paintings have been linked to Cameron's photographs, but her artistic inspirations were not Pre-Raphaelite; instead, they came from the same sources as her artistic mentor George Frederic Watts. Watts's study of Cameron (fig. 47) displays the subtle earth colours, delicate tones and plain dark background that reflect his interest in portraits by Tintoretto and Van Dyck.[22]

One can see the connections in Watts's and Cameron's respective portraits of Cameron's niece May Prinsep (figs 50 and 51). Unlike Jane Morris's mannered pose in John Robert Parsons's photograph and Rossetti's painting (figs 48 and 49), Watts and Cameron present a simple, natural posture that brings out the fine line of Prinsep's long neck. In contrast to Rossetti's strong, modern colours, Watts's restrained palette is echoed in the modulated tonal range of Cameron's photograph, which can be appreciated even in a print that has deteriorated over the years.

Watts admired the Italian Renaissance, and it is in this older art that we find precedents for the soft outlines of Cameron's forms, whose delicately shaded highlights and shadows owe much to the *sfumato*[23] of the old frescoes that

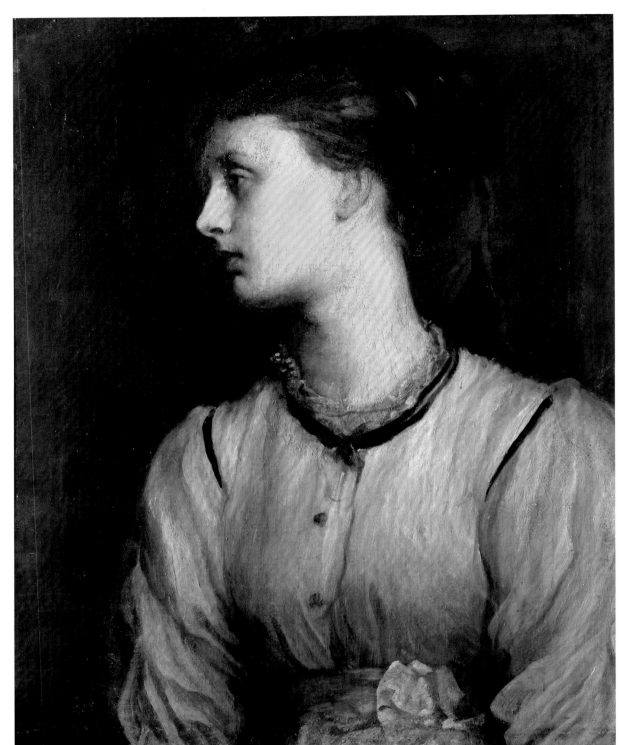

Left, fig. 50
George Frederic Watts,
May Prinsep, 1867–69. Oil
on canvas, 66 × 53·3 cm.
Watts Gallery, Surrey.

Opposite, fig. 51
Julia Margaret Cameron,
Study of May Prinsep
(*Study No. 9*), October 1870.
Albumen print, 35·5 ×
26·6 cm. The Royal
Photographic Society
Collection at the National
Media Museum, Bradford.

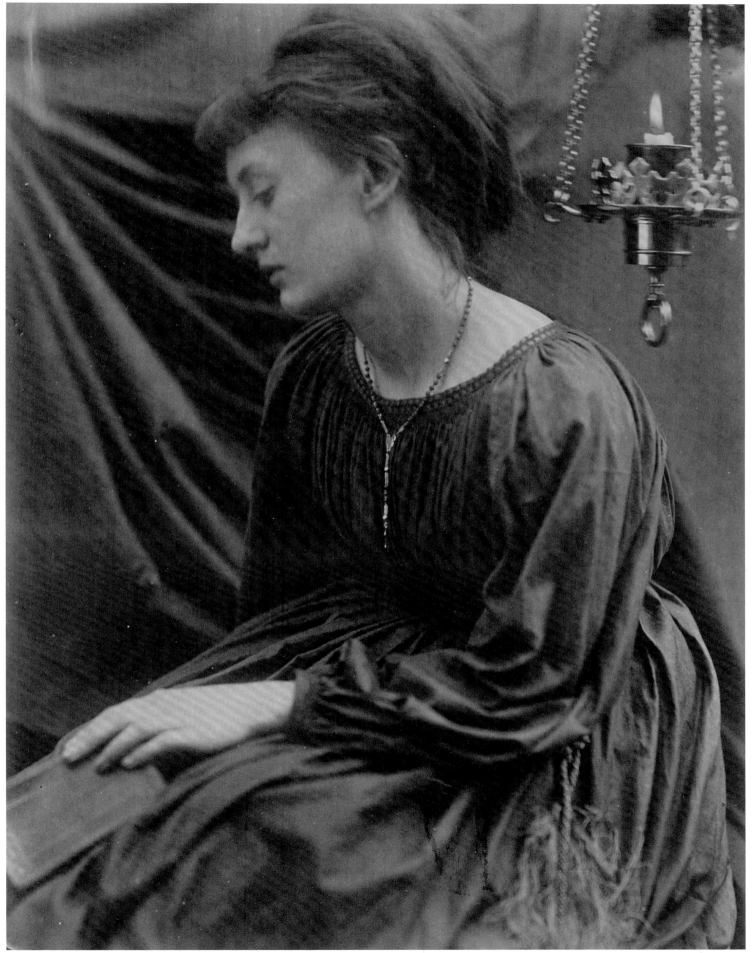

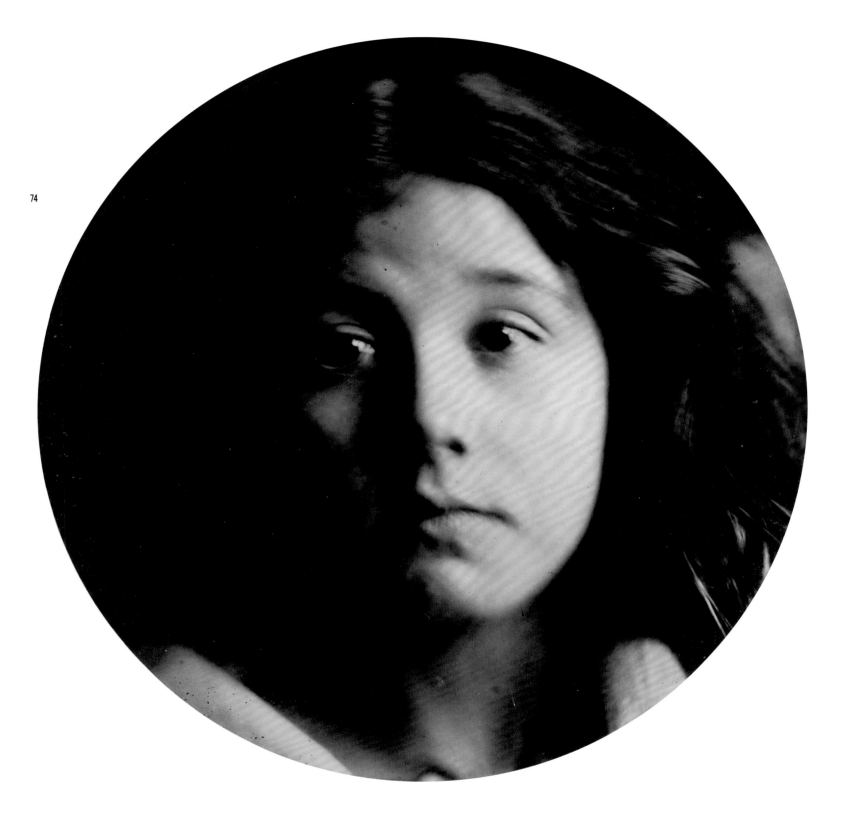

Opposite, fig. 52
Julia Margaret Cameron, *Kate Keown*, about 1866. Gold-toned albumen print, 29 cm (diameter). Gregg Wilson, Wilson Centre for Photography.

Above, fig. 53
Gustave Doré, *The English Beggar Girl*, about 1872. Watercolour on paper, heightened with white gouache, 38·5 × 30·4 cm. Prat Collection, Paris.

Watts loved. He allied her pictures with much earlier models and against the Pre-Raphaelites:

I have received with your letter two beautiful photos more like old pictures than ever. I don't know that they are your very best but they are certainly amongst the most artistic. Some parts of the child with half a head are wonderful [–] more like Phidias & more anti preRaphaelite [sic] than anything I have seen.[24]

These art citations are resolutely historical; Cameron's circular portrait of young Kate Keown (fig. 52) could be a fragment of a Correggio, whose paintings are among the earliest works to form the National Gallery's collection. Cameron's print is a beautiful example of gold toning, which shifts the red-brown image colour towards a colder aubergine brown and deepens the shadow density while preserving the ivory clarity of the highlights.

The photograph shows a marvellous sense of movement in the blurred forms. They are the result of the imperfect optics of Cameron's lenses, but she turned the effect to pictorial advantage. An echo of her approach is found in a Gustave Doré watercolour of an English beggar girl (fig. 53), made around the time of his illustrated book *London: A Pilgrimage*, 1872.[25] Doré's delicate brushwork presents the same soft contours, close framing and plain background that were so characteristic of Cameron's work. This is more than simple visual resemblance, for Cameron and Doré knew each other. In 1871, Cameron gave Doré an 1866 photograph entitled *Fillette en prière* (*Little Girl in Prayer*),[26] and in early August 1872, she photographed him, swathed in black velvet against a dark background, so that only his head and neck were visible.[27] They may have met through Cameron's sister, Sarah Prinsep, for Doré was a guest at Prinsep's London salon. Alfred Tennyson, too, might have effected an introduction: Doré illustrated Tennyson's *Idylls of the King* (1866–68), as

did Cameron, whose photographs were the basis of engravings for the 1875 edition.[28] She simultaneously produced her own photographically illustrated version.

PORTRAITURE AND TIME

Nicky Bird's portrait of her niece Jasmin (fig. 55) was inspired by Cameron's photograph of Kate Keown as the mythical sorceress Circe (fig. 54). But it is in Cameron's tondo portrait of Kate (fig. 52) that we find the most resonant equivalent to Bird's photograph. These works show young sitters who struggle to stay still for an exposure that in Cameron's case took more than 15 seconds. Bird was photographing in a dimly lit room, so even her modern film would need an exposure of a few seconds. In the duration of both photographs, Kate and Jasmin moved, and time intervened, making its presence felt in the blur that marks their movement. Blur is a technical issue (resulting from a long exposure) and a temporal one that speaks to Bird's process of photographing the face of her niece over a six-month period. The implied time is longer still, suggesting a shift from the nineteenth century forward; the portrait is part of a wider project in which Bird tracked the genealogies of Cameron's sitters. Despite her remarkable resemblance to Kate Keown, Jasmin is not a descendant, though her mother grew up in the West Wight, not far from Cameron's old home at Freshwater, both on the Isle of Wight.

These photographs extend time; as the moment of taking the picture recedes into

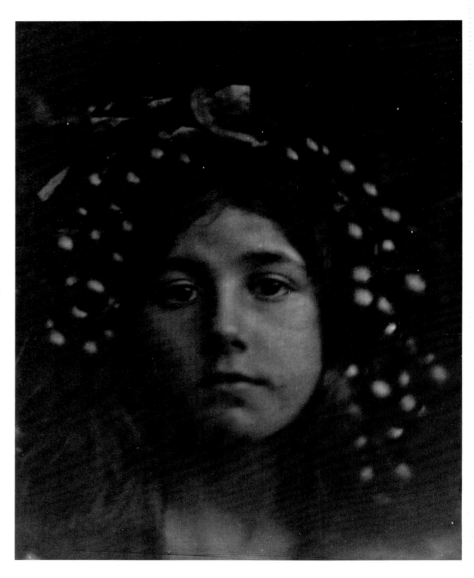

Above, fig. 54
Julia Margaret Cameron, *Circe (Kate Keown)*, 1865. Albumen print, 25·3 × 20·1 cm. The Metropolitan Museum of Art, New York.

Opposite, fig. 55
Nicky Bird, *Jasmin, Ryde, Isle of Wight*, July 2000– January 2001, from the series 'Tracing Echoes', 2001. Colour Iris print, 29 × 23·8 cm. Collection of the Artist.

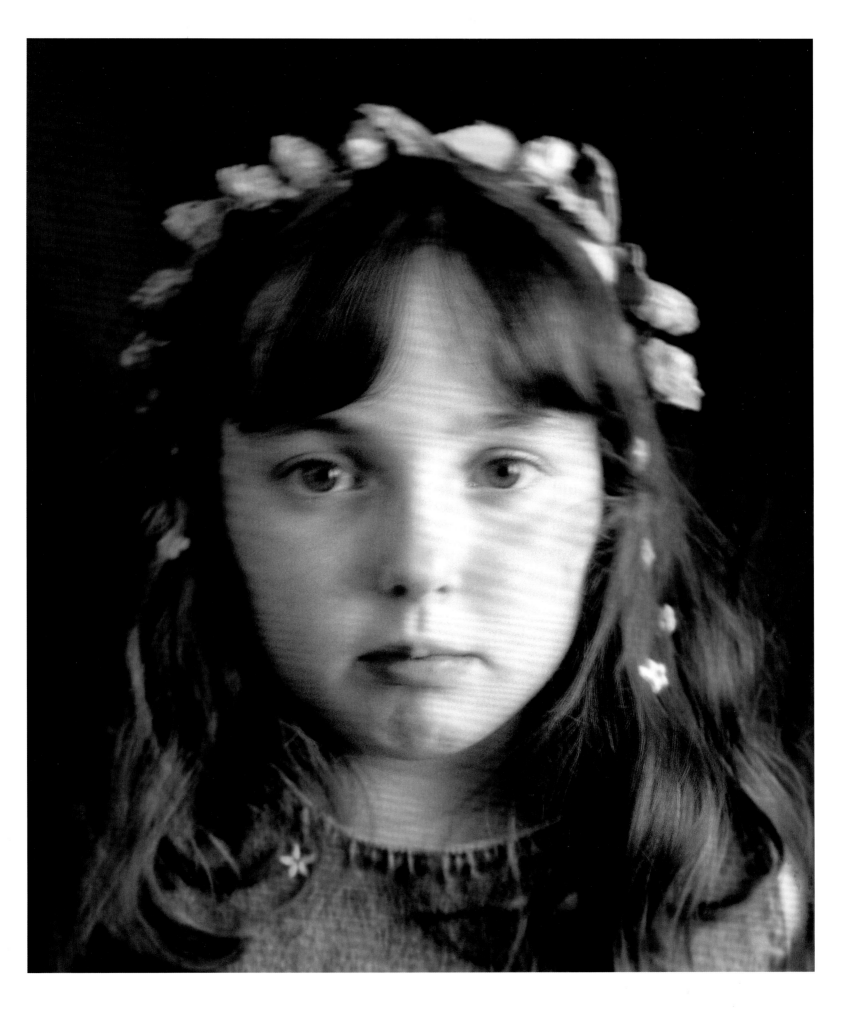

The concentrated framing and plain dark backgrounds of the Cameron and Horsfield portraits remove them from their periods; either could exist in an historical or modern time. The same pictorial elements are seen in Sir Anthony van Dyck's portraits (fig. 58). Their subdued palette is also found in Horsfield's digital pigment print and the rich sepias of Cameron's albumen prints.[39] Van Dyck was a recognised art-historical influence in Cameron's time, as noted in a review of her first monograph show: 'Now the beauty of the heads in these photographs is the beauty of the highest art. We seem to be gazing upon so many Luinis, Leonardos, and Vandycks [sic]'.[40]

Van Dyck inspired a number of nineteenth-century painters and photographers through his 'Iconographia', a celebrated series of etched portraits of artists and scholars alongside leaders in political and military life. The prints were published from 1630 and engraved copies proliferated over the next two centuries, influencing G. F. Watts's 'Hall of Fame' paintings, begun in the early 1850s and donated to the National Gallery (now at the National Portrait Gallery) from 1861. The same impetus is found in Cameron's photographs of notables such as Charles Darwin, Anthony Trollope and Gustave Doré; her scalps included visitors to her neighbour Alfred Tennyson on the Isle of Wight and her sister Sarah Prinsep's London salon.[41]

But the closest connection to Van Dyck comes in David Wilkie Wynfield's photographs, published in 1864 as *The Studio: A Collection of Photographic Portraits of Living Artists, Taken in the Style of Old Masters, by an Amateur.*[42] Wynfield was a successful if critically underappreciated painter of historical subjects and the photographs may have begun as studies for his paintings. His sitters were his contemporaries, photographed in costume as an historical continuum of artists stretching back to Holbein and Van Dyck. An *Illustrated London News* review in 1864 described the photographs as resembling 'very choice portraits by Titian, Rembrandt, Van Dyke [sic] and other old masters'.[43] Wynfield's portrait of the illustrator John Dawson Watson (fig. 59) is posed after Van Dyck's portrait of King Charles I (see fig. 60), from the gesture of his hand to his seventeenth-century collar and goatee beard, trimmed down from its usual mode (fig. 61).[44]

Wynfield's biographer, Juliet Hacking, has suggested that Van Dyck's 'Iconographia' was a template for Wynfield's project.[45] There is a parallel in the visual coherence of these monochrome portraits produced in a single medium, identical format and equivalent scale. The cumulative impact is reinforced by the consistency of style: Wynfield's sitters mirror Van Dyck's half-length poses against plain dark backgrounds. Wynfield's work influenced Cameron; it was published soon after she began photographing in 1864, and Watts suggested that she look carefully at the photographs to improve her own work.

Fig. 58
Anthony van Dyck, *Portrait of Giovanni Battista Cattaneo*, about 1625–27. Oil on canvas, 73·5 × 60·5 cm. The National Gallery, London.

Left, fig. 59
David Wilkie Wynfield,
John Dawson Watson,
1862/63. Later carbon
print, after 1864 and before
1911, 21·1 × 16·1 cm. Royal
Academy of Arts, London.

Opposite, above, fig. 60
**William Sharp (after
Anthony van Dyck)**,
King Charles I, published
1815. Line engraving, 46·8 ×
37 cm. National Portrait
Gallery, London.

Opposite, below, fig. 61
**Elliott & Fry (founded in
1863 by John Elliott and
Clarence Edmund Fry)**,
John Dawson Watson, 1860s.
Albumen print mounted as
carte-de-visite, 9·1 × 5·8 cm
(image). National Portrait
Gallery, London.

Wynfield and Cameron's pictures show a wonderful sense of depth; the shallow focus of their portrait lenses tricks the eye into seeing volume (for in human vision, things that are out of focus are usually far away).[46] The works also share a darkly harmonious tonal range that is very different from ordinary photographs of that time, whose harsh contrasts of light and dark came from the bright daylight required for a fast exposure. Reviews compared that effect with historical art – Cameron's pictures were described by P. G. Hamerton as showing 'a massive breadth not unlike the gloom and obscurity of some old pictures'. He judged the works 'The nearest approach to fine art yet made by photography', and felt that the portraits were enhanced by their subjects, 'for several of the noblest heads in England were copied in her camera'.[47]

SOCIAL PORTRAITS
Cameron and Wynfield's portraits were quite large for the time: Cameron's 'heads' averaged 14 × 11 inches, while Wynfield's prints measured just over 6 × 8 inches.[48] Those big prints required negatives of the same size, because contact printing was the only option; practicable enlargers and projection-speed

printing paper were still some decades in the future.[49]

Today, many photographs no longer require an enlarger because digital laser printers 'write' an image directly on to photographic paper, the software and paper size dictating the image's dimensions. But film gives higher resolution than a digital file, and many of the contemporary practitioners in this book still choose to make big negatives with a large camera. Thomas Struth's large-format camera can be adjusted to produce an optically correct rectilinear image, giving a distortion-free field of view to his cityscapes, museum interiors and group portraits.

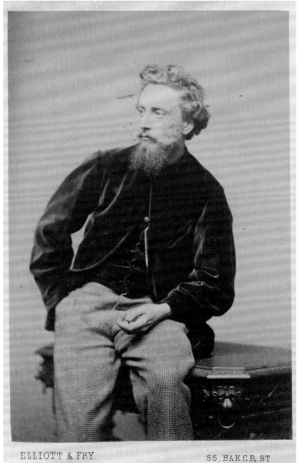

ELLIOTT & FRY

55, BAKER ST
PORTMAN SQUARE

Opposite, fig. 62
Thomas Struth, *The Smith Family, Fife, 1989*, 1989. C-type print, 69·7 × 96·3 cm. Tate, London.

Right, fig. 63
Unknown photographer, *Family portrait*, Lübeck, Germany, about 1845. Daguerreotype, 9·2 × 13·3 cm (image); 21 × 25·5 cm (framed). Wilson Centre for Photography.

A large-format camera requires the lens to be stopped down for a good depth of focus, and this means a long exposure time, particularly when only natural light is used. Struth's sitters (fig. 62) must hold very still, and the results are reminiscent of early portraits, as seen here in another family group photographed just six years after photography's invention (fig. 63). The muted grey of the daguerreotype and the direct gaze of each sitter gives the photograph a very modern air. It brings us forward again to the constrained calm of Struth's subjects, posed for the long exposure just as that long-ago family held still for the duration demanded by the daguerreotype plate.

Struth's portrait work led him to look at historical sources in Renaissance painting,

drawing him into the museums that became the subjects of his next project (fig. 12, p. 29). His approach is respectful, but when contemporary photographers choose such traditional subjects, the results can be as much provocation as homage. Karen Knorr's sharply drawn portraits of privilege are an insightful critique of the genre of social portraits. *Belgravia, ('Security')* (fig. 64) is part of Knorr's series about the denizens of one of London's most affluent districts, made at a time of sharp divisions between rich and poor, reminiscent of the nineteenth century. Knorr's project was political, but it was also personal; the subjects were family and friends, photographed at her behest, not theirs.

**Today Security is
more than a Luxury.
It is an absolute
Necessity.**

The careful posing and placement of the subjects updates historical portrait painting. Knorr also recast the conventions of commercial photographic portraits in the nineteenth century. Knorr's sitters are in their own elegant rooms – not prop-filled studios emulating the interiors of an elevated social class. But she undercut the grandeur with text: 'Historically, portraiture of the upper classes has tended to be flattering, but the combination of image and text brings this work closer to satire and caricature, without losing the strong reality effect specific to photography'.[50]

Like Knorr, Tina Barney portrays the representatives of a social class (the aristocracy of Europe and the American East Coast, fig. 65)

that normally exercises careful control over the circulation of its images. But Barney's sense of the complex relationships concealed by the self-control reveals the real people behind the protective barrier of public roles. The photographs have the same attention to social and psychological circumstances as Struth's family photographs. The well-observed balance between the confident surroundings and the fragile humanity of the subject gives a nuanced melancholy to *The Ancestor* (fig. 66), complicating our reading of it with an unexpected poignancy.

Photography can now capture a fleeting moment, but in the nineteenth century, exposures were long enough for a fresh expression to turn into something more stolid.

Fig. 66
Tina Barney, *The Ancestor*, 2001. C-type print, 120 × 150 cm (framed). Courtesy Janet Borden, Inc., and the Artist.

Martin Parr used that shift to satirical effect in his work for *Signs of the Times* (1992), a BBC documentary film series on modern British life for which Parr was the creative director and the stills photographer. The photograph reproduced overleaf (fig. 68) is a still for which the camera was set up, the pose held and the shot delayed until the subjects became self-conscious; their rigid postures register their discomfort. By comparison, Thomas Gainsborough's *Mr and Mrs Andrews* (fig. 67) shows the subjects at ease and in full possession of their substantial status and property. Painters build up portraits over time. For Martin Parr, an extended pose might parallel the process of sitting for a painted portrait, yet the result is not an artist's smooth synthesis but a moment out of a prolonged arrangement of increasingly uneasy sitters.

OUT OF THE STUDIO

Portraiture encompasses a range of approaches, from the symbolism of an allegory to a simple personal memento, and from individual psychological expression to a typology of class and social environment. Whether painted or photographed, historical and contemporary portraits share stylistic devices and narratives. Conventions persist: a standing subject communicates authority, while another sits at ease. The surroundings may add social context, while a plain background removes the sitter from the specifics of time and place, concentrating our attention on physiognomy and demeanour.

This continuum has been frayed by snapshot photography, whose visual conventions are marked by the ephemeral and disposable nature of the pictures. Serendipity has its own beauties, and, since the first Kodak amateur camera of 1888, the informality of snapshots has steadily displaced the formal traditions of studio portraiture, whose role has reverted to what it was in the very earliest years of photography, when only a special occasion – a wedding, a christening – merited the expense of a professional picture. Today, top-notch professional portraiture exists in a rarefied world of celebrity photographs and public commissions, like Thomas Struth's 2011 Diamond Jubilee portrait of Queen Elizabeth and Prince Philip for the National Portrait Gallery. For everyone else, it used to be Kodak; now it is Facebook.

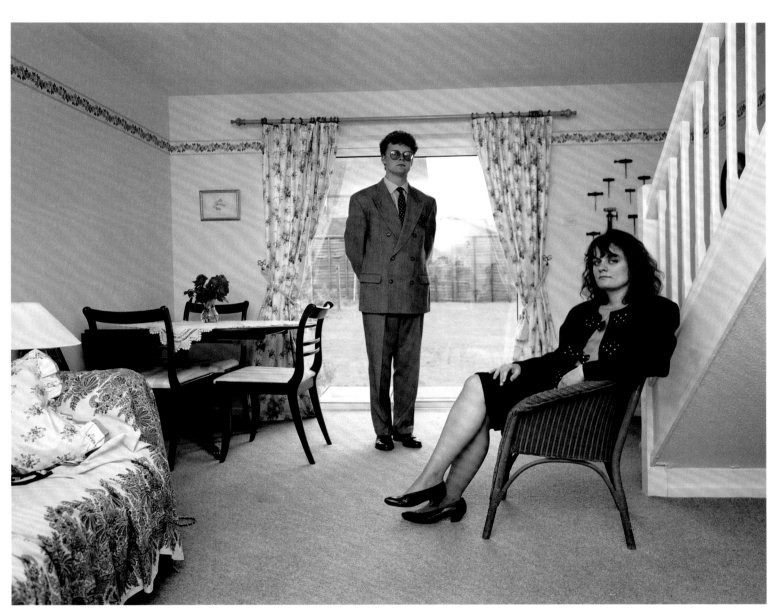

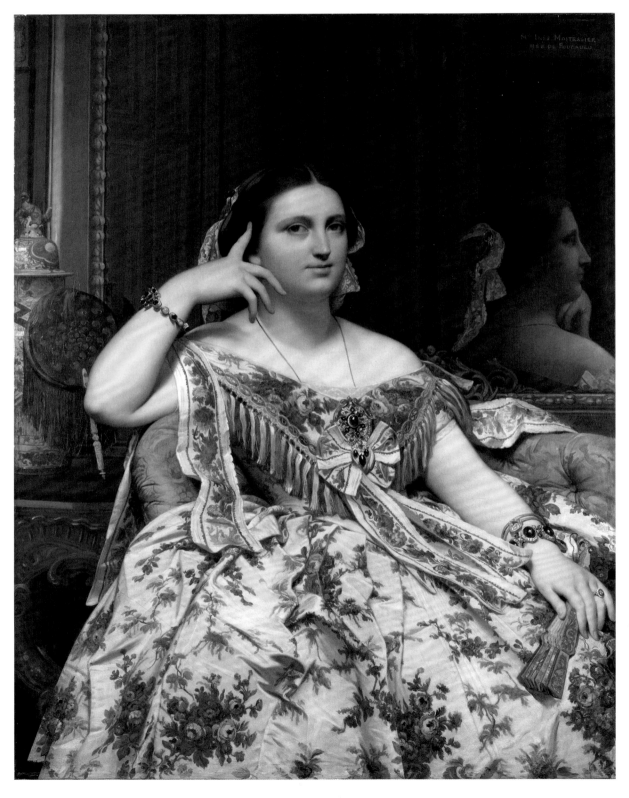

Left, fig. 69
Jean-Auguste-Dominique Ingres, *Madame Moitessier*, 1856. Oil on canvas, 120 × 92·1 cm. The National Gallery, London.

Opposite, fig. 70
Richard Learoyd, *Jasmijn in Mary Quant*, 2008. Unique Ilfochrome photograph, 148.6 × 125.7 cm. Courtesy of McKee Gallery, New York.

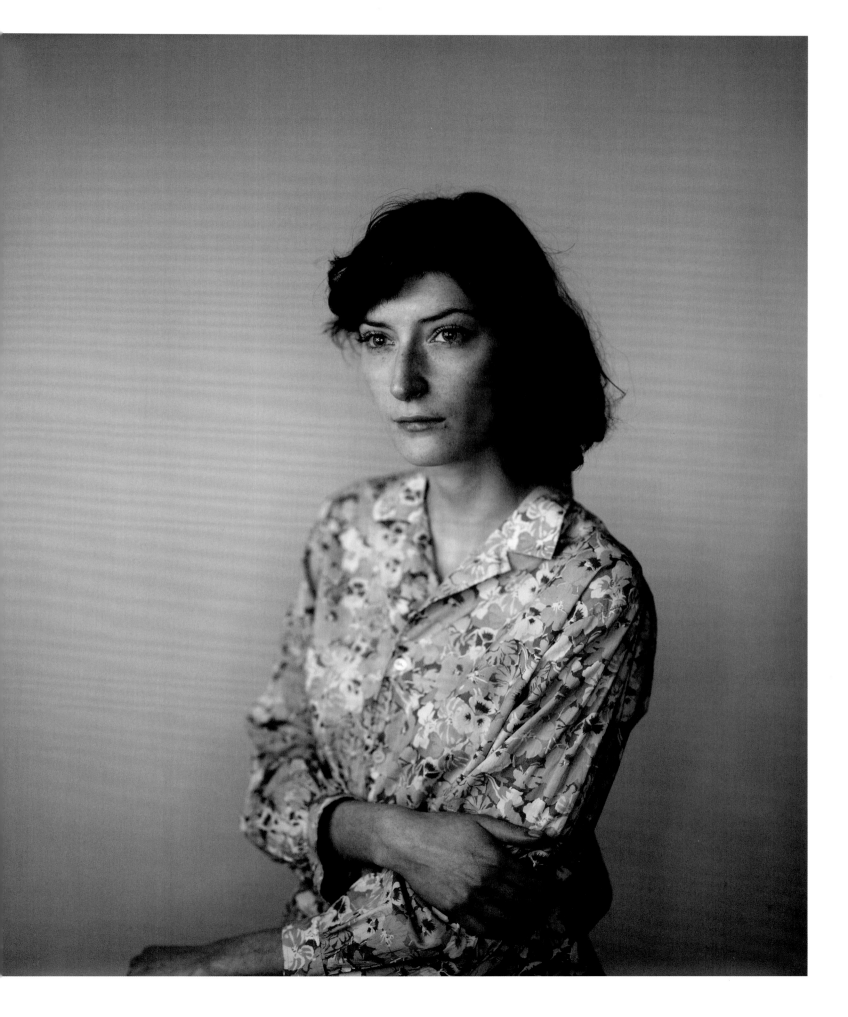

98 *We're in front of Ingres's* Madame Moitessier *[fig. 69], which we know from the long history of its creation – from 1844 to 1856 – was a kind of collaboration with the sitter.* I think that any portrait eventually has to be. I mean, you see some very cold pictures that are strict representations, but I think when something comes out of the picture that betrays a person there has to be collaboration. Especially if there is eye contact, which is very difficult. I think there has to be – not necessarily whether they were friends or lovers – but the desire for the sitter to keep sitting while the artist is working [fig. 70, p. 97].

But do they think he was using optical devices here?

Well, David Hockney certainly thinks so. It has to do with the positioning of things. It's an alignment of certain elements of the foreground within a single plane. You see it here. One picture I did [*Male Nude*] is a reclining figure; it fits perfectly into the plane. All the attention points of the hands, the body, are on the one plane.

If you just use a lens [like I do] then everything is upside down. Ansel Adams used to say he could tell a photograph that was made with a view camera rather than a prism [single lens reflex] camera because of the way the pictures were composed. There is a sense of things having been made upside down, and I certainly know from my experience that you rely on the vertical centre line in a picture because it's a way to locate things in an upside-down room.

The one thing that never, ever ceases to amaze me, in myself as well as in other people, is the misjudgement of scale. People are always saying these are one-to-one lifelike figures, but if they actually met the person that they think is one-to-one, she would be the eight-foot-four woman. People are incredibly bad at judging the size of hands and heads, for some reason. It's funny – I am too. People think that their hands are a lot smaller than they are. They just can't read it.

You use a very narrow depth of field in your photographs. Yes. It's about 5mm. It's a product of the physics of the process. Once you get optics of a certain kind, the image distances away from the material, and the depth of field shrinks. It's just an inevitability of the physics. I've talked to lens designers and been to courses and looked into it quite seriously and there are very few ways to get around it. With my pictures, the depth of field mimics vision at a certain scale. I think with paintings of a certain scale you're stood ten-feet back from the whole picture and then you come in. In my photographs you're allowed to do the same thing. You can stand a way back and you can make an evaluation of the composite values and whether the thing works. And then you come in; then you're allowed into the detail.

Is this true for all genres? When I studied, I ended up as a sort of landscape photographer for a long time. And it was a bit like listening to music that you didn't really like. You were trying hard to appreciate it, and you were told that you ought to. And then you get to a certain age and you just don't really care. When I walk round the National Gallery, I'm drawn to figure pictures and portraits in particular. It's what excites me in pictures. The older, the more curious the better in some ways.

*In this Degas portrait of his cousin [*Portrait of Elena Carafa, about 1875*], the pentimenti are obvious. It was only at the last moment that Degas turned her face from strict profile to three-quarter view, and then he had to compensate, as you see, by repositioning the left shoulder.* You know, I think there is a similarity between painting and a lot of photography. In painting you can make decisions as you go along. In photography it is more of an editing process. You make the photograph, you see the photograph, you make decisions about what's right or what's wrong based on that photograph. And then you change it, and the changes evolve until it becomes satisfactory. It's evolution, just a different process.

Are you ever surprised by what comes out? Always. Photography, good photography, all it is, it's just the sensation that you feel something from the thing that you are looking at, however it's made, whatever it is. I mean the tools and the person who made it exist, but it is what it is.

Has your picture-making process changed much over the years? I take photographs of my photographs on an iPhone now. It reduces the scale [of the original] and it gives you a different way of looking at the thing. Sometimes the scale of the thing is too big to take in, and to be able to look at something quite small is a good way to evaluate what you're up to. It's funny, isn't it? You need that change, that freshness, to look at something you're doing.

And then what do you take back to the picture itself? I think that seeing something smaller and more condensed is a really good way of evaluating whether a composition balances. You can get swayed very easily [on a large scale] by the more seductive elements of texture or the things that you want to be in the picture, and you sometimes have this nagging feeling that can be confirmed only by taking the iPhone picture; maybe it doesn't balance. To reduce it in scale is really handy. I've only been doing it for a year or so, but it's really helped. Because what happens is you go 'yes, that's fine', but then the next day you come in and you know the nagging, miniscule thing that's picking away at your left synapse at the back of your brain is right, and you've got to start all over again. It just snaps you out of lying to yourself, which is interesting.

What about technological developments in photography? The digital revolution? Photography is now a regressive medium. It's interesting, isn't it? It's reached a point in its technology where it's regressing back to a sort of Kodak infancy. The sophistication of the materials was probably highest in the mid-1990s, when analogue technology was reaching a peak, when the sensitivity and sophistication of the materials and colour relationships were all being resolved. And then [with digital] it collapsed, like a house of cards, into something where you have to accept peach faces – it's quite amazing.

The material that I use, I've had to buy a lifetime supply because they've stopped making it in Switzerland. It's the end of that world! It's finished now. Kodak will go down; Ilford will have to decide if their factory is more valuable as a housing estate. At one point the technology was being taken up by Eastern European countries and India, but now they've sort of bypassed it, decided it's irrelevant. I feel like one of those typesetters, you know, saying it's a real skill and it's really great, but you don't know…

There is a letter in our archives from a man writing to the Director in about 1870, saying that his wife is not at all educated and yet she understood [a certain picture] after looking at it for only twenty minutes. When was the last time you spent twenty minutes looking at a picture? I'm one of the few photographic artists I know who actually spends time looking at a work hung up while I'm working on it. What I tend to do is work one day, go to the studio the next day, hang the picture up for that day, and revisit it before I allow it to be in my world. I spend a considerable amount of time looking. Most people don't. When you're painting you need to live with the *process*, whereas I have a very quick process but I have to live with the *result*.

And with you, unlike most photographers today, the result is unique. Yes. Other unique photographic works tend to be photograms, where there's light shining on the thing, rather than something that actually looks like other films or photographs.

You wouldn't necessarily deduce that it's a single. My whole take on it is it shouldn't; the process should be invisible. It's the idea that photography itself, or the initiation of the idea for photography, is practically perfect. Because it is, you know. You look at a projected image on a piece of white cloth, and it's perfect, it's absolutely perfect, there is no interference, no nothing. It's about making what that is. Obviously the human hand is involved, but there's something to that idea, that the idea in itself is unspoilt.

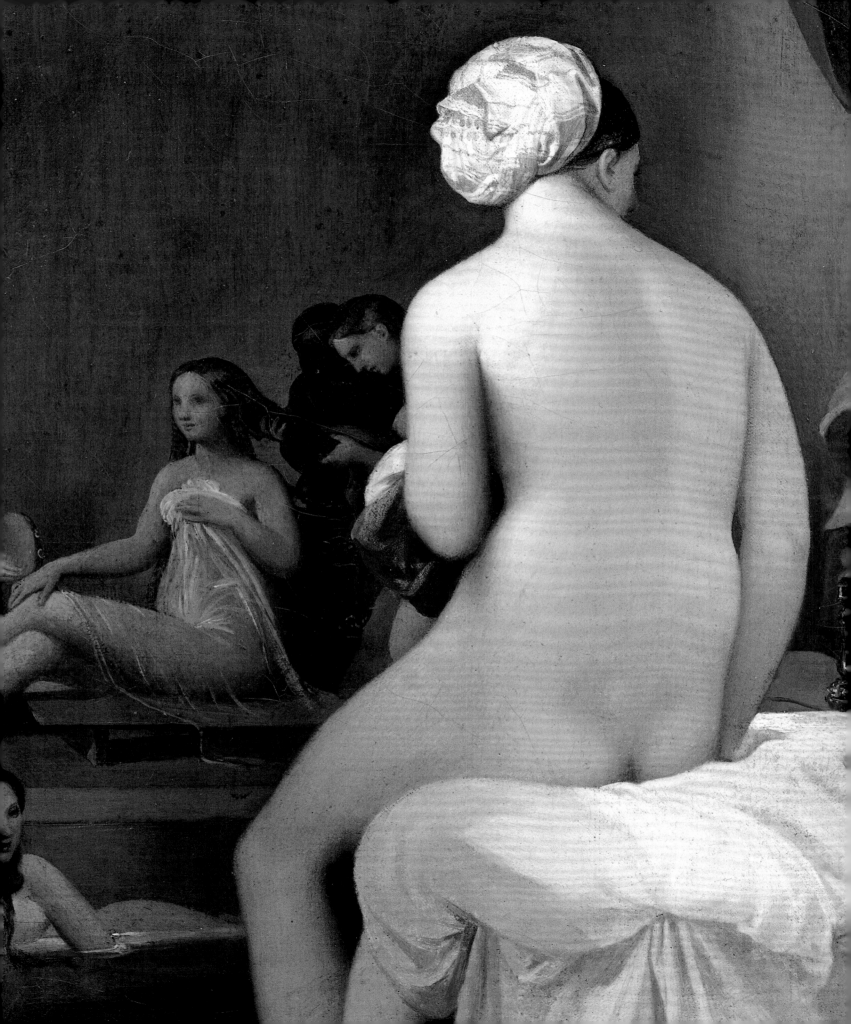

THE DIVINE IDEAL ? PHOTOGRAPHING THE BODY

Celebrated and censored, the depiction of the human body has been an artistic and critical battleground for centuries. Photography's entry into that arena has invigorated the debate. A painter can idealise the subject, but the photographer must deal with the reality that the camera lens shows. Photographers were sensitive to the conventional view that while a painted figure could be termed a 'nude', its photographed equivalent was a bare nakedness that could never achieve artistic status. Henry Peach Robinson, one of O. G. Rejlander's exhibition-hall peers, took a pragmatic view: 'The nude is the divine ideal; the undressed is the modern naked girl'.[1]

The question of the ideal versus the real permeates *Ruin* (fig. 72), Helen Chadwick's self-portrait photograph made within the space of her installation 'Of Mutability' at the Institute of Contemporary Arts in London.[2] Chadwick positions herself in front of a television image of *Carcass*, a glass column of vegetable matter that decayed over the course of the exhibition. The smoothness of her skin contrasts with the rotting mass behind her and the rough brown bone of the skull on which her hand rests. This is a memento mori, signalling mortality in no uncertain terms.[3]

Chadwick used photography alongside her primary medium of sculpture, but her photographed body was so often the focus of critical attention, for her work was caught up in passionate debates about the body and the representation of women. She tried

to remove her 'self' from the picture by shielding her face, a pose Rejlander used in his artists' studies (fig. 71). The averted face turns the image from a portrait (or in Rejlander's case, a toga-clad self portrait) into a generic figure study. But photography's insistent actuality presents an image of the 'real' Helen Chadwick: this was not a safely idealised painted or drawn figment of the artist's imagination. And to Chadwick's chagrin, those who had applauded her feminist

Opposite, fig. 71
Oscar Gustav Rejlander,
Artist's study (self portrait),
about 1856–57. Modern
gelatin silver print, about
1987, 23 × 18 cm. The
Royal Photographic Society
Collection at the National
Media Museum, Bradford.

Right, fig. 72
Helen Chadwick, *Ruin*,
1986. Cibachrome, 93 × 49 ×
4·5 cm (framed). Mehmet
Dalman Collection.

resoluteness in tackling difficult issues in the form of her own flesh now accused her of representing her body in a seductive way. She was philosophical: 'You cannot spend a significant portion of your artistic life making explicit nude revelations about yourself without becoming aware of your work's ability to excite.'[4]

Chadwick's presence in her pictures was read as vanity, not courage. She was irked by the jibes, explaining her disappointment in a terse sentence: 'When I am looking to cross the taboos that have been instigated[,] I hate being hauled up as an example of negative women's work.'[5] Chadwick decided that she would no longer show herself in a recognisable form, and moved ever closer into her flesh, making microphotographs of her own cells, which formed her last works.

Today, the aesthetics of the nude are subsumed within issues of power relations, feminism and the viewer's own psychosexual response.[6] Critical theory acknowledges eroticism but redirects its power to move us, just as the Victorians displaced desire with art history and the pictorial codes of academic art. In her study on the nude in Victorian art, Alison Smith perceptively observes: 'We have inherited from the Victorians two opposing but by no means mutually exclusive ways of perceiving the nude, broadly termed…the aesthetic and the moral.'[7]

In painting and sculpture, morality may be expressed through the arrangement of the figures, colours that are boldly fleshy or pale as

Left, fig. 73
Jean-Auguste-Dominique Ingres, *Angelica saved by Ruggiero*, 1819–39. Oil on canvas, 47·6 × 39·4 cm. The National Gallery, London.

Opposite, fig. 74
Louis-Jean-Baptiste Igout, *Académie No. E791*, 1870s. Albumen print, 14·2 × 9·8 cm. Wilson Centre for Photography.

marble and an execution in rough or smooth brushwork. In *Angelica saved by Ruggiero* (fig. 73), Ingres painted a nude so evenly pallid as to seem entirely artificial. This, of course, was intentional, for his neoclassical ethos held that art's intellectual elevation came through idealisation. True to his teacher Jacques-Louis David, Ingres valued design over colour; linear form addressed the intellect, while colour appealed to the senses. So colour was used with restraint, and Angelica's skin has no more bloom than a waxwork. This is a work of art standing in for an idea, for the subject matter was an epic poem dating from the fifteenth century, Ludovico Ariosto's *Orlando Furioso*. Within that context of chivalrous honour, the specific attributes of a real model would have been jarring – and vulgar. As G. F. Watts explained, the 'taint of indecency clings to the idea of the "individual"'.[8]

THE NAKED AND THE NUDE
Photographic nudes were on the market

within a few years of photography's invention, initially as expensive daguerreotypes, hand-tinted and presented in decorative casings (fig. 77, p. 108).[9] Mass-produced paper prints from glass plate negatives were also profitable, for the genre commanded a ten-fold premium.[10] Stereoscopic views were popular; their optical illusion of three-dimensionality gave voyeurs an extra thrill.[11] By 1854, Paris was a veritable factory for every permutation of nakedness from academic studies to out-and-out pornography.[12] In London, similar material was available from booksellers and print dealers, most infamously along Holywell Street, a narrow lane not far from Trafalgar Square. While the display of obscene books and prints had been illegal since the 1820s, outraged reports in the press indicate that racy photographs were on view in shop windows alongside more respectable material.

We do not see nineteenth-century photographic figure studies in the same way that they were perceived in their own time. The photographs are part of today's art market and are collected and exhibited as examples of antique work. To us, they are exquisite daguerreotypes on polished silver plates or small brown-and-ivory images on old albumen paper. Without colour, the models seem far away in the past, sufficiently distant to be safe, even nostalgic (fig. 74). But originally, these were surprising pictures of real bare flesh, and they were narrowly proscribed in the public domains of print dealers' shops and photographic exhibitions.[13]

106 Studies of the nude by artists, termed
académies, were valuable reference works.[14]
Traditionally, they were incorporated into
'copybooks', drawing manuals illustrated with
engravings after details of Old Master works,
isolating the parts of the human body. In the
early nineteenth century, lithographic prints
took the place of engravings and photographic
studies followed in the early 1850s.

Life drawing is an especially demanding
practice, requiring long study and knowledge
of anatomy; even established artists attend life-
drawing classes throughout their working lives.
Photographic *académies* cost much less than
hiring a model[15] and they were acknowledged
as aiding artists in correcting distorted ideas of
anatomy. In 1853, Ferdinand-Victor-Eugène
Delacroix contrasted the nudes in photographs
(albeit 'poorly built, oddly shaped…and not
very attractive generally') with the figures
portrayed in sixteenth-century engravings. The
engravings compared badly; one 'experienced
a feeling of revulsion, almost disgust, for their
incorrectness, their mannerisms, and their
lack of naturalness'.[16] The following year, he
recorded several sessions in Eugène Durieu's
studio, where he helped pose and light the
models (fig. 75). Delacroix found the realism
of the photographs a valuable corrective to
academic idealisation, writing in 1855 that
'these photographs of the nude men – this
human body, this admirable poem, from which
I am learning to read – and I learn far more
by looking than the inventions of any scribbler
could ever teach me.'[17]

Opposite, fig. 75
Eugène Durieu, *Artist's study from an album made for Eugène Delacroix*, about 1853. Gold-toned albumen print, 20·9 × 12·7 cm. Wilson Centre for Photography.

Right, fig. 76
Louis-Jean-Baptiste Igout, *Académies*, page from a sample album published in the 1870s. Albumen print, 27·8 × 21 cm (sheet). Wilson Centre for Photography.

Fig. 77
Unknown French photographer, *Four nude studies*, about 1855. Hand-tinted and pin-pricked daguerreotypes mounted within gilt surrounds and set into thermoplastic 'union' case, 19·6 × 16 cm (open). Wilson Centre for Photography.

The male model rarely appears in photographic *académies*; Louis Igout's late 1870s images (fig. 76) are among the very few. The male studies in Durieu's album for Delacroix are mostly unique prints, unlike the female subjects in the album, for which the numbers of extant prints suggest that they were more widely sold.[18] The paucity of male nudes may reflect a decline in their representation at the Paris Salon; by 1863, men accounted for only a quarter of figure studies, which mostly featured women and young boys.[19] This ratio must be set against a drop in the overall numbers of exhibited nudes, which, even at the Salon, were down by about half from the 1820s to the middle of that century.[20]

There is a correlation between surviving prints and their original market, for *académies* were the most lucrative of published genres. Within a year of the 1852 decision to include photographs in the French government's copyright register, almost half of photographic entries were listed as *académies*.[21] A few would have been anodyne genre studies, which were also called *académies*, but the numbers suggest a popularity that extended beyond the art schools. Rejlander observed that artists did not buy many photographs: 'my clientele has been so small...the cost has been to me sometimes more than I earned.'[22] This implies that the real customers for nude studies were not impecunious artists but the general public, who would pay good money for risqué pictures.

Traditionally, the publication and sale of indecent images constituted a misdemeanour rather than a crime and was difficult to prosecute. Indeed, press reports suggested that London's Holywell Street shops were protected by their customers down the road at the Houses of Parliament. But in September 1857, the Obscene Publications Act ruled that intentionally obscene printed matter was liable to statutory confiscation and destruction.[23] The law was tougher in France, where photographers, models and vendors were regularly arrested, fined and imprisoned. Yet the profits were so great that few moved to less risky imagery – the same photographers and dealers were collared over and over again.

The trade continued as a black market. Models hid their faces, preserving their anonymity as much to avoid prosecution as to defend their dignity. Photographs were distributed outside French borders; Igout's *académies*, originally published by Auguste Calavas in Paris, are frequently found with German titles. Pornography was purveyed in a variety of ingenious ruses, including microphotographs set into tiny opera glasses and binoculars fitted with magnifying lenses.[24] In another camouflage, four gloriously hand-tinted French daguerreotypes are presented in a case bearing the bas-relief scene of a mother, a child and a faithful dog – a perfect pastoral 'blind' for the nudes within (fig. 77).[25]

The image was beyond the means of mid-century photography, as no lens could resolve a large field of view without radically reducing the aperture and extending the exposure time. A long exposure, in turn, was impractical for these animate subjects, even if each group could be persuaded to pose simultaneously (and it is evident that the same sitters appear in different roles).

Rejlander's solution was to make a composite picture from 30 separate glass plate negatives (fig. 79), which were printed in a laborious sequence to produce what was called 'an immense…mosaic'.[29] This was an exciting pictorial opportunity, for composite photographs are synthetic constructions, like paintings, and synthesis had a higher artistic value than literal depiction. The method may have had an artistic provenance and it was certainly a compositional necessity. However, it fatally undermined photography's special virtue of truthfulness, as the writer Alfred Wall argued in 1861: 'Photographs have been pardoned many faults on the ground of their redeeming merit – *truth*. When it is confessed that this is wanting, what contemptible shams its productions become'.[30]

Conceived as an exhibition piece, *The Two Ways of Life* demonstrated both Rejlander's capabilities and those of his medium.[31] Here was the same great sweep of a multi-figured story found in famous paintings like Raphael's *The School of Athens*, a Vatican fresco that was widely reproduced in engravings (fig. 80).

Fig. 79
Oscar Gustav Rejlander, *Penitence (Study for The Two Ways of Life)*, about 1857. Modern gelatin silver print, about 1987, 18·2 × 23 cm. The Royal Photographic Society Collection at the National Media Museum, Bradford.

Right, fig. 80
Francesco Faraone Aquila (after Raphael), *The School of Athens (Picturae Raphaelis Sanctij Urbinatis: Plate 11)*, published in Rome 1722. Etching and engraving on paper, 51·8 × 70·7 cm. The British Museum, London.

Overleaf, fig. 81
Thomas Couture, *Romans of the Decadence* (*Romains de la Décadence*), 1847. Oil on canvas, 472 × 772 cm. Musée d'Orsay, Paris.

Another inspiration may have been Thomas Couture's *Romans of the Decadence* (*Romains de la Décadence*, fig. 81), which had caused a stir at the Paris Salon of 1847. *The Two Ways of Life* repeats Couture's clever blend of orgiastic tableau and moral sermon, though it does not include Couture's political message, which contrasted the virtues of a Roman (and French) republican past with the decadence of Imperial Rome and Louis-Philippe's July Monarchy of 1830–48.

Rejlander's audience would have recognised his sources, from high art to low. Moral tales were illustrated in photographic stereo cards called 'sentimentals'; these ran the gamut from pious to lurid. In the theatre, burlesque performances called *poses plastiques* presented scenes from myth, legend or famous works of art. There was often an erotic subtext; Eve, Venus and Lady Godiva were favourite subjects, as was minimally draped Greco-Roman statuary.

Left, fig. 82
Oscar Gustav Rejlander, *Reclining female nude, artist's study*, late 1850s. Modern gelatin silver print, about 1987, 18·3 × 23·2 cm. The Royal Photographic Society Collection at the National Media Museum, Bradford.

Below, fig. 83
Oscar Gustav Rejlander, *Reclining female draped, artist's study, dorsal*, about 1856–57. Modern gelatin silver print, about 1987, 18·3 × 23·2 cm. The Royal Photographic Society Collection at the National Media Museum, Bradford.

It was said that Rejlander's models were hired from a *pose plastique* troupe at the music hall near his Wolverhampton studio (figs 82 and 83).[32] The troupe's performances were popularly thought indecorous and worse aspersions were cast. It was known that prostitutes performed for pornographic photographs; who else would consent to pose for *The Two Ways of Life*? In 1863, *Photographic Notes* distinguished between painted nudes and Rejlander's models:

> There is *no* impropriety in exhibiting such works of art as [William] Etty's "[Female] Bathers Surprised by a Swan," or the "Judgement of Paris;" but there *is* impropriety in allowing the public to see photographs of nude prostitutes, in flesh-and-blood truthfulness and minuteness of detail.[33]

William Etty was a relevant reference; in the early nineteenth century, he was the most notable English painter of nude subjects (fig. 84). Indeed, *The Two Ways of Life* was coyly described by one Birmingham paper as 'a somewhat Ettyish picture, with plenty of the nude to satisfy those who believe in and desire the display of the human form divine'.[34]

In the photography world, there was no precedent for *The Two Ways of Life*, and the picture created a controversy that made Rejlander's name, as he intended.[35] So too did the patronage of Queen Victoria, who ordered a ten-guinea print to give to Prince Albert and later bought a second copy.[36] She purchased other figure studies from Rejlander, in keeping with her noted connoisseurship of painted and sculpted figures. Such official sanction should have absolved photographic nudes. But hypocrisy was rife, as *The Photographic News* later noted in 1886 when reporting the

Fig. 84
William Etty, *The Judgement of Paris*, about 1825–26. Oil on canvas, 183·5 × 277 cm. Lady Lever Art Gallery, Liverpool.

trial of a dealer in nude photographs. With regard to one witness for the prosecution, the *News* asked: 'Has he never seen the crowds at The National Gallery? Did he visit the Royal Academy last year when there were at least a dozen nudities at which young ladies gazed without a blush?'[37]

Of course, the real and the ideal evoked very different responses. Photographs of classical sculpture (fig. 85) were unimpeachable, as Disdéri explained in 1862:

What man has ever felt obscene thoughts awakened in him by the sight of those antique statues which are so true and yet so human?…In these supreme efforts of art the reality is sanctified or consecrated as it were by beauty…which…pervades the whole soul, and reigns there sovereign, preventing the entrance of ideas of a very inferior and totally different nature.[38]

This was lofty stuff, but in 1858, the *Photographic Journal* had already spotted the hypocrisy: 'it would seem that anything which bears with it the impress of antiquity, however lewd or indelicate, is idealized [sic] into classicism.'[39]

Above, fig. 85
Studio of James Anderson, *'Venus of Praxiteles' in The Vatican, Rome*, about 1860. Two albumen prints as stereo view mounted on card, 8·1 × 17·2 cm. Wilson Centre for Photography.

Opposite, fig. 86
James Anderson (?), *The Laocoön Group*, about 1855–65. Gold-toned albumen print, 42 × 29·4 cm. Wilson Centre for Photography.

The ideal nude resided within the impeccable bastions of the British Museum, where, by 1856, Roger Fenton's photographs of classical statues were on sale to visitors. Marble sculptures were early subjects for photographs; the white stone reflected a good deal of light, so that exposures were practicable even indoors.[40] Fenton's customers were artists and members of the general public, and his most popular subject was the nude discus thrower known as 'Discobolus'.[41] Fenton's venture was paralleled in other capital cities and major art institutions; from the mid-1850s, a number of Roman photographic studios specialised in reproductions of historical art. James Anderson was one of the most successful, and his *Laocoön Group* was a widely sold subject.

The Laocoön Group (fig. 86) is an extreme representation of human form under dynamic strain, as the suffering protagonists of Greek myth struggle with sea serpents of divine retribution. The photograph describes an extraordinary anatomical topography, echoed by the curves of the serpents. Another sea creature coils around the male figure in Richard Learoyd's *Man with Octopus Tattoo II* (fig. 88), and, like the Laocoön sculpture, the effect is both sensuous and disturbing. Learoyd's two-dimensional photograph is surprisingly sculptural. Its form is volumetric, for the artist uses a very large copying lens whose shallow depth of field gives a sense of depth to the subject. Furthermore, the surface of the figure is like marble in the

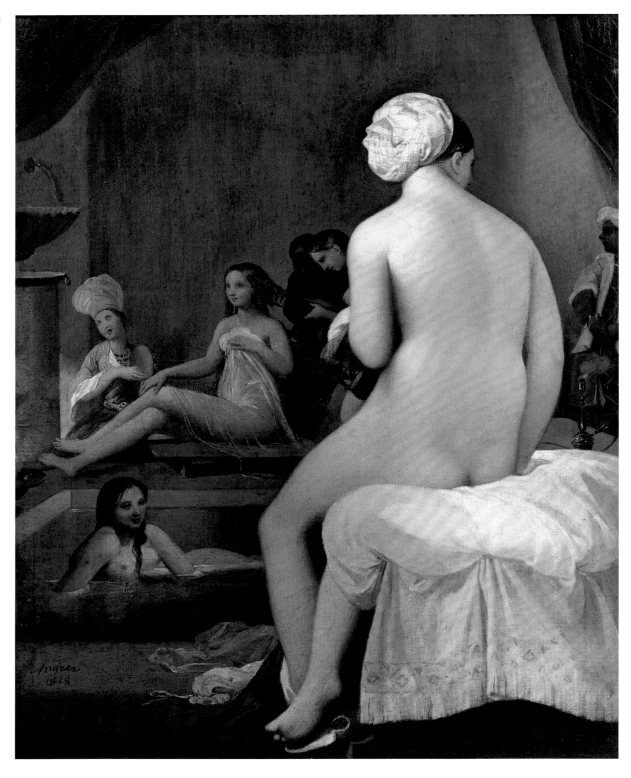

Left, fig. 87
Jean-Auguste-Dominique Ingres, *The Small Bather. Interior of Harem (La petite baigneuse. Intérieur de harem)*, 1828. Oil on canvas, 35 × 27 cm. Musée du Louvre, Paris.

Opposite, fig. 88
Richard Learoyd, *Man with Octopus Tattoo II*, 2011. Unique Ilfochrome photograph, 148·6 × 125·7 cm. Courtesy of McKee Gallery, New York.

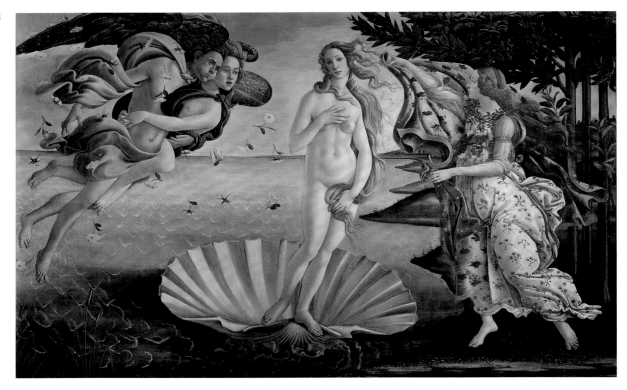

Left, fig. 92
Sandro Botticelli, *The Birth of Venus*, about 1482–86. Tempera on canvas, 172·5 × 278·5 cm. Galleria degli Uffizi, Florence.

Opposite, fig. 93
Paolo Veronese, *Unfaithfulness* from the group 'Four Allegories of Love', about 1575. Oil on canvas, 189·9 × 189·9 cm. The National Gallery, London.

A PROFOUND VISUAL EXPERIENCE

While nineteenth-century photographers and their critics agonised over the insistent realism of photographic nudes, that nakedness was still small-scale. They could never have imagined how large photographs would get. When figures expand to the size of the works by Dijkstra and Learoyd, there is a proportionate increase in the subject's physical presence. As Learoyd said in 2009:

> I suppose one of the basic ideas in the work is to reintroduce the notion of

a 'profound visual experience' back into viewing photography, by denying photography its re-producible element and emphasising the unique qualities of singular photographic objects.[44]

He was referring both to size and to the nature of his photographs as one-off prints, and a similar impetus drives Craigie Horsfield, who has for decades made a single, larger-than-life print of each photographic exposure.

The tremendous scale of Horsfield's nude (fig. 94) gives a visceral weight to the image.

In matching the scale of the representation to that of the original subject, the viewer's perceptions are strongly engaged. Like Paolo Veronese's *Unfaithfulness* (fig. 93), the two-dimensionality of the work is belied by the figure's solid, sculptural, volumetric form. Horsfield summed up his intentions in 1991:

> This surface should be of the place and time, it should be as vulnerable as skin, it should account [sic] the exorbitant weight of the world, the presence, the sensation of objects as filling the world. It does not simply signify; through it we may experience the gravitational pull of the phenomenal world.[45]

Those words describe the visual and tactile experience of the black-and-white photographic print, whose matt surface is slightly stippled, like the pores of skin. And when Horsfield says that the surface should be as vulnerable as skin, he is speaking literally, for his framed photographs are unglazed, giving the surface its due, but also leaving it unprotected. Horsfield argues that he was looking for a different physical substance:

> I did not like the presence of the great majority of photographs. The surface of the photograph does not act. The surface of a painting does, even the surface of film, but the surface of the photograph is redundant, it is not engaged by the artist.[46]

THE ABSENT SUBJECT

Horsfield's nude is the sole object; in that powerful chiaroscuro of shadows and highlights, there is no background, no context. The figure is turned away, like Degas's model (fig. 95) and so many of the nudes in this chapter. That concealed face counters the specificity of an individual sitter. If the photograph includes the face, it portrays a

Opposite, fig. 94
Craigie Horsfield,
*E. Horsfield, Well Street, East
London, February 1987*, 1988.
Photographic paper mounted
on aluminium, 141·5 ×
141·5 cm. Colección TEA
Tenerife Espacio de las Artes,
Tenerife.

Above, fig. 95
**Hilaire-Germain-Edgar
Degas**, *After the Bath,
Woman drying herself*, about
1890–95. Pastel on woven
paper laid on millboard,
103·5 × 98·5 cm. The
National Gallery, London.

recognisable person at the place and time
of the exposure. The face, and indeed the
facial expression, will colour the viewer's
response to the body. There is a predicable
and prosaic reason, for real nude bodies are
remarkable; most human bodies that we
encounter are clothed.

Degas used the averted face and rear
viewpoint in his many similar nudes.
Christopher Riopelle describes the pose and
position as giving the sense of stumbling on a
scene of intimacy; the woman is oblivious to
all but the sensuous pleasure of the moment.
It is a fiction, however; this is a hired artist's
model and the pose is a careful invention.
There is another important difference between
Horsfield's photograph and Degas's pastel.

The former is printed on a single large
sheet of photographic paper as a unitary
image. Riopelle explains that Degas's picture
comprises no fewer than seven sheets of
paper; six supplementary sheets have been
carefully added to include the model's left
foot and most of her right arm, introducing
a more ample body and a fuller sense of
ambient environment. These additions register
the expansion of Degas's conception of the
composition, his willingness to elaborate on
a motif in the process of depicting it. Degas's
process may have taken weeks or months,
a luxury not available to photographers.

We may feel that when it comes to the
nude, photography is at odds with art.
Certainly, the mid-nineteenth century found
it a contentious combination of subject and
medium, and photographers like Rejlander
made strenuous efforts to embody an idealistic
subject in a realistic medium. It may seem that
contemporary photographers do not attempt
to idealise the nude, but they have also
found ways to counter the camera's relentless
specificity through devices such as pose, the
exclusion of the face and a scale that gives
the images the presence of large paintings.
The nude remains a demanding discipline
for photographers, as Learoyd has said: 'I still
find it fascinating to photograph people with
no clothes on. As a subject, [the nude] has a
teaching ability and demands a certain clarity
of thought'.[47]

CR *I note as we stroll around the National Gallery that you're drawn to the intense realism of early Netherlandish paintings by Jan van Eyck and his contemporaries.* Yes. That preciseness and that looking very carefully, that's what I really like and what I try to capture in my photographs as well. I try to get rid of everything that's not important and to focus on details.

HK *Looking at Piero della Francesca's work, I'm struck by the way he often drops the horizon lines in his paintings. You do something similar in your photographs of bathers on beaches, like in* **Kolobrzeg, Poland, July 26 1992** *[fig. 90, p. 124].* I chose a lower camera position to isolate the people from the background. By separating the people from their surroundings they became more autonomous, more abstract. The nice thing about a beach location is that the sand, sea and sky are natural and constant, but always appear differently, because of the weather conditions and time of day.

HK *Did you feel they responded to you differently when the camera was a little bit lower?* I can imagine it feels somewhat less threatening. The camera was here, more or less [*gestures to waist-level*].

HK *When you use an analogue technical camera, it doesn't look like a normal camera, you aren't holding it up to your face. I wonder whether all of that somehow makes it seem less intrusive for your subjects?* I think the thing that helped me so much was to work with this camera. It's so simple and I think that people are always curious about it. They ask: 'What is this; what kind of camera is this?' They are always interested because it is so special in a way. With my big field camera on my tripod, it's like the box is making the picture. Of course, I have to focus and operate it, but I'm always looking at them, so there is a direct contact between me and the sitter.

CR *Do you usually have conversations with them?* I try to. I try to make them feel at ease because everybody is always a bit nervous in front of the camera. While I talk to them I try to find an expression that is real. It is really hard because you try to have a conversation, but at the same time you look at them and think: 'Is this a good moment?' And then you almost have to interrupt them to take the photograph.

I work with a large 4 × 5 inch field camera on a tripod. This results in a slower way of working, and you really feel like you are making an image because you have one plate at a time. You cannot take multiples. I guess I never felt that I needed to take a hundred pictures; it's better to do five or six.

You have to build it up a little bit, then there is a peak of concentration, and then it falls down. You can't ask people to concentrate for too long a time. Using this type of camera creates a different kind of experience for the subjects. They accept that the session takes longer than using a snapshot camera. I think people also feel a kind of concentration or intensity that comes into the image.

CR *We're looking at a small, remarkably intense* **Portrait of a Man** *of about 1475–76 by Antonello da Messina.* He looks really alert, doesn't he? It's the eyes; it's because the eyes are turning. I like these little details like the hair and the skin, and the chiaroscuro, and this little thing here [*gestures at a detail of the shirt collar*]. I think painters spend so long executing a work that they think about every little detail. With photographs, sometimes it's not until the work has come out that you notice things. You can never see everything when you are making the picture.

CR *We're in front of Rembrandt's* **Belshazzar's Feast** *of about 1636–38. Is Rembrandt someone you go and look at?* Yes, he is one of my favourites. [The painting] still looks so contemporary because the emotions are so real. And the actual activity of painting! It has a great tactility. So there's a liveliness in the way the paint's put on and there's a liveliness in the expression, like a photographic moment. It's like the next moment will be different.

HK *When we see so many portraits together like this, I find I stop thinking about them as examples of 'a Rembrandt' but as very different individuals and personalities. Do you feel that way doing a series of photographs?* I always try to emphasise how people

distinguish themselves. I try to capture something universal that has to do with a topic, like school children or Israeli fighters or people in a park. But then when I've chosen the topic it is really only about the individual. Then it's interesting because you have this group and you have to compare each one. And then, because you compare them, you see the differences.

I think even for me, working with this bulky, old-fashioned, slow camera, and trying at the same time to make a natural portrait seems almost impossible. But there is always something in this friction that is going to work. I can't explain what it is, but it's...

CR *You know it when it happens?* Yes. I think the thing that helped me so much was to work with this camera. It is really simple. These modern cameras, with too many possibilities, I hate them! I only need a shutter and an aperture. I don't need anything else!

HK *It is certainly interesting to deal with a medium where there are limits. One of the things I feel is so frustrating about digital photography is that anything is possible. When there are no limits, no boundaries...* ...what do you choose then? As a test, I always shoot a Polaroid first, to see the composition, but also to check the lighting. After the session, I give the Polaroid to the sitter. And it's about a couple of days until I see the actual contact sheet, which is good because I need that time for reflection, that distance. Sometimes even after a week I can't make a decision about which is the best picture, and then after six weeks I can see it right away.

HK *That is really different from what a painter is doing because painting is a constant evolution, and if it is not right at this point it might be right at another point, whereas you have to work with what you're producing and what you're given.* It's really in that moment I'm taking the photograph, everything has to come together: the light, the moment, the gestures, the detail, everything. I think with a painter the really difficult thing is deciding when the work is finished. It can go on and on and on, no?

CR *We're looking at Jan Gossaert's* Adam and Eve *[1520]. As they are being expelled from paradise the thing about the Fall is that you learn shame. Shame does not exist before the Fall.* That's why they look so awkward. When you have your picture taken you feel that you are showing everything. I remember very well, when I took the picture of the girl in the green bathing suit on the beach of Kolobrzeg. She was very shy; I think she was excited, but scared at the same time. Finally, the image worked so well, because I could turn her awkwardness into something graceful. It was only at home when I studied the contact sheets that I could see a resemblance with the famous painting *The Birth of Venus* by Botticelli [about 1482–86, fig. 92, p. 126]. But my bather is not so much about beauty, rather an uncertainty and trying to find a pose.

CR *We're looking at pointillist paintings by Georges Seurat and his followers.* It's so exciting to see them all. With some paintings, I think you can get a good sense of them from reproductions, but with these I really think you have to see them. Actually, I think with my photos you really have to see them, and not just in small reproductions. It is about the scale and the colour. What I think about size is that it's important you can see the pictures from different distances. But there should still be an intimacy when you go up close to look at the details.

Today, still life is the most widely seen photographic subject, appearing in advertisements and on every packet of frozen food. It figured among the earliest photographic images, an ideal theme for a medium whose exposures were counted in minutes (or hours) rather than seconds. What better way to explore new pictorial and technical issues than through arrangements of inanimate objects in a controlled environment?

There was plentiful inspiration in painted precedents. Still-life motifs are found in portraiture and tableaux, but still life is also an autonomous genre, most notably in Dutch painting from the 1600s onwards. Conveniently for a naturalistic medium, still-life paintings were often highly realistic, as in Jan van Huysum's study of *Hollyhocks and Other Flowers in a Vase* (fig. 99). Later works such as Fantin-Latour's *The Rosy Wealth of June* (fig. 96) show an observant, painterly approach to a more informal arrangement that communicates a modern sensibility.

Both paintings were the starting point for lens-based projects by Ori Gersht, and they presented him with a particular challenge, for the pictures he saw at the National Gallery affected him very differently from photographs. He realised that while a photograph's literalness can convey visual information quickly and efficiently, a painting communicates slowly and partially:

Above, fig. 96
Ignace-Henri-Théodore Fantin-Latour, *The Rosy Wealth of June*, 1886. Oil on canvas, 70·5 × 61·6 cm. The National Gallery, London.

Opposite, fig. 97
Ori Gersht, *Blow Up: Untitled 5*, 2007. LightJet print mounted on aluminium, 248 × 188 × 6 cm (framed). Mummery + Schnelle, London.

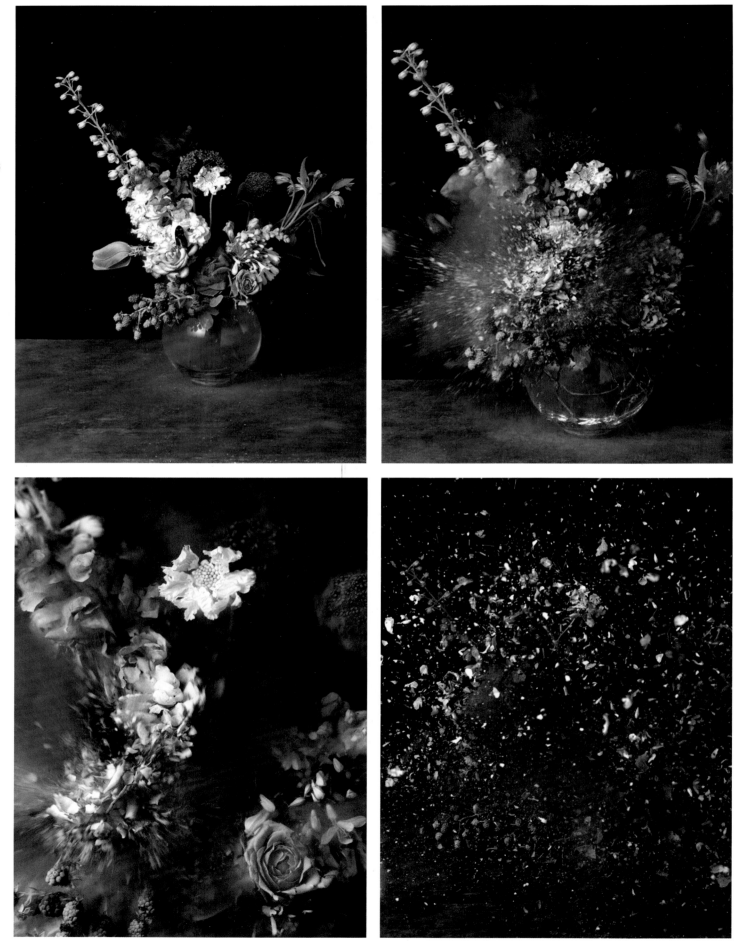

Opposite, fig. 98
Ori Gersht, Four stills from *Big Bang 2*, 2007. HD film; 5 minutes 33 seconds. Mummery + Schnelle, London.

Above, fig. 99
Jan van Huysum, *Hollyhocks and Other Flowers in a Vase*, 1702–20. Oil on canvas, 62·1 × 52·3 cm. The National Gallery, London.

With painting there is something about the way the information is revealed that makes it impossible for you to digest it in one look and be fully satisfied. You can stand in front of it for hours every day, and still it will evade you.[1]

Gersht was interested in an extended visual experience and he expressed this in a sequence of photographs modelled on *The Rosy Wealth of June*, in which the painted blooms are re-created as a perfect bouquet of vibrantly, even artificially, tinted roses (fig. 97). What we do not at first realise is that the flowers are frozen

with liquid nitrogen; this is a *nature morte* stilled and killed by frost. Hidden among the flowers are small explosive charges that detonate, breaking the petals into icy shards that fly across the dark space. The explosion is registered on a high-speed digital camera that produces a series of stop-action images.

Gersht took his title, *Blow Up*, from the 1966 Michelangelo Antonioni film of the same name, which, he said, 'explores the relationships between photography and truth, reality and appearance'.[2] In Gersht's picture, as in the Antonioni film, appearances are deceptive. But his work has a bigger message. Gersht grew up in Israel through the Arab-Israeli conflicts of the late 1960s and 1970s, and the bombings gave his childhood a background hum of anticipatory fear. This animates a related work of his, *Big Bang 2* (fig. 98). The film begins with a frozen flower arrangement modelled on Van Huysum's *Hollyhocks*, which becomes wreathed in slow, icy tendrils of vapour that seep outwards across one minute, and then another. A faint humming on the soundtrack becomes more acute as the sound – a mechanical wail – builds in volume. Its crescendo – and the flowers – are obliterated by the sound and force of an explosion. The Yom Kippur War brought air-raid sirens into Gersht's life. The siren is what we hear as the flowers spray outwards against a night-black background.





STUDIES OF TIME AND BEAUTY: STILL-LIFE PHOTOGRAPHY

Gersht aggressively updates the artistic genre of still life and does so with explosive force. What is the photographic tradition against which his work should be measured? The very earliest photographic still lifes were primarily technical exercises; Louis Daguerre's arrangements of plaster casts are akin to William Henry Fox Talbot's studies of bric-a-brac. Talbot used *Articles of Glass* (fig. 100) to demonstrate the challenge of photographing objects with different light values.[3] He presented such subjects as practical documents, visual inventories for insurance purposes.[4]

Still-life studies were useful lessons. In writing about photographic picture making, watercolourist and photographer William Lake Price suggested still life as a means to study 'various textures, surfaces and colours, and the treatment each necessitates to arrive at a satisfactory result.'[5] He explained that 'such subjects can be made extremely interesting and picturesque, and…will always be looked upon with interest…as the taste of the composition and grouping is artistic and pleasing'.[6]

In the 1840s, informal still-life studies were produced by French photographers like Hippolyte Bayard and Louis-Adolphe Humbert de Molard. The works were not made for sale, for this was prior to the establishment of a market for photographs through photographic associations and exhibitions. Yet once those structures were in place in the early 1850s, still life had a limited presence compared

with portraiture and landscape views. The traditional hierarchy of art subjects may have had an impact; in the ranking of tableaux, portraiture, figure studies and landscape, still life received the least notice in the exhibition halls and the press. Indeed, when exhibition reviews talked about photographs as artistic productions they focused on the most elaborate works. Rejlander's tableau, *The Two Ways of Life*, was often cited, even twelve years after its first showing in 1857 (fig. 78, pp. 110–11).

Still-life photographs are rarely found in the archives of artists.[7] Perhaps it was too easy to simply paint directly from the subject, which

Above, fig. 100
William Henry Fox Talbot, *Articles of Glass*, about 1844. Salted paper print, 19·1 × 23·9 cm. Wilson Centre for Photography.

Opposite, fig. 101
Adolphe Braun, *Bouquet with Hollyhocks (Étude de Fleurs)*, about 1857. Coated gold-toned salted paper print, 23·4 × 22·5 cm (corners rounded). Private collection courtesy of Hans P. Kraus Jr., New York.

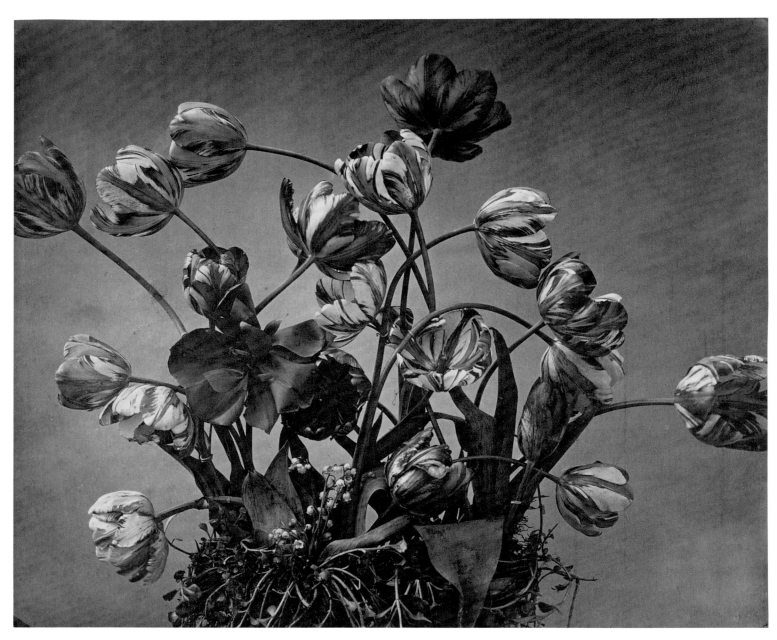

Fig. 102
Adolphe Braun, *Study of Tulips*, late 1860s. Carbon print, 36·9 × 44 cm. K & J Jacobson, UK.

would not change from one hour to the next (although the flowers would eventually wilt).

Unlike human models, still-life arrangements did not charge a fee, though there would be an initial outlay to the florist. Colour rendition was photography's main disadvantage. Not only were photographs monochrome, but they were also colour-blind, registering blues as bright white, greens as dark tones and reds as black shadows. What use was that to an artist? However, the monochrome gradations of flower studies could evoke colour, as explained in the press review of an Adolphe Braun still life very like *Bouquet with Hollyhocks* (fig. 101): 'In their gradation, running from white to dark brown, the rose seems to recover its cool incarnation, the digitalis is nuanced with purple, and the finely striated iris appears to have kept its tender blue'.[8]

ADOLPHE BRAUN'S FLOWER MOTIFS

Braun's picture is not a grand Dutch display of exotic blooms. His simple, informal composition of ordinary flowers resembles Fantin-Latour's *The Rosy Wealth of June*, but pre-dates the painting by almost thirty years. Braun's fine study was a motif for fabric and wallpaper, for his company provided designs to the textile mills at Dornach near Mulhouse, Alsace. He began to photograph flowers around 1853, collecting three hundred plates into six folios for *Fleurs photographiées* (*Flowers from Nature*) in 1855.[9] The works were exhibited at the 1855

Exposition Universelle in Paris, where they won a gold medal.

In this context, the lack of colour was not a disadvantage. Braun's photographs were made for industrial designers, whose china and textile patterns needed only schematic form. The colour palette would be chosen later to match commercial demand rather than strict naturalistic accuracy. The photographs were modern substitutes for the old Dutch line engravings traditionally used by designers, and it was important to represent the forms with precision and detail. However, the appearance of volume in the photographed objects required more effort to translate into line drawings, and the photographic studies were not especially successful.[10]

Braun's earliest photographs were gold-toned salted paper prints varnished to enhance the depth of the shadows. By the early 1860s, the firm was printing on albumen paper, but problems with fading led Braun to try a more permanent process called carbon printing.[11] Braun's carbon print of tulips is a beautiful example (fig. 102); a lush tangle of striped blooms sweeps across a plain background whose depth is suggested in a subtle modulation of tone from periphery to centre. Braun experimented with colour, varying the monochrome carbon tints to suit different subjects from flower studies to art reproductions.[12] In the late 1860s, he sold the large carbon prints as individual pictures in their own right, claiming that his market was 'people of sophistication'.[13]

Left, fig. 103
Balthasar van der Ast,
*Flowers in a Vase with Shells
and Insects*, about 1630. Oil
on oak, 47 × 36·8 cm. The
National Gallery, London.

142

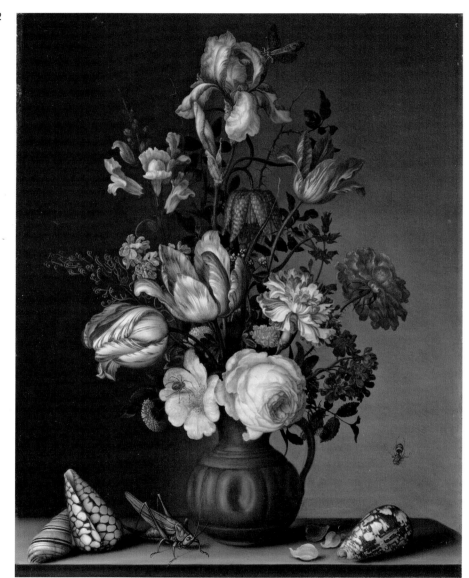

Braun's flower pictures became a sideline to his more profitable photographic art reproductions. Other photographic companies echoed this model. In admiring the art of nineteenth-century photographs, we often focus on works that were tangential to the real business of photography. For example, today the Paris publisher A. Calavas is best known for purveying photographic nudes by Louis Igout and others. However, his most reliable income came from designs for the decorative arts, not studies from life but photographic reproductions of Louis XV-era patterns for wall coverings.[14]

LIFE IS SHORT BUT ART IS LONG: *VANITAS* PICTURES

Braun's flower photographs are fine photographic prints whose present-day equivalent is found in the lustrous tones and surfaces of John Blakemore's work (fig. 104). Blakemore uses the nuances of photographic printmaking to communicate with the viewer, explaining that 'the tonal scale of the print parallels the musical scale, a print may be "played" pianissimo or fortissimo…[to] provide a first level of connotation to which a viewer responds prior to an investigation of content'.[15] Blakemore's selenium and gold-toned gelatin silver prints are conspicuously traditional in their craft, as virtuosic in their own medium as the Dutch still-life paintings that inspired them. But Blakemore replaces the voluminous perfection of Balthasar van der Ast's arrangement (fig. 103) with earthy, sexualised tulips that live (and die)

Opposite, fig. 104
John Blakemore, *Tulipa –
'The Generations' No. 14*,
1994. Selenium-toned gelatin
silver print, 39·7 × 29·5 cm.
John Blakemore.

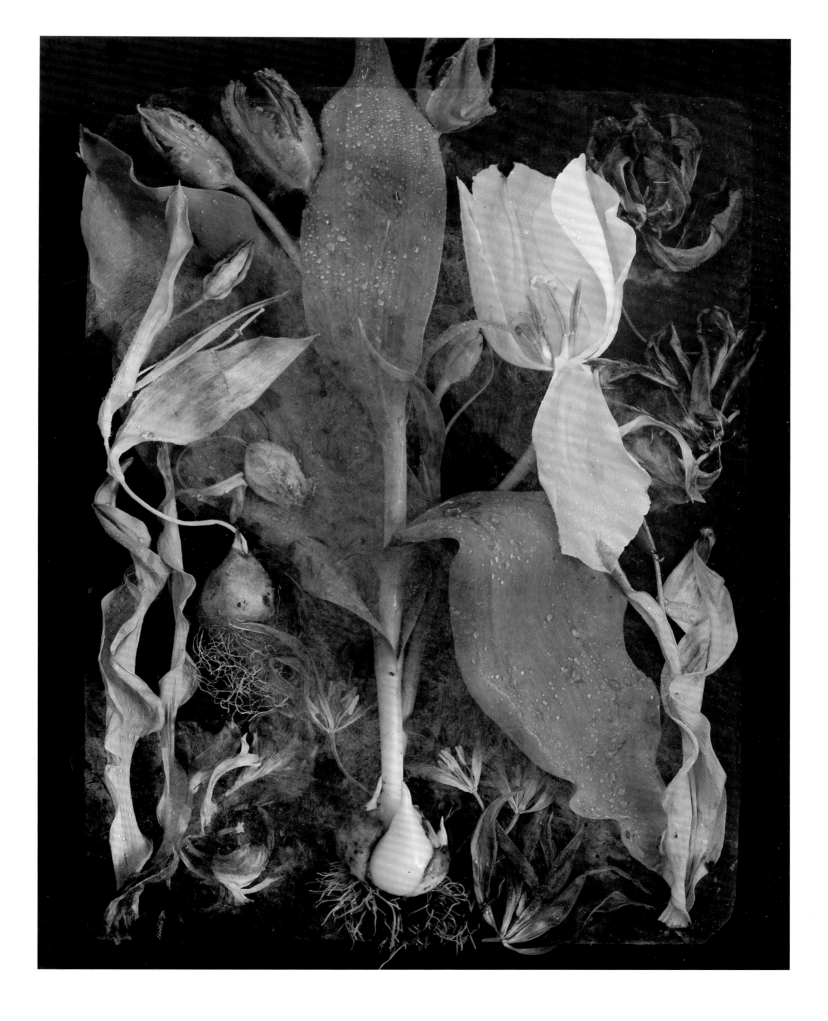

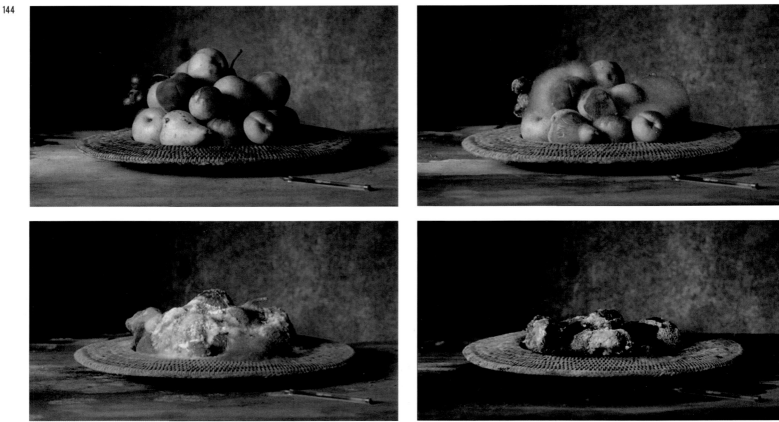

Opposite, fig. 105
Sam Taylor-Wood, Four stills from *Still life*, 2001. 35mm film/DVD; 3 minutes 44 seconds. Uziyel Collection.

Below, fig. 106
Michelangelo Merisi da Caravaggio, *The Supper at Emmaus* (detail), 1601. Oil and tempera on canvas, 141 × 196·2 cm. The National Gallery, London.

in flattened time and space. If *Tulipa* shows no illusionistic depth, this is not to say that the picture is a single layer; in fact, it is a multiple exposure, a composite of what Blakemore has described as 'processes of growth, of decay, of [the natural] cycle'.[16] These phases are part of the *vanitas* tradition, where beauty is short-lived and death is closing in. In Latin, *vanitas* means 'emptiness'; loosely translated, it corresponds to the transient nature and meaninglessness of material existence.

Still lifes appeal to each of our senses: sight, touch, taste, smell and even sound in the implied buzz of an insect. Such sensory splendours are fugitive, as are their emblems; flowers wilt and fruit rots, reminding us that our lives are as temporary. The ephemerality of life and its pleasures is the subject of Sam Taylor-Wood's *Still Life* (fig. 105), a silent, time-lapse film that compresses weeks of decomposition into a few minutes. The fruit shrivels to grey mould, while a pen lies to one side, a purposely banal substitute for the knife of a traditional still life, pointing to the queasy drama of the centrepiece.

Baroque painters such as Caravaggio inspired Taylor-Wood's careful chiaroscuro. She also echoes Caravaggio's interest in

146 the emergence of the extraordinary in the ordinary world. The still life at the centre of *The Supper at Emmaus* (fig. 106) is the axis around which the scene revolves, its pyramid of fruit crowned by the grapes, which make wine, a symbol of Christ's blood, as the bread stands in for his body.

Artists can create allegories in the simplest of subjects, for a seemingly straightforward depiction may communicate as much as an elaborate tableau. Nan Goldin's photograph recasts still-life conventions in a simple arrangement of grapes and other fruit on brown paper, among the folds of a plain chenille bedspread (fig. 107). This is not Caravaggio's revelatory scene; it is simply how it was in that hotel room in Paris.

Immediacy is key to Goldin's approach. Her work appears to be spontaneous, without stylistic embellishment, no more than a snapshot. She often shoots without focusing, looking for a transparency that works as a badge of honesty: 'If it were possible, I'd want no mechanism between me and the moment of photographing'.[17] Her insistent grip on the ephemeral instant belies the loss and death that seam her work. Why else photograph that bed, that fruit, except to memorialise it, to fix it in a still moment in the onward flow of time?

Caravaggio's supper is set in a simple inn, very like the taverns or rustic kitchens of Spanish *bodegón* pictures. Those austere still lifes had religious connotations; fidelity symbolised by lemons alongside the bread and wine of the Eucharist (fig. 108). Evelyn Hofer drew upon this art-historical precedent for her study of vegetables and fruit and a beautifully burnished Mexican vase (fig. 109). Like Meléndez, she asks us to notice the textures and the play of light and shadow, brought out in the high resolution of her large 5 × 4 inch negatives. The layered colours of the dye-transfer print give a painterly solidity to the shapes, while the process, with its extraordinary control of colour saturation, subtly mutes the palette.[18] Hofer also adopts Meléndez's low vantage point, which gives the objects a greater presence in the space and enhances our sense of their illusory realism.

PHOTOGRAPHS AS PICTURES

Hofer's photograph was part of an intensive project made in one year, late in her life. In this, it bears comparison with Roger Fenton's luscious study of fruit and flowers, part of a series of still lifes made at the end of his photographic career (fig. 110). Fenton took the photographs in the summer of 1860 and exhibited them just twice. Apart from the stereo views that he produced at the same time and published separately, this was his one public foray into the genre. Fenton gave up photography in 1861 for reasons that are unknown. But two events in the spring of 1860 may have undermined his spirit. His only son died aged fifteen months in April, and the same month brought the death of Marcus Sparling, his long-time assistant and Crimean compatriot.

Fig. 107
Nan Goldin, *My Bed, Hotel La Louisiane, Paris*, 1996. Cibachrome, 76·2 × 76·2 cm. Courtesy of Sprovieri Gallery, London.

Left, fig. 108
Luis Meléndez, *Still Life with Lemons and Oranges*, 1760s. Oil on canvas, 48 × 35·5 cm. The National Gallery, London.

Opposite, fig. 109
Evelyn Hofer, *Oaxaca Vase with Aubergine, New York [Still Life No. 2]*, 1997. Dye transfer print, 40·1 × 52·3 cm. Wilson Centre for Photography.

Fig. 110
Roger Fenton, *Still life with fruit, flowers, vase and putti*, 1860. Gold-toned albumen print, 27·8 × 29 cm. The Royal Photographic Society Collection at the National Media Museum, Bradford.

150 Were Fenton's still lifes *vanitas* pictures in memory of his little son and his photographic comrade? Plaster statuettes of putti appear in many of the arrangements; one holds an ear of corn, the other the shield of St George. Perhaps it is fanciful to imagine that these figures stand in for a harvest lost and a photographic and military campaign remembered.

A more prosaic motivation for the still lifes can be surmised. In 1859, Fenton had photographed a George Lance still-life painting and exhibited the result at the 1860 exhibition of the Photographic Society of London (fig. 112). Lance's work was popular; Fenton himself owned more than one Lance still life. Why not attempt the same subject matter with a camera?[19] Fenton's own still-life photographs were compared with Lance's paintings (fig. 111) in the *British Journal of Photography*: 'Mr. Roger Fenton…may now be regarded in the photographic world in the same light as Lance amongst painters….How delighted Lance would be with these!'[20]

In choosing and arranging the objects, Fenton had to anticipate the translation of the colours into monochrome. The results are superb: pale, satiny flower petals are beautifully offset by the deep lustre of the purple-black grapes, whose original colour is replicated in the heavily gold-toned albumen silver print. Yet Fenton's colourless flower studies were thought to compare badly with tinted engravings, as the *Stereoscopic Magazine* wrote in 1863, it was 'hopeless to

be able to apply the art [of photography]
to the purposes of botanical illustration'.[21]

Fenton made his large still lifes as
decorative pictures to hang on the wall.
The arched top of the print is a common
mode in mid-nineteenth-century photographs;
it quotes the high-art form of an altarpiece
and also serves to camouflage the vignetting
that resulted from inadequate lens coverage.[22]
He also made many of the still lifes in three
different sizes: big 16 × 20 inch exhibition
prints, 15 inch square prints for print dealers
and stereo cards for general sales (fig. 113).[23]
Each size demanded a different camera,[24]

and the variations in camera format and
lenses changed the framing of the still life,
from the powerfully concentrated composition
of the largest images, where the arrangement
filled ninety per cent of the image plane, to
the wide field of view seen in the stereos.[25]
Some of the stereo views even include the
edge of a brick wall, alerting us to the fact
that the still lifes were taken outdoors to
get the maximum light level (the summer
of 1860 seems to have been a particularly
dreary one).

Despite Fenton's efforts, this was not a
successful project. The large prints were

Opposite, fig. 111
George Lance, *Fruit ('The Autumn Gift')*, exhibited 1834. Oil on mahogany, 46 × 52·1 cm. Tate, London.

Right, fig. 112
Roger Fenton, *'Comus'. A Painting by George Lance*, 1859. Photographic art reproduction as albumen print, 20·9 × 42·3 cm. The Royal Photographic Society Collection at the National Media Museum, Bradford.

Below, fig. 113
Roger Fenton, *Flowers and Fruit. A Study*, 1860. Two albumen prints as stereo view mounted on card, 8·4 × 17·4 cm. K & J Jacobson, UK.

expensive, for they were priced according to the cost of production.[26] The sole recorded sale was to Queen Victoria and Prince Albert, who bought two 'studies from life' from Fenton not long after the still lifes were made.[27] He may have hoped that the stereoscopic versions would be more profitable; in the 1850s, stereo cards were relatively pricey, though oversupply meant that prices were dropping. Fenton had already made

stereos as a populist sideline to his full-size landscape views and British Museum studies, while Adolphe Braun published flower studies as stereo cards. However, given the vast numbers of stereo views on the market at this time, Fenton's still lifes could not compete with more sensational subjects (though some of the fleshy fruits carry a distinctly erotic charge).

EXPANDING THE FIELD OF VIEW

The best stereographic still lifes can show a vivid three-dimensionality that replicates the painstaking trompe l'oeil of traditional painted still life. But in Fenton's time, stereographs were not respected as pictures; the Photographic Society's exhibitions relegated stereos to a separate display area among tourist views, novelties and narrative entertainments like 'sentimentals'. The stereoscopic illusion of depth was considered too close to reality to be aesthetically gratifying. Serious photographers adopted from painting the idea that good picture making translated three-dimensional space into a two-dimensional representation; many deemed stereo photography a betrayal of this tradition and its practitioners charlatans.

Contemporary practitioners can disregard the conventions of pictorial practice and simply revel in the opportunity to expand visual experience. Sarah Jones's diptych *The Rose Gardens* (figs 115 and 116) reproduces a three-dimensional view in flat planes side by side; we see the front and back of the roses at the same time. The two exposures were made by electronic flashlight, which picked out the flowers but did not reach into the background, turning it – and the daylight scene – into the black of night. The isolating darkness echoes seventeenth-century Dutch flower studies such as Rachel Ruysch's *Flowers in a Vase*, whose dark background concentrates the viewer's attention on the painted forms (fig. 114). Jones's edgy roses, held by the flash exposure, suggest the tension between photography's

stubborn correlation with the material world and its power to transform our perceptions of reality.

Still-life pictures begin with the simple premise of an arrangement of inanimate objects. At this level, their purpose is straightforward: to be a seductive illusion that shows off the artist's skill and the splendours of nature. But there is another level, for we read the objects as symbols, standing in for war, religion, sex and death. Through still life, artists can deliver a double-edged message: there is beauty in the world, but it is fugitive. Pleasure is accompanied by inevitable loss, for life is often less permanent than a painting or photograph.

STUDIES OF TIME AND BEAUTY: STILL-LIFE PHOTOGRAPHY

158 **CR** *Flower painting is an old tradition, rich in associative meanings about life and death. What brought you to still lifes as a photographer?* There were a number of different reasons or influences. When I did a residency at the Norwich Castle Museum, I was looking at the landscape pictures, and then read the wall labels about some beautiful still-life paintings by female artists in the mid-1800s. One label said it wasn't socially acceptable for women to paint *en plein air*, to be seen outside with their palettes like male artists. So, in effect, they brought the outside in. Because of my previous work exploring the relationship between the outside and the inside, and still life and portraits – the blurring of the genres – I was thinking about taking the studio outside. I wanted to take a very ordinary and familiar landscape, such as a municipal park, and turn it into a still life. I started to take my studio flashlights outside, to light only the roses and in doing that I wanted to allude to both the night and to the studio (although these photographs weren't shot at night, they were shot in the day). I wanted to use the conventions of the studio still life and look at the rose garden in that way. I was interested in where landscape becomes still life.

The Rose Gardens [figs 115 and 116] also adopts the traditions or conventions of a diptych. When I was the Photography Fellow at the National Media Museum, Bradford, I was looking at the nineteenth-century stereographic photographs in their archive. I was struck by how when you look at those photographs as two separate prints, rather than through a stereographic viewer, you see that tiny shift between the left and right, like the difference between seeing through the left and right eye. There's a very small slippage. It suggested a slight falling away or extension of time. My diptychs are done in response to that. They also kind of swivel around the subject, to attempt to fully describe it. I was thinking about what early photographers were interested in, how they tried to replicate an experience of the real, to re-create the three-dimensional. Perhaps it's like the return of 3-D viewing glasses in cinemas now. I began to think there was also a possibility of an imagined third space, an imagined moving around an object…as though when viewing the diptych you are in two places at the same

time – both in front of and behind the roses. And it is perhaps perverse to see the back of something that's on display.

CR *Another largely nineteenth-century tradition is pressed flowers. The black background in your work gives something of that effect.* I love that, and it happened purely by chance. It was only really in looking back at the work that I suddenly saw it reminded me of pressed flowers on a page. As with the Dutch still lifes in the National Gallery, for example, there is a flattening of space and depth in my rose gardens work. The roses appear to be both pushed into and emerging from a photographic inky black background, an effect of the way they are lit.

Looking at the Dutch still lifes we might say that they are painted in an almost photographic manner, in what we now might think of as a hyper-real way, a close attention to detail and 'the studio set-up', too. Having come initially from a painting background, I remember my art teacher saying: 'Photographs are always so flat – they can never describe the world in the way a painting can'. That's always stuck with me, and I've often thought that the perceived limitations of the medium are very interesting. I ask myself what can you do with photography? You know there are slices of the moment of time, of depth. I use studio lights outdoors, artificial light mixed with the natural, and a frontality when photographing, to emphasise a way of seeing and experiencing particular to the camera. I'm recalling also the concerns of Renaissance painters, who have been a big influence on my practice: the use of mathematics, the reduced space seen in their paintings and also how they first described distance with the colour blue, for example.

I photograph in a really plain way. When I was studying, the idea of an interesting composition, or that the camera might be at an interesting angle, or there might be a very theatrical light – these were all ideas I went through very early on. And the thing that really interested me was the surface, the plane, I guess the photograph as an object itself. That was a preoccupation when I was doing my MA: the relationship of the subject to how we experience the physical photograph.

CR *In works like* The Drawing Studio (I) *[fig. 11, p. 25], you use only a few colours and get very close to something like Minimalism.* Rothko was an early influence and also what was going on in dance – I was interested in a stripping back to small gestures. The cloth reminded me of paintings by Delacroix and Ingres. But I think this particularly came out of photographing a space such as a psychoanalyst's consulting room – the couch is an ongoing subject in my work. Not wanting to fill up the image with any narratives outside of what already exists there.

HK *I'm struck by your comment about stripping things back to the very smallest of gestures.* I remember being told that the best technician is the dancer in whom you can't see the technique, where it looks effortless and you are not aware of the work going into the performance. I just try to set up very straightforwardly. It is only recently that I have realised how much studying dance has informed me. I did Fine Art and Contemporary Dance as a first degree and saw a lot of contemporary dance and still do. When I was training there was an interest in staging, a pulling back so that you could see the lights, so that you could see the machine of the theatre working.

HK *It is interesting that you consistently use analogue technology: Polaroids for your reference images, a camera with photographic film and C-type paper.* There is some digital work. I use a small digital camera to make reference photographs, like sketching. I used to go through a more elaborate process of printing my own proofs, going to the lab and having the negatives scanned, and then I'd present the 12 × 16 inch C-type to the person I worked on-screen with and say 'Can you match that?' And it was just a mad way of working. But it's good, it's about learning a different language and it has influenced my work in a way, which is why I wanted to do it, with the threat of the disappearance of film. I've recently started working on a 10 × 8 inch camera, alongside my usual 5 × 4 inch format – and I'm planning to combine this with a return to the darkroom in some way.

CR *You're very interested in the space of your photographs.* Yes – in how space is articulated in the photograph. I'm really interested in the way that, as with the roses, there is a sense of the subject being pushed right up towards you, that idea of everything almost sitting on the surface. So the viewer's experience of it – it's almost in your world, it's in your viewing experience….In many of my photographs there's an appropriation of life size, a one-to-one scale. The hanging height in the gallery [recalls] how the subject might have been originally experienced. And the width, how much you can get into your peripheral vision.

CR *Do you work quickly or slowly?* Slowly, I'm quite a slow worker. But then once I'm in a location, all of that [planning] falls into place relatively quickly, if all goes to plan. But then I do a lot of looking once I've got the negative. The printing process is central; getting the proportions and scale right and the tone and quality of the print are really important.

CR *What role does beauty play in your work?* I'm all for it. I'm interested in a kind of collision between something that appears to be quite stripped back and something that suggests the idea of pleasure and beauty – as an experience and also as a form or as a convention. With the still lifes, I'm interested in the idea of something being at once beautiful and also the reverse: there's the flower, but there is also the diseased leaf that suggests the classical idea of mortality.

WILD POETRY SEASCAPES AND LANDSCAPES

Of all artistic subjects, the landscape presents a perfect compass of photography's attributes. The 'mirror of nature' shows us reality in all its glory, and through its pictures we can stop and applaud the ephemeral beauties of the world. In 1872, the painter, photographer and journalist William James Stillman argued that landscape brought photography closest to art:

> I believe that it will be generally decided by the artistic world that the proper artistic side of photography is not the emulation of painting, but the record of facts, subject to the qualities of beauty which are contained in fortunate natural combinations of scenery, exquisite gradation, and effects of sun and shade, in what we may call the affidavits of nature to the facts on which art is based.[1]

Such photographs were celebrated as pure, unmediated visions of the world, uncorrupted by art's calcified formulae. In 1863, the landscape photographer Lyndon Smith proclaimed the genre as a purgative to the 'effete and exploded "High Art," and "Classic" systems of Sir Joshua Reynolds...and...the cold, heartless, infidel works of pagan Greece and Rome'.[2] Here was a modern technology of drawing with light, as the *Photographic Journal* described it: 'This clear-sighted, deep-seeing, sure-handed, steam-power spirit of the sun'.[3] A brave new world, indeed.

Fig. 117
Richard Billingham, *Storm at Sea*, 2002, from the series 'Landscapes'. LightJet print mounted on aluminium, 111 × 130·5 cm (framed). Courtesy Anthony Reynolds Gallery, London.

Fig. 118
Gustave Le Gray, *Seascape,*
The Steamer (*Marine,*
Le Vapeur), about 1856.
Gold-toned albumen print,
30·4 × 40·7 cm. Gregg
Wilson, Wilson Centre for
Photography.

164 SEASCAPES

Richard Billingham's *Storm at Sea* (fig. 117)
is all atmosphere: layers of cloud, grey-violet
and pale cerulean blue, over a ribbon of
bright air and a night-blue sea striped with
long lines of waves. Time seems suspended
in diffused vapour. This palpable aerial effect
is reminiscent of photographs made almost
150 years earlier. In the winter of 1856 to
1857, Gustave Le Gray exhibited a number
of seascape photographs in London and Paris.
They stood out for their size and spectacular
phenomena, each one a *tour de force* of
resplendent clouds or glittering light on water,
captured almost instantaneously (fig. 118).[4]
More seascapes followed, as did the praise of
such 'marvels of clouds and sea, in which there
is so much of wild poetry perceptible'.[5]

Le Gray's British audience was already
sensitive to art that displayed nature's
drama, as an 1857 review of his photographs
explained:

> The sentiment of landscape scenery lies in
> the sky and distances, and in atmospheric
> effects. Those who doubt this may work
> for another season at the old class of
> subjects ['field gates, stiff trees, and stuck-
> up country mansions'], but they will find,
> unless we are very much mistaken, that
> the public have read Ruskin, and studied
> Turner to advantage.[6]

Later that year, a photographic review
compared Le Gray's work with a Turner

Fig. 119
François Bocion, *Steamer on
Lake Geneva: Evening Effect*,
1863. Oil on canvas, 33·6 ×
75·5 cm. Victoria and Albert
Museum, London.

painting known as the 'Egremont Marine': 'this last and others by the same artist are to some extent successfully imitated, unintentionally no doubt, by Mr. Le Gray in his sea and cloud pictures'.[7]

Eleven years on, poet and art collector Chauncy Hare Townshend bequeathed a large number of drawings, paintings and photographs to the South Kensington Museum. Among the portfolios of watercolours, etchings and engravings were thirteen Le Gray seascapes, along with three landscape views.[8] The bequest included a seascape painted by François Bocion, a Swiss artist whom Townshend had known for some years.[9] Bocion's *Steamer on Lake Geneva: Evening Effect* (fig. 119) is a fine observation of twilight in keeping with work by Jean-Baptiste-Camille Corot, whose influence Bocion acknowledged. The title, too, was indebted to Corot, in whose paintings the term 'effect' designated a time of day.

The Bocion work bears a significant resemblance to Le Gray's seascape of a steamer, *Seascape, The Steamer* (*Marine, Le Vapeur*, fig. 118), a print of which was included in Townshend's bequest.[10] The proportions and composition are uncannily similar. Another comparison can be made in Eadweard Muybridge's 1868 stereo view of San Francisco Bay (fig. 120). In all three images, the boats are mere silhouettes, dramatically outlined against a great expanse of water and air, while the plume of smoke conveys a sense of immediacy. Muybridge's title, *Moonlight Effect*, echoes Bocion, and while there is no known connection between these practitioners, the works are part of a wider interest in landscape subjects as evocations of mood. Muybridge was in London in 1862, when photographs of sky and water were shown at the International Exhibition as pictures in their own right rather than as the backgrounds in narrative subjects.

Fig. 120
Eadweard Muybridge, *No. 328. Moonlight Effect. Steamer El Capitan. San Francisco*, 1868. Two gold-toned albumen prints as stereo view mounted on card, 8·7 × 17·6 cm. Published by Bradley and Rulofson, San Francisco. Wilson Centre for Photography.

328—Moonlight effect, Steamer El Capitan.

Muybridge's best-known landscapes are the large and dramatic photographs of the wild western United States, but *Moonlight Effect* is one of a series of experimental views around the Bay.[11] A number of these were thus titled, and, like the *El Capitan* picture, were actually underexposed daylight scenes printed very dark to look like night. Le Gray employed the same technique a decade earlier, printing *The Steamer* darker and using heavy gold toning to increase the density and contrast. Fellow photographers like Thomas Sutton found fault with this approach, arguing that it falsified the reality of the original scene.[12]

A real landscape has a wide range of luminance from bright sky to dark ground. The sky has a high level of actinic light, which, in an early blue-sensitive photograph, will be fully exposed before the rest of the scene, obliterating details such as clouds.[13] If the exposure was shortened, the clouds would register but everything else would be underexposed. In either case, a portion of the tonal range would be lost. The best result came from a seascape, where, as Elizabeth Eastlake observed, 'the sea…from the liquid nature of its surface, receives so much light as to admit of simultaneous representation with the sky above it'.[14] In principle, Le Gray and Muybridge could simultaneously expose both sky and sea, and this seems to have been the case with *The Steamer*. Muybridge sometimes used a 'sky shade' on his camera, which masked out the sky during the exposure, allowing the foreground to catch up.

Like Muybridge, Le Gray used innovative techniques to photograph transitory effects. *The Great Wave, Sète* (*La Grande Vague, Sète*, fig. 121) has the energy of a painted sketch at a time when artists like Norwegian painter Peder Balke used rapid brushwork to summarise a volatile sea and sky (fig. 122). Balke's execution perfectly captures the dynamic sweep of the storm. It was not instantaneous, but neither was Le Gray's photograph.

The Great Wave displays a remarkable immediacy. Today's exposures of a fraction of a second would have to be slowed down at least 125 times to equal the fastest plate of the late 1850s. Yet the waves in Le Gray's image were apparently exposed in a twentieth of a second, an interval too brief to be accomplished by the ordinary procedure of removing the camera's lens cap.[15] Instead, Le Gray would have used a primitive shutter, most likely a perforated sliding lens cap.[16]

In any event, Le Gray did not capture *The Great Wave* in a single shot. He added the clouds from a different negative and the immediate foreground from yet another, making this a combination print like Rejlander's *The Two Ways of Life* (fig. 78, pp. 110–11). As with Rejlander's composite, critics felt that Le Gray had contravened photography's much-lauded truthfulness in the pursuit of fame and profit. Writing for *The Art-Journal* in 1858, photographer Robert Hunt suggested that Le Gray was chasing sales at a cost to photographic art,

Opposite, fig. 121
Gustave Le Gray, *The Great Wave, Sète* (*La Grande Vague, Sète*), about 1856–59. Gold-toned albumen print, 33·5 × 42 cm. Gregg Wilson, Wilson Centre for Photography.

Right, fig. 122
Peder Balke, *The Tempest*, about 1862. Oil on wood, 12 × 16·5 cm. The National Gallery, London.

Fig. 123
Achille-Etna Michallon,
A Tree, about 1816. Oil on
paper, 30·5 × 24 cm. The
Gere Collection, on long-term
loan to the National Gallery.

172 for his spectacular pictures, 'which have excited attention in the windows of the dealers in London', were manipulated: 'the effects, beautiful though they be, are the reverse of the truth'.[17] Nevertheless, Le Gray's seascapes were appreciated as 'pictures' and sold as such, for the market for photographs was booming, aided by public exhibitions like the annual shows of the Photographic Society of London and Paris's Société française de photographie, where many works were for sale.[18]

LANDSCAPE: FONTAINEBLEAU AND BEYOND

Le Gray's impressive seascapes were made for the exhibition halls. But there was a taste for more modest views of nature. In reviewing the 1856 exhibition of the Photographic Society of London, the *Athenaeum* singled out the 'stem of an elm-tree' as 'the most exquisite bit in the whole Exhibition':

> Where the sun falls on the tree…it is wood glorified. You see every fibre and line and wrinkle of that tree's hide, and its coat-of-mail bark, knotted and squared. It is better than common nature, because it is a small surface of nature seen in a poetical and mysterious moment.[19]

In 1849, Le Gray made his first photographs in the forest of Fontainebleau, an old, largely unspoiled royal hunting ground just over an hour by train from Paris. The Knotty Oak was a well-known specimen (fig. 124), for the oaks of Fontainebleau were famous and guidebooks identified them by name. The forest was busy with tourists and painters, its paths well marked and its notable trees named, signposted and sometimes pruned to a more aesthetic shape.

Le Gray's photographs plot the rough rocky outcrops and unkempt foliage that are familiar from French painting of the time, and when he later exhibited forest views at the Société française de photographie, a review applauded one work as if 'painted by Diaz in one of his greatest moments'.[20] The comparison is with Narcisse-Virgilio Diaz de la Peña, one of the great painters of the Barbizon School, a group who made Fontainebleau their territory from the early 1830s until the middle of that century. These artists' emphasis on the direct observation of nature was a paradigm for photographers like Le Gray and his colleagues Charles Nègre and John Beasly Greene.

Photography's early years paralleled a shift in art, away from the studio and its conventions and towards the inspirations of the natural world. A number of the Barbizon painters had studied with Achille-Etna Michallon, who encouraged his students to paint *en plein air*, in the open air, directly in front of the subject. This approach was not as easy as it might seem: light changed, weather intervened and the temptation was to make a few sketches and repair to the studio. The practical difficulties of painting out-of-doors encouraged artists' studies, and here photography played a useful role. In 1857, the *Photographic Journal* presented photography

as an aide-memoire: 'a real extension of the powers of art...invaluable to the landscape painter, who has for some centuries sighed as the lovely "Cynthia of the minute" has melted from his raptured gaze'.[21]

Like Michallon's tree study (fig. 123), some of the photographic landscapes that are now collected as works of art were originally produced as artists' studies.[22] There was even confusion in Le Gray's own time: when, in 1850, he submitted nine photographs (including two views of Fontainebleau) to the Salon of the Académie des Beaux-Arts, the jury rejected them, unable to decide whether they were classified as original works of art or as reference prints like lithographs.[23] There might have been a visual comparison, for Le Gray's early forest views were exposed on paper negatives, whose rugged delineation resembles lithographs. Le Gray later used glass plate negatives for his seascapes; they produced a faster exposure, with better resolution and a more nuanced tonal range.[24] But many Fontainebleau photographers preferred the broad, tonal 'breadth of effect' produced by paper negatives, which were also more practicable for photographing in the field.[25]

We know that a painted landscape is a confection, though we may long to believe that the real scene was just like that. With a photograph, we know – or think we know – that the camera registers exactly what is in front of the lens, and so it was just like that. But, of course, it is not that simple, because the photographer makes many choices: to point the camera in this direction or that one, to frame the view tightly or broadly, to choose this moment of exposure or another one, when the light is this way or that way. As photographer Jabez Hughes explained in 1861, 'the artist may select the period of the year, the condition of the weather, time of day, point of sight, length of exposure, &c, as material agencies in modifying his picture'.[26]

In *Knotty Oak near the Carrefour de l'Epine*, Le Gray selected the portion of a view that

gave him a composition, and what he framed is extraordinary: a strong tree trunk with a perpendicular branch, mirrored by the dark silhouette of its twin (fig. 124). This radical use of negative and positive forms suggests that Le Gray understood how to abstract a recognisable view into graphic shapes. He was helped by his large view camera, which showed the image inverted on the ground-glass screen (unlike in modern single-lens reflex cameras, there was no integral mirror to flip the view). Upside down, the world is perceived as an arrangement of forms.

IDYLLS AND ELEGIES

Like Le Gray, Jem Southam works with a view camera. It is striking how often contemporary landscape photographers use the old camera designs, finding, under the dark cloth, a way of isolating themselves from their surroundings.[27] It is easier to frame a picture in this interior world. By comparison, with small modern cameras, the photographer can be distracted by peripheral vision.[28]

Southam's large camera produces large negatives, from which he makes contact prints, as did Le Gray. Their photographs show a pictorial concentration, a density of leaves and light that almost crackles. Southam's delicate filigree of branches and twigs weaves among leaves of different hues, impossible for Le Gray, working in monochrome and with the limited colour sensitivity of nineteenth-century materials. Le Gray's woodland view shows the

Fig. 124
Gustave Le Gray, *Knotty Oak near the Carrefour de l'Epine (Forêt de Fontainebleau)*, about 1853. Albumen print, 24·5 × 36·4 cm. Wilson Centre for Photography.

Figs 125–28
Jem Southam, *The Painter's Pool*, 2002–04. Left, *9 January 2003*; below, *28 May 2003*; opposite, above, *9 November 2003*; opposite, below, *4 January 2004*. Four chromogenic dye coupler contact prints, 18·5 × 24 cm (each). Jem Southam, courtesy James Hyman Photography, London.

Fig. 129
Ori Gersht, *Ghost: Olive 7*, 2004. C-type print mounted on aluminium, 100 × 80 × 4 cm. Mummery + Schnelle, London.

problem of using photographic materials that cannot distinguish between greens and browns. The leaves and bark mass together in a complex distribution of shadows, among which we struggle to find a coherent composition. As Elizabeth Eastlake explained in 1857:

> The colour green, both in grass and foliage, is now [the photographer's] greatest difficulty. The finest lawn turns out but a gloomy funeral-pall in his hands; his trees, if done with the slower paper process, are black…missing all the breadth and gradations of nature.[29]

Southam made *The Painter's Pool* photographs (figs 125–28) in an ancient woodland near Exeter, for more than twenty years the artistic landscape of the painter Mike Garton. Southam explains that 'the series of pictures grew initially from an attempt to see how the photographic medium might be used to deal with a similar set of concerns to those he had pursued through painting'. As the painter's health declined, the elements changed:

> In the early pictures signs of his presence – an easel, wooden poles, bent twigs and bits of string – appear. Gradually as time went on and he was no longer able to work, these collapsed and disappeared into the fabric of the woods.[30]

In Southam's project, the painter's implied presence makes the work a kind of memorial – in the shift of seasons and the disappearing traces of his artist's tools. And while Southam keeps very close to the script of material reality, there is a narrative, developed through the series of photographs. In nineteenth-century landscape pictures, pictorial 'effect' alone, without an overarching story, was an artistic innovation. But contemporary photographers like Ori Gersht have reintroduced an allegorical or moral imperative to landscape. *Ghost: Olive 7* (fig. 129) pictures a 500-year-old olive tree in a Palestinian village in Galilee, now Israel. As Gersht says, 'olive trees are symbols of contested territories' in Palestine and Israel.[31]

Gersht's olive tree is not realistic. As signalled by the title, it is a ghost of a tree, faded and deteriorated. The image is under attack from the forces that made it, for Gersht overexposed the image in bright sunlight, so that the exposure ate away at the photosensitive emulsion, eroding the outlines between light and dark forms. This is a kind of halation, an effect well known in the nineteenth century and of interest to photographers and painters.[32] It is especially attractive in pictures of trees, for the encroachment of light in dark foliage produces a beautiful translucence in the dark edges of leaves and branches, frilled like lace against the bright sky. John Ruskin warned against the effect, writing a useful summary of the mechanics:

The brightness of the sky will dazzle and perplex your sight. And this brightness causes…some loss of the outline itself; at least the chemical action of the light in a photograph extends within the edges of the leaves, and…eats them away, so that no tree extremity, stand it ever so still, nor any other form coming against the bright sky, is truly drawn by a photograph; and if you once succeed in drawing a few sprays rightly, you will find the result much more lovely and interesting than any photograph can be.[35]

Gersht originally interpreted the blazing exposure as a kind of violence against the photographic image. Yet he found in printing the series that the photographs were surprisingly frail, delicately lovely. Gersht reproduces other visual characteristics of early photography: slow exposure speeds blur the moving leaves and colour shifts mimic the oxidation of an old silver photograph. The photograph's appearance implies that the image comes from long ago, like the olive tree and the historical struggle for land. This re-created photographic past connects with Gersht's realisation, as a child in Israel, that 'the present is already doomed, yet one still has a great need to hold on to it'.[34]

Another elegy for the past is implied in Roger Fenton's *Paradise, View down the Hodder, Stonyhurst* (fig. 130). It was among Fenton's last landscapes in this favourite haunt near Stonyhurst College, Lancashire, and the adjacent riverside property owned by his family.[35] The work was made in the course of producing a series of stereo views – *Stonyhurst College & Its Environs* – published in 1860.[36]

Fenton shoots *contre-jour*, against the light. The leafy branches arching overhead show halation, their dappled forms framing the view. Aerial perspective gives the more distant foliage a lighter tone than that of the middle ground, while the foreground tree is a dark silhouette and so too the young boy against the lambent water. This tonal gradation helps to differentiate the green foliage, which the blue-sensitive photographic plate would otherwise represent as a largely undifferentiated dark mass. Fenton's pictorial elements are also seen in landscape painting: a simple viewpoint and a composition based on a point of convergence, enhanced by a harmonious gradation of tones and emphasised by a dark foreground. The scene is encircled by foliage to give a sense of completeness, so that the viewer has no unsatisfied curiosity about what lies beyond the picture frame. The boy takes our place as the spectator, embodying a subjective, contemplative experience in the Romantic landscape tradition of Caspar David Friedrich. There may be a spiritual aspect to this view, in the sense of God being revealed in the natural world. Certainly, one of Fenton's admirers insisted that 'truthfulness' was not only found in accurate representation but in 'that grand and mighty quality which depicts the perfect whole – the spiritual as well as the material aspects of nature'.[37]

Fig. 130
Roger Fenton, *Paradise, View down the Hodder, Stonyhurst*, 1859. Gold-toned albumen print, 28 × 28·2 cm. Wilson Centre for Photography.

Fig. 131
John Constable, *The Cornfield*, 1826. Oil on canvas, 143 × 122 cm. The National Gallery, London.

Fig. 132
Richard Billingham,
Hedgerow (New Forest),
2003. LightJet print
mounted on aluminium,
122 × 155 cm. Southampton
City Art Gallery, Southampton.

Whether as paintings or photographs, nineteenth-century landscapes were a refuge from modern life. In 1868, French art critic Ernest Chesneau called landscape painting, 'a place of asylum, apart from the devouring activity, the continuous fever of the city'.[38] Contemporary landscape can fulfil a similar role. Richard Billingham searched for a timeless idyll in the landscapes of southern England: a farmer's field and a golf course resurrected John Constable's painting *The Cornfield* (figs 131 and 132). A banal scene is transformed by the beauty of dark foliage framing the bright distant view, approached by a serpentine path that echoes the road in Constable's painting.

In the nineteenth century, landscape photography united aesthetic and realist aims, glorying in the natural world and the camera's ability to capture it. But over the intervening century and a half and, most particularly since the 1970s, those old celebrations of nature have been called into question. Landscape does not connote freedom; it is property and power, bought and sold to the advantage of some and the detriment of others (though this was also true in the nineteenth century). To that is added a postmodern suspicion of beauty as a superficial blandishment to the viewer. We are blasé; the camera's ability to capture material splendours is no longer a cause for wonderment, and with the advent of digital technology, we are more likely to mistrust photography's claim to objectivity.

CONSTRUCTED LANDSCAPES

Beate Gütschow's photographs are a complicated amalgam of old and new versions of landscape. She builds them as digital files from references that include Nicolas Poussin (fig. 134), Claude Lorrain, Jacob van Ruisdael and Thomas Gainsborough:

> Two-hundred-year-old landscape paintings are not interesting to me.... But to take something normally found in painting and transfer it to photography, that's what interests me. The landscape is just the door I use to enter the idea of perception.[39]

LS#13 (fig. 133) is made up of many negatives, carefully replicating the elements that form a landscape: a foreground through which the viewer enters the picture space, which is peopled in the middle ground and bounded by trees. Those details are drawn from man-made parks, industrial sites and urban places. And the people in the landscapes are not the mythological characters of the seventeenth century, nor the Arcadian shepherds of the eighteenth century, but ordinary people, unposed, photographed with a zoom lens and without permission. There is an edgy tension between the modern details and their composition into an aestheticised landscape. The images show a stubborn lyricism that confounds the flat twenty-first-century banality of the raw material.

Fig. 133
Beate Gütschow, *LS#13*, 2001. C-type print, 108 × 85 cm. Eric and Louise Franck Collection, London.

The subject matter may refer to painted predecessors, but the final prints proclaim their photographic origins; laboratory data is printed along the margins, with production notes on size and image resolution, along with the crop marks for a neat framing they will never have. This undermines the perfection of the seamless digital composite within the margins. But for all this technical sophistication, as Gütschow says, the medium is almost incidental: 'I define myself as an artist who happens to use photography'.[40]

Fig. 134
Nicolas Poussin, *Landscape with Travellers Resting*, about 1638–39. Oil on canvas, 63 × 77·8 cm. The National Gallery, London.

CODA: GOETHE AND LANDSCAPE

Tacita Dean's *Fernweh* (fig. 135) is also a composite, created from four nineteenth-century postcards woven into an eight-panel photogravure: 'an improbable landscape made of cliffs, forest and dunes'.[41] But it is not a digital production; Dean is a forceful champion for analogue photography and film, and she works in the old way, photographing the original postcards, then enlarging, rephotographing and retouching to make the final images, which are printed as photogravures. Photogravure is a photomechanical process appreciated by nineteenth-century art photographers for its resemblance to aquatint in the random grain structure of its subtle tones. Like her historical predecessors, Dean values gravure's capacity for intervention on the part of the practitioner – working directly on the printing plate makes this less of a mechanical process and more susceptible to the artist's hand. In *Fernweh*, she amplified that effect by inscribing words from Goethe's *Italian Journey* of 1786–87.

While the original postcards showed an area of Saxony near Dresden, Dean imagined the topography south of Rome, as Goethe described it:

> When, from the heights, we caught sight of the mountains of Sezza, the Pontine marshes, the sea, and the islands, in that very moment a heavy squall was moving across the marshes toward the sea, and light and shadow, alternating quickly, enlivened that desolate area quite diversely.[42]

Fernweh resonates with Goethe's pilgrimage to Italy, where he lived incognito for almost two years. As Dean explains:

> 'Fernweh' is discontinued parlance for a longing to travel, an aching to get away. Different, I imagine, from 'Wanderlust', which is a more spirited desire to be in the landscape.... We do not have a single word in English for this more considered desire to be gone. This work should be approached through its title.[43]

Just as Dean came to the work through Goethe, she encourages us to do the same. This is part of her recognition that our engagement with nature is shaped by interpretation and imagination: 'Even those places that remain unaltered by humankind, areas of pristine wilderness, have become the crowded habitat of our cultural minds, from writers and poets to artists'.[44]

The same applies to the photographs of landscape. They should be simple things, direct and objective depictions of the material world. But they never are: being human, we are always adding – allegories, histories, memories, emotions and spiritual insights. Landscape and its representations fulfil more than an aesthetic impulse; they are nostalgia, escape and divine inspiration.

Fig. 135
Tacita Dean, *Fernweh*, 2009.
Photogravure in eight parts
on Somerset 400g paper,
228 × 500 cm. Collection of
Contemporary Art Fundación
"la Caixa".

CR *You began as a painter. How did you effect the transition from painting to photography?* When I did a foundation course before my degree, I was able to paint all the time. At that point, I was living in a tower block with my dad. I thought I'd like to make some paintings just about him and his room. I looked at other painters who did figures in interiors, like Sickert and the British Post-Impressionists, and did 20 or 30 paintings. I wanted to make more detailed paintings but I couldn't get Dad to sit still long enough. Ten minutes was about it and he wanted to fidget, have a drink.

I got a camera – I won't say how – but I got it and started taking photographs. They were set up at first, so I could paint from them later. I didn't value these photographs at the time. They were just to paint from. I thought if I take a photograph like this and one like this, then maybe I can construct a painting. So that's how the photographs began. Now, I would have been maybe 19 or 20 at that point. Up until that time, and for maybe another four years after that, I didn't look at the work of any other photographer, just painters who worked with photography, like David Hockney or Degas, but only in the way they'd used photographs like I was using them, as source material.

When I finished my foundation course I went to Sunderland University. That's when I started to paint landscape, but I wasn't any good at it! I couldn't find my own style I guess. I was always looking through the eyes of another painter, I couldn't see it fresh, whereas, when I was using the camera, I didn't look at the work of any other photographer, so I could be honest with the camera. I'd no idea of the power that photographs could have. I thought the camera was just a tool or something. And the strength of that early photography is in the innocence.

CR *What strikes me about your landscape and seascape photography is its great simplicity.* Yeah, clarity I guess. It's the viewpoint. You've got to get in the best position that gives the best summary of that landscape, when everything just looks right. It depends on the clouds and the weather as well. It's the way everything is situated in space. I don't actually see it, I feel it: a sense of balance in the weight of things.

The seascape, *Storm at Sea* [fig. 117, pp. 162–63] was taken in Ireland on the Cliffs of Moher. It was a very windy day. I mean I had to hold on to something to take it. It looks quite calm [but] I saw people being blown across the grass.

When I got the picture back from the chemist, it didn't have any of those colours in, but because the composition was right I kept it. Then when it was printed large I was expecting it to have dull colours, but then all those mauves came out, and reds. So I was very lucky with that.

CR *Is Englishness, in a Constable kind of way, important to you?* It's part of my identity. When I was a kid, I'd spend whole days in the library looking at Constable, looking at other landscape painters. It's ingrained in me. They were always the kind of landscapes that I wanted to go to as a kid, when I was in the tower block. It's amazing though; if you go out into the British countryside you can still find pockets of countryside that look how they used to look in nineteenth-century paintings. You can find them.

As a kid, I used to study maps of Britain and I'd see where all these regions are that are very good for nature, like the New Forest [*Hedgerow (New Forest)*, fig. 132, p. 183] or Wyre Forest or Snowdonia or Norfolk or Dartmoor. These are places that I've photographed in, places that I had this imaginary relationship with as a kid. So a lot of this landscape comes from childhood in a way.

When I went to photograph the Constable landscape, I couldn't recognise it that much [from] the paintings. But then when I got my pictures back, I recognised it more in the photographs, the way that they were composed, or the way that the camera rendered the shapes.

I found that the only place I went to [that felt right] – I walked, I didn't drive – was this one spot in the middle of this flat, flat land with dykes. And for about a mile radius I took all the best [photographs] there. When I went outside of that, I didn't feel like I was going back in time. It just felt right. I don't often question things when I'm doing them. It's only with time later. I spent probably months on and off walking all round Norfolk. My back hurt! And I thought after a while 'why don't I just stick in that one spot'. But it took me a couple of months to work

it out. I guess I thought I could find other places but I couldn't.

I noticed a lot of [my] landscapes…have this kind of enveloping shape. Even if it's an open landscape it's just the way the clouds are.…It feels like there's a space in the middle. They're like looking through little windows. You're looking, you peer into them.

HK *So what do you think about the size? This matches up with the Constable.* I think it is the size that I want to see it on the wall because it's life sized and that's how I took it – from that position.

HK *So you're actually showing your own field of view when you do that? You have said that you put your thumb next to the lens to crop things out. You really are working in camera.* For the landscapes? Yes. But with film you never really know how the camera is going to flatten space. You never really know until you get it back. And I'm not sure if you know that with digital either because you can look on the screen on the back but it's just a small electronic image, isn't it? I never really used digital seriously.

CR *What role does technical mastery of the medium play?* I was using a medium format [camera]. I did it for two or three years and I never thought I would do snapshots again. I thought there was no way back. And what happened was, about five years ago my parents died. I looked at the photographs my mum had taken at the zoo, and they were snapshots. You might get a bird down here or something, but it was the pen she was photographing really, the animal would be marginalised to her. But there was something very moving about them and I realised it was the innocence in them. And then I thought I'd like to make photographs with the 'crappy cameras' that she'd use, still using film then – she'd have a mobile phone camera now if she was still alive – but I did quite a lot of photographs of animals in zoos in that style. And I worked out that there was a way to make snapshots again. And then I adopted that technique with the landscapes.

A lot of the pictures I've taken in the last three years have been with disposable cameras with plastic lenses.

I've probably got about a hundred of them altogether, I look at the idiosyncrasies of each, and I try to use the defects to my advantage.

It enabled me to feel the subject more. I think [with medium-format photographs] you've got to select your position and there's more cognitive thought in it, whereas with the [disposable cameras] I could be much more spontaneous. I'm not saying they're better but they're more enjoyable to do.

CR *Do you take satisfaction from being part of a tradition, being part of a continuum, in this case landscape and seascape?* I think I do. It's identity. I don't know how to explain it other than that. It's a sense of belonging. And I looked at all those books in the library as a kid. I think those compositions and shapes have stuck in my head. And the ways of constructing pictures. I think what you notice, what you see when you're young – up until the age of 20 – really shapes you for the rest of your life.

AFTERWORD

'There's something that's very interesting and in the water at the
moment with this idea of looking back.'[1]

Maisie Broadhead's comment came towards the end of her National
Gallery interview. She, Christopher Riopelle and I were standing in
Room 41, near wonderfully alive portraits by Danish painter Christian
Købke. We had been wandering through the collection, looking at the angles
of light in Vermeer's interiors, the memento mori in Holbein's *Ambassadors*,
Ingres's splendid Madame Moitessier in her fashionably flowered silk dress and
Manet's Eva Gonzalès, improbably dressed in white to paint at her easel. With
a little time and talk, these long-ago works and their subjects readily came back
to life, with stories to tell and comparisons to be made. Does Vermeer truly show
a single source of illumination? (Photographers struggle to match the fictions
of paintings.) How can Eva Gonzalès's white dress be represented without
overwhelming her skin tone? (Broadhead, like O. G. Rejlander before her, dips
white clothes in tea or coffee to subdue their reflectance and avoid glare in the
photographed image.)

The old and new photographs in this book compare notes with the other
works of art in the same way. The subjects are the same – the traditional genres
of tableaux, portraiture, figure studies, still life and landscape remain relevant
over the centuries. There are philosophical and artistic affinities: portraits hold
a personal charge, as in Rejlander's study of his wife in profile (fig. 42, p. 63),
and landscapes like Tacita Dean's *Fernweh* (fig. 135, pp. 188–89) embody a
desire for an Arcadian idyll. Visual styles persist through changing technology
or reappear several hundred years later with fresh power – Van Dyck's influence
accounts for a number of the past and present portraits in this book. The material
character of the photograph matters too, from the silver lustre of an anonymous
daguerreotype to the velvety print surface of Craigie Horsfield's nude (fig. 93,
p. 128), 'as vulnerable as skin'.

Above all, these photographs are pictures, made by artists who are deeply
invested in their practice. It is notable how few works are made by most of the
practitioners. These are not snap-happy digital magpies; they plot and plan, and
think long and carefully about their approach. Their photographic method may
not take as long as the act of painting, but each brief exposure will be part of
a process drawn out over days and months. They work with a technology that
is constantly changing, producing new digital resources that are increasingly
accessible to everyone, whether trained in the medium or not. But digital marvels
are not required for photographic art. Most of the contemporary practitioners
in this book take their photographs with large- or medium-format cameras

on analogue film to produce an image quality beyond the capabilities of the most expensive digital camera back. Digital cameras produce virtual resolution, extrapolating the data to fill out the image. The attributes are remarkable but as yet they do not match ordinary 35mm film, much less the large sheet film used by the likes of Jem Southam and Rineke Dijkstra, or Richard Learoyd's seemingly grainless Ilfochrome paper.

This connection to the past is a matter of pragmatism; the old technology produces the required results. An attention to past art is also a considered means to the end of producing a work of art. Why limit one's range, why not explore all of art's rich vocabulary? In 1858, William Lake Price concluded his book on the art of photography by quoting Sir Joshua Reynolds on the study of historical art:

> The great use of studying our predecessors is to open the mind, to shorten our labour and to give us the result of the selection made by those great minds of what is grand or beautiful in Nature: her rich stores are all spread out before us; but it is an art, and no easy art, to know how or what to choose, and how to obtain and secure the object of our choice.
>
> What is learned in this manner from the works of others becomes really our own, sinks deep, and is never forgotten; nay, it is by seizing on this clue that we proceed forward and get further and further in enlarging the principles and improving the practice of our art.[2]

This call to arms was addressed to Reynolds's students at the late eighteenth-century Royal Academy of Arts, London. Seventy years later, his words were used to rally the practitioners of a medium less than twenty years old, and there was a sense of great horizons opening up. All was possible.

Price's optimism was not misplaced, but it would be a long time before photography was widely accepted as an art form. The art world is now an expansive arena where producers are 'artists' whatever their materials, and photography is an art form among many. The medium has both legitimacy and an artistic pedigree.

That happy ending is the result of long battles. Like William Lake Price, I advocate connections across time and media: historical art woven into modern sensibilities and traditional art forms revamped for a new pictorial technology. All is possible.

194

Fig. 136
Karen Knorr, *The Work of Art in the Age of Mechanical Reproduction*, 1988. Cibachrome print mounted on aluminium, 92 × 92 cm. Collection of the Artist, courtesy Eric Franck Fine Art.

Karen Knorr's astute illustration of the division between the intellectual and visceral appreciation of art is set in the Victoria and Albert Museum, London. In Knorr's scene, the printed reproduction is the sole focus of the sitter, who ignores the 'real' works of art, themselves only reproductions: casts of Renaissance sculpture and Raphael Mengs's vast 1755 copy of Raphael's Vatican fresco, *The School of Athens*.

Knorr's title comes from Walter Benjamin's 1936 essay, in which he proposed that lens-based reproductive media (photography and cinema) would release art from the preoccupation with 'aura', that near-religious value ascribed to the unique artefact that bears the sacred imprint of the artist.

BIBLIOGRAPHY

NOTES / ABBREVIATIONS

BJP: *British Journal of Photography*
BJP Almanac: *British Journal Photographic Almanac and Photographer's Daily Companion*
LMPJ: *The Liverpool and Manchester Photographic Journal* (later, *British Journal of Photography*)
Photographic Journal: *The Journal of the Photographic Society of London*
Year-Book of Photography: *The Year-Book of Photography and Photographic News Almanac*

PRECEDENTS

Howard 1990
J. Howard, *Whisper of the Muse: The World of Julia Margaret Cameron*, London 1990.

London 2000
R. Morphet, *Encounters: New Art from Old*, exh. cat., The National Gallery, London 2000.

Paris 2004
S. Lemoine and F. Heilbrun, *Correspondances No. 1: Pierre Soulages et Gustave Le Gray*, exh. cat., Musée d'Orsay, Paris 2004.

Paris 2007
S. Lemoine with J. P. Criqui and M. P. Salé, *Correspondances No. 12: Jeff Wall et Paul Cézanne*, exh. cat., Musée d'Orsay, Paris 2007.

Paris 2009
U. Pohlmann and G. Cogeval, *Voir l'Italie et mourir: Photographie et peinture dans l'Italie du XIX siècle*, exh. cat., Musée d'Orsay, Paris 2009.

Washington, D.C., 2008
K. Jones, *In the Forest of Fontainebleau: Painters and Photographers from Corot to Monet*, exh. cat., National Gallery of Art, Washington, D.C., 2008.

Washington, D.C., 2011
D. Waggoner, *The Pre-Raphaelite Lens: British Photography and Painting, 1848–1875*, exh. cat., National Gallery of Art, Washington, D.C., 2011.

TECHNOLOGY

Baldwin and Jürgens 1991 (rev. ed. 2009)
G. Baldwin and M. C. Jürgens, *Looking at Photographs: A Guide to Technical Terms*, Los Angeles, 1991 rev. ed. 2009.

Jürgens 2009
M. C. Jürgens, *The Digital Print: The Complete Guide to Processes, Identification and Preservation*, London 2009.

Lavédrine and Gandolfo 2009
B. Lavédrine and J. P. Gandolfo, *Photographs of the Past: Process and Preservation*, Los Angeles 2009.

Wilhelm and Brower 1993
H. Wilhelm and C. Brower, *The Permanence and Care of Color Photographs: Traditional and Digital Color Prints, Color Negatives, Slides, and Motion Pictures*, Grinnell, IA 1993.

REFERENCES

Titles with an * asterisk refer to key texts on artists.

Armstrong 1896
W. Armstrong, 'The Art of Velasquez' [sic], in *The Portfolio: Monographs on Artistic Subjects*, no. 29, London 1896, pp. 1–104.

*** Aubenas 2002**
S. Aubenas, *Gustave Le Gray, 1820–1884*, ed. G. Baldwin, exh. cat., J. Paul Getty Museum, Los Angeles 2002.

Avery-Quash and Sheldon 2011
S. Avery-Quash and J. Sheldon, *Art for the Nation: The Eastlakes and the Victorian Art World*, London 2011.

*** Baldwin, Daniel and Greenough 2004**
G. Baldwin, M. Daniel and S. Greenough, *All the Mighty World: The photographs of Roger Fenton, 1852–60*, New Haven and London 2004.

Baldwin and Taylor 2004
G. Baldwin and R. Taylor, 'Chronology' in G. Baldwin, M. Daniel and S. Greenough, *All the Mighty World: The photographs of Roger Fenton, 1852–1860*, New Haven and London 2004.

Balfour 1889
G. Balfour, 'Aims', *Journal of the Camera Club*, 3 no. 31 (April 1889), pp. 71–74.

Bills and Bryant 2008
M. Bills and B. Bryant, *Victorian Visionary: Highlights from the Watts Gallery Collection*, New Haven and London 2008.

*** Blakemore and Comino-James 2011**
John Blakemore Photographs 1955–2010, eds J. Blakemore and J. Comino-James, Stockport 2011.

Blank 2004
G. Blank, 'What Does a Portrait, Human and Unsentimental, Look Like Now?', *Influence*, issue 2 (2004), pp. 76–89, published online http://www.gilblank.com/images/pdfs/dijkstrainflmag.pdf (accessed 20 March 2012).

*** Burke and Norfolk 2011**
J. Burke and S. Norfolk, *Burke + Norfolk: Photographs from The War in Afghanistan by John Burke and Simon Norfolk*, Stockport 2011.

*** Claremont 1996**
V. Hamilton, *Annals of My Glass House: Photographs by Julia Margaret Cameron*, exh. cat., Ruth Chandler Williamson Gallery, Claremont, CA 1996.

*** Cox and Ford 2003**
J. Cox and C. Ford, *Julia Margaret Cameron: The Complete Photographs*, London 2003.

Daniel 2004
M. Daniel, '"On Nature's Invitation Do I Come": Roger Fenton's Landscapes', in G. Baldwin, M. Daniel and S. Greenough, *All the Mighty World: The photographs of Roger Fenton, 1852–1860*, New Haven and London 2004.

*** Dean 2011**
T. Dean, *7 Books Grey*, Göttingen 2011.

Dean and Millar 2005
T. Dean and J. Millar, *Art Works: Place*, London 2005.

Disdéri 1862 (repr. 1863)
M. Disdéri, *L'Art de la photographie* (Paris 1862), reprinted as 'The Aesthetics of Photography' in *The Universal Text-Book of Photography*, Leeds 1863.

Eastlake 1848
C. L. Eastlake, *Contributions to the Literature of the Fine Arts*, London 1848.

Eastlake 1857
Lady E. Eastlake, 'Photography', Article V, *Quarterly Review*, 101 no. 202 (April 1857), pp. 442–68.

Gefter 2004
P. Gefter, 'The Picnic that Never Was', *The New York Times*, 21 November 2004, published online http://www.nytimes.com/2004/11/21/arts/design/21geft.html (accessed 20 March 2012).

Goethe 1816–17 (repr. 1994)
J. W. Goethe, *Italian Journey*, ed. T. P. Saine, trans. R. R. Heitner, 1816–17 (repr. Princeton 1994).

*** Goldin 1986**
N. Goldin, *The Ballad of Sexual Dependency*, New York 1986.

Greenough 2004
S. Greenough, '"A New Starting Point": Roger Fenton's Life' in G. Baldwin, M. Daniel and S. Greenough, *All the Mighty World: The photographs of Roger Fenton, 1852–1860*, New Haven and London 2004.

Hacking 1998
J. L. Hacking, *Photography Personified: art and identity in British photography, 1857–1869*, DPhil thesis, The Courtauld Institute of Art, London 1998.

Hamber 1996
A. J. Hamber, *A Higher Branch of the Art: Photographing the Fine Arts in England 1839–1880*, Amsterdam 1996.

Hamerton 1871 (rev. ed. 1889)
P. G. Hamerton, 'The Relation between Painting and Photography' (1860), in *Thoughts About Art*, London, 1871 rev. ed. 1889.

Hannavy 1976
J. Hannavy, *Roger Fenton of Crimble Hall*, Boston 1976.

Haworth Booth 1984
M. Haworth Booth, 'The Dawning of an Age. Chauncy Hare Townshend: Eyewitness', in *The Golden Age of British Photography 1839–1900*, London 1984.

Henisch and Henisch 1994
H. K. Henisch and B. A. Henisch, *The Photographic Experience 1839–1914: Images and Attitudes*, University Park, PA 1994.

House 1995
J. House, *Landscapes of France: Impressionism and its rivals*, London 1995.

Hughes 1861
C. Jabez Hughes, 'Art-Photography: Its Scope and Characteristics', *Photographic Notes*, 6 no. 117 (15 February 1861), pp. 57–60.

Hunt 1858
R. Hunt, 'The Photographic Exhibition', in *The Art-Journal*, vol. 21 (new series vol. 4) (1858), pp. 120–21.

Jacobson 1996
K. Jacobson, *Étude d'après Nature: 19th Century Photographs in Relation to Art*, Petches Bridge 1996.

Jacobson 2001
K. Jacobson, *The Lovely Sea-View: A Study of the Marine Photographs Published by Gustave Le Gray, 1856–1858*, Petches Bridge 2001.

Jammes 1981
I. Jammes, *Blanquart-Evrard et les origines de l'édition photographique française. Catalogue raisonné des albums photographiques édités, 1851–1855*, Geneva and Paris 1981.

Januszczak 1987
'Invading Your Space', Helen Chadwick interviewed by Waldemar Januszczak, *The Guardian*, 18 November 1987, published online http://www.guardian.co.uk/artanddesign/1987/nov/18/20yearsoftheturnerprize.turnerprize (accessed 20 March 2012).

Kennel 2008
S. Kennel, 'An Infinite Museum: Photography in the Forest of Fontainebleau' in K. Jones, *In the Forest of Fontainebleau: Painters and Photographers from Corot to Monet*, exh. cat., National Gallery of Art, Washington, D.C., 2008.

Kingsley 1886
C. Kingsley, 'Two Years Ago' in *The Works of Charles Kingsley*, London 1886, vol. 88.

Knorr 2009
K. Knorr, 'About Belgravia', 2009, http://www.karenknorr.com/photographs/archives/belgravia/ (accessed 20 March 2012).

Leighton 1853
J. Leighton, 'On Photography as a Means or an End', *Photographic Journal*, 1 no. 6 (21 June 1853), pp. 74–75.

Levanto and Puranen 2007
Dialogue: M. Levanto and J. Puranen, Galerie Anhava (Spring 2007), published online http://www.anhava.com/exhibitions/puranen/index-a.html (accessed 20 March 2012).

London 1865
Mrs Cameron's Exhibition of Photographs, 120, Pall Mall, exh. cat., French Gallery, London November 1865.

*** London 1986**
H. Chadwick, M. Warner and R. Cork, *Of Mutability*, exh. cat., Institute of Contemporary Arts, London 1986.

London 1991
'A Discussion with Jean-François Chevrier and James Lingwood, 10 May, 15 & 16 June, 30 June, 1 July 1991, London', in J-F. Chevrier, C. Horsfield, J. Lingwood, *Craigie Horsfield*, exh. cat., Institute of Contemporary Arts, London 1991.

*** London 1995**
J-F. Chevrier, *Jeff Wall*, exh. cat., Whitechapel Gallery, London 1995.

*** London 2000**
J. L. Hacking, *Princes of Victorian Bohemia: Photographs by David Wilkie Wynfield*, exh. cat., National Portrait Gallery, London 2000.

*** London 2005**
C. Wiggins, *Tom Hunter: Living in Hell and Other Stories*, exh. cat., National Gallery, London 2005.

Lubow 2007
A. Lubow, 'The Luminist', *The New York Times*, 25 February 2007, published online http://www.nytimes.com/2007/02/25/magazine/25Wall.t.html?pagewanted=all (accessed 20 March 2012).

*** Martin 2007**
'A Conversation, with Beate Gütschow, Natasha Egan, Lesley Martin, and Akiko Ono' in L. A. Martin, *Beate Gütschow LS/S*, New York 2007.

McCauley 1994
E. A. McCauley, *Industrial Madness: Commercial Photography in Paris, 1848–1871*, New Haven and London 1994.

Mulvey 1989
L. Mulvey, *Visual and Other Pleasures*, Bloomington and Indianapolis 1989.

*** Paris 2006**
Craigie Horsfield: Relation, ed. Catherine de Zegher, exh. cat., Jeu de Paume, Paris 2006.

Patmore 1866
C. Patmore, 'Mrs. Cameron at Colnaghi's', *Macmillan's Magazine*, 13 (January 1866), pp. 230–31.

Price 1858 (repr. 1868)
W. L. Price, *A Manual Of Photographic Manipulation: Treating Of The Practice Of The Art And Its Various Applications To Nature*, London, 1858 (2nd ed. 1868).

Price 1860
W. L. Price, 'On Composition and Chiaroscuro. –XV', *Photographic News*, 4 no. 90 (25 May 1860), pp. 37–38.

Rejlander 1858
O. G. Rejlander, 'On Photographic Composition; with a Description of "Two Ways of Life"', *Photographic Journal*, 4 no. 65 (21 April 1858), pp. 191–97.

Rejlander 1866
O. G. Rejlander, 'Desultory Remarks on Photography and Art', *Year-Book of Photography* (1866), pp. 45–46.

Rejlander 1871
O. G. Rejlander, 'Stray Thoughts on Photography and Art', *Year-Book of Photography* (1871), pp. 65–66.

Richon 1989
O. Richon, 'Zabat: A Photographic Work by Maud Sulter', *Portfolio*, 8 (Summer/Autumn 1989), pp. 8–9.

Roberts 2004
P. Roberts, 'Roger Fenton and the Still-Life Tradition' in G. Baldwin, M. Daniel and S. Greenough, *All the Mighty World: The photographs of Roger Fenton, 1852–1860*, New Haven and London 2004.

Robinson 1869 (repr. 1893)
H. P. Robinson, *Pictorial Effect In Photography: Being Hints On Composition And Chiaroscuro For Photographers*, London 1869 (reprinted 1893).

Robinson 1896 (repr. 1973)
H. P. Robinson, *The Elements of a Pictorial Photograph*, London 1896 (facsimile reprint, New York 1973).

Rosenblum 1979
N. Rosenblum, 'Adolphe Braun: A 19th Century Career in Photography', *History of Photography*, 3 no. 4 (October 1979), pp. 357–72.

Rosenblum 1990
N. Rosenblum, 'Adolphe Braun: Art in the Age of Mechanical Reproduction' in *Shadow and Substance: Essays on the History of Photography in Honor of Heinz K. Henisch*, ed. Kathleen Collins, Bloomfield Hills, MI 1990.

Ruskin 1857 (repr. 1903–12)
J. Ruskin, 'Elements of Drawing' (1857) in *The Works of John Ruskin*, eds E. T. Cook and Alexander Wedderburn, London 1903–12.

*** Santa Barbara 2011**
J. Joyce, *Ori Gersht: Lost in Time*, exh. cat., Santa Barbara Museum of Art, Santa Barbara, CA, 2011.

Scharf 1968 (rev. ed. 1974)
A. Scharf, *Art and Photography*, Harmondsworth, Middlesex 1968, rev. ed. 1974.

Slack 1867 (repr. 1890)
H. J. Slack, 'Mrs. Cameron's Photographs', *Intellectual Observer*, 1867, reprinted in *Journal of the Camera Club*, 4 no. 47 (July 1890), pp. 160–62.

Smith 1996
A. Smith, *The Victorian Nude: Sexuality, morality and art*, Manchester 1996.

Smith 1858
W. L. Smith, 'On the Choice of Subject in Photography, and the Adaptation of Different Processes', *Photographic Journal*, 5 no. 72 (6 November 1858), pp. 68–69.

Smith 1863
W. L. Smith, letter to the Editor, *Photographic Notes*, 8 no. 168 (1 April 1863), p. 83.

* Southam 2006
J. Southam, 'The Painter's Pool', *The Painter's Pool*, Portland, OR 2006.

* Spencer 1985
S. Spencer, *O. G. Rejlander: Photography as Art*, Ann Arbor, MI 1985.

Stillman 1872
W. J. Stillman, 'Photographic Specialty – A Word to Amateurs', in *Year-Book of Photography* (1872), pp. 48–52.

Sulter (date unknown)
M. Sulter, 'Culture and Identity in Photography: A Study Room Resource', Victoria and Albert Museum, http://www.vam.ac.uk/images/image/41279-popup.html (accessed 20 March 2012).

Sulter 1989
M. Sulter, 'Zabat: A Photographic Work by Maud Sulter', *Portfolio*, 8, (Summer/Autumn 1989), pp. 10–13.

Sutton 1863
T. Sutton, 'On some of the Uses and Abuses of Photography', *Photographic Journal*, 8 no. 129 (15 January 1863), pp. 202–06.

* Talbot 1844–46 (repr. 1989)
W. H. F. Talbot, *The Pencil of Nature*, London (1844–46) in Larry J. Schaaf, *H. Fox Talbot's The Pencil of Nature; Anniversary Facsimile*, New York 1989.

Wall 1860
A. H. Wall, 'Photographic Exhibition', *Photographic Notes*, 5 no. 97 (15 April 1860), pp. 112–14.

Wall 1861
A. H. Wall, 'An Artist's Letters to a Young Photographer. On Landscape', *BJP Almanac*, 8 no. 149 (2 September 1861), pp. 310–11.

Wark 1975
Sir Joshua Reynolds, Discourses on Art, ed. R. R. Wark, London 1975.

Watts 1865
G. F. Watts, Letter to J. M. Cameron, The Watts Collection, National Portrait Gallery (P125 1a), London (21 June 1865).

Watts 1872
G. F. Watts, Letter to J. M. Cameron, The Watts Collection, National Portrait Gallery (P125 4a/4b), London (19 October 1872).

Whitacre 2009
Luc Delahaye interview with Valérie Whitacre, 10 April 2009, in V. C. Whitacre, *Finding Meaning in Documentary Photography: Luc Delahaye's History Series*, MA diss., The Courtauld Institute of Art, submitted June 2009.

Wright 2003
P. Wright, 'Little Pictures: Julia Margaret Cameron and Small-Format Photography' in J. Cox and C. Ford, *Julia Margaret Cameron: The Complete Photographs*, London 2003.

REFERENCES (AUTHOR UNKNOWN)
Athenaeum 1856
'Photographic Society Exhibition', *Athenaeum*, no. 1472 (12 January 1856), pp. 46–47.

BJP 1860
Editorial, *BJP*, 7 no. 121 (2 July 1860), pp. 187–88.

BJP Almanac 1871
Mary S.–, 'Photographs and Photographs', *BJP Almanac*, 1871, pp. 122–26.

LMPJ 1857
'Exhibition of Art Treasures at Manchester', *LMPJ*, 2 no. 16 (15 August 1857), p. 170.

LMPJ 1858
'Exhibition of Photographs at the South Kensington Museum, Second Notice', *LMPJ*, 2 no. 7 (1 April 1858), pp. 82–83.

Photographic Journal 1857
'The Photographic Exhibition', *Athenaeum*, reprinted in *Photographic Journal*, 3 no. 50 (21 January 1857), pp. 192–95.

Photographic Journal 1858
'The Exhibition', *Photographic Journal*, 4 no. 66 (21 May 1858), pp. 207–11.

Photographic News 1861
'Photography as a Fine Art', *The London Review*, repr. in *Photographic News* London 5 no. 125 (25 January 1861), pp. 41–42.

Photographic News 1886
'The "Artistic Photograph" Case', *Photographic News*, 30 no. 1450 (18 June 1886), pp. 386–87.

Photographic Notes 1857(a)
'Exhibition of The Photographic Society', *Photographic Notes*, 2 no. 25 (15 April 1857), pp. 140–42.

Photographic Notes 1857(b)
'Meeting of the Birmingham Photographic Society', *Photographic Notes*, 2 no. 28 (1 June 1857), pp. 197–202.

Photographic Notes 1857(c)
'Exhibition of the Birmingham Photographic Society', *Photographic Notes*, 2 no. 39 (15 November 1857), pp. 441–42.

Photographic Notes 1864
'Photography and Fine Art', *Illustrated London News*, repr. in *Photographic Notes*, 9 no. 192 (1 April 1864), p. 97.

FURTHER READING ON ARTISTS
Tina Barney
T. Barney, M. Foresta and G. Sheffield, *The Europeans*, Göttingen 2005.

Richard Billingham
R. Billingham and S. Craddock, *Landscapes: 2001–2003*, Stockport 2008.

Luc Delahaye
L. Delahaye, *History*, London 2003.

Rineke Dijkstra
J. Blessing and S. S. Phillips, *Rineke Dijkstra: A Retrospective*, Guggenheim Museum, Los Angeles 2012.

Nan Goldin
G. Costa, *Nan Goldin*, London 2010.

David Octavius Hill and Robert Adamson
S. Stevenson, *Facing the Light: The Photography of Hill and Adamson*, National Galleries of Scotland, Edinburgh, 1999.

Evelyn Hofer
S. Breidenbach and E. Hofer, *Evelyn Hofer*, Göttingen 2005.

Sarah Jones
S. Jones, *Sarah Jones*, Dijon 2001.

Karen Knorr
D. Campany, R. Comay, A. Guzman and K. Knorr, *Genii Loci: The Photographic Work of Karen Knorr*, London 2002.

Eadweard Muybridge
P. Brookman, *Eadweard Muybridge*, exh. cat., Tate Gallery, London 2010.

Nadar
M. M. Hambourg, F. Heilbrun and P. Neagu, *Nadar*, New York 1995.

Martin Parr
V. Williams, *Martin Parr*, London 2004.

Jorma Puranen
L. Wells, *Jorma Puranen: Icy Prospects*, Osterfilden 2009.

Thomas Struth
T. Bezzola, A. Kruzynski and J. Lingwood, *Thomas Struth: Photographs 1978–2010*, New York 2010.

Sam Taylor-Wood
M. Crutchfield, *Sam Taylor-Wood*, Museum of Contemporary Art, Cleveland, 2008.

Jeff Wall
J-F. Chevrier, T. de Duve, B. Groys, M. Lewis and A. Pelenc, *Jeff Wall: Complete Edition*, London 2009.

Bettina von Zwehl
D. Leader and J. Lowry, *Bettina von Zwehl*, Göttingen 2006.

FURTHER READING
Baltimore, New Haven and London 2008
S. Bann, *The Repeating Image: Multiples in French Painting from David to Matisse*, ed. Eik Kahng, exh. cat., The Walters Art Museum, Baltimore, New Haven and London 2008.

Bann 2011
Art and the Early Photographic Album, ed. S. Bann, National Gallery of Art, Washington, D.C., New Haven and London 2011.

Date and Hamber 1990
C. Date and A. Hamber, 'The Origins of Photography at the British Museum, 1839–1860', *History of Photography*, 14 no. 4 (October–December 1990), pp. 309–25.

Pollock and Turvey Sauron 2008
The Sacred and the Feminine: Imagination and Sexual Difference, eds G. Pollock and V. Turvey Sauron, London 2008.

Wiener 1985
M. J. Wiener, *English Culture and the Decline of the Industrial Spirit 1850–1980*, Harmondsworth, Middlesex 1985.

NOTES

198

INTRODUCTION

1 In 2006, The National Gallery of Victoria broke the $1-million mark (in Australian dollars) when it bought an artist's proof of Jeff Wall's photograph *Untangling* (1994). Since then, prices have escalated, culminating with Andreas Gursky's *Rhein II* (1999) going for $4.3 million at Christie's New York in November 2011.

2 Beatrice Cenci's father raped her and mistreated the rest of her family. Beatrice, her mother and brothers hired assassins to murder him and were executed for that crime.

3 Nicholas Penny kindly alerted me to the Dickens reference. *Charles Dickens: Pictures from Italy*, Kate Flint (ed.), London, 1998, pp. 147–48.

4 Jeremy Howard discovered the Legoux engraving as a source for Cameron's Cenci. Howard 1990, pp. 28–29. I am especially grateful to Per Rumberg for correcting the engraver's name, context, and the provenance for the engraving. He also tracked Legoux's workshop to 52 Poland Street in Soho, London.

5 Daguerre's work came from his collaboration with Joseph Nicéphore Niépce, who died in 1833. Talbot's approach was paralleled by Hippolyte Bayard's direct positive silver iodide process of 1838–39.

6 See glossary on *daguerreotype*.

7 See glossary on *paper negative* and Talbot's *calotype* and *salted paper print*.

8 See glossary on *collodion negative* and *albumen print*.

9 See glossary on *gelatin silver print* and *digital photograph*.

10 Eastlake 1857, p. 461.

11 Rigby appears in more than 20 different Hill and Adamson photographs; at least 18 are solo portraits. In about 1848, Hill gave Rigby's future husband, Sir Charles Eastlake, a presentation album of his work with Adamson, *One Hundred Calotype Sketches*. Charles Eastlake's involvement with photographic associations dated from 1851 and is detailed in Hamber 1996, pp. 338–39.

12 The Photographic Society of London became the Royal Photographic Society in 1894.

13 Eastlake 1857.

14 Robinson wrote about Van Dyck's *Cornelis van der Geest* (painted around 1620) and discussed 15 specific Turner works. Robinson 1869 (repr. 1893), p. 4 and pp. 26–27.

15 Leighton 1853, p. 74.

16 A camera obscura is a box with a simple lens that projects an exterior image on to an interior viewing surface. Such devices have long been used as drawing aids. Wark 1975, pp. 237–58.

17 Rejlander 1866, p. 46.

18 Jeff Wall, interview with Els Barents in 1986; quoted in London 1995, p. 11.

19 Wall cited the inhabitants of the ghetto: '[Lee] Friedlander, [Diane] Arbus and [Garry] Winogrand and Stephen Shore'. Lubow (2007).

20 Wiggins 2005, p. 70.

21 *BJP* 1860, p. 187.

22 In 1976, John Szarkowsi of New York MoMA presented the first monograph exhibitions of colour photography, leading with William Eggleston and following with Stephen Shore.

23 Claudia Beck and Andrew Gruft's Nova Gallery in Vancouver was active from 1976 to 1981.

24 Jeff Wall, interview with Els Barents in 1986; quoted in London 1995, p. 11.

25 With thanks to Roger Taylor's De Montfort University project and website: Photographic Exhibitions in Britain, 1839 to 1865. http://peib.dmu.ac.uk

CHAPTER 1

1 *The National Gallery. A Selection of Pictures by The Old Masters Photographed by Signor L. Caldesi. With Descriptive and Historical Notices by Ralph N. Wornum, Keeper and Secretary, National Gallery* (London: E. Avery, 1873).

2 A single lens cannot reproduce the three-dimensionality of human binocular vision. The sharp focus across all planes of Struth's photograph further flattens the view.

3 Chadwick trained as a sculptor and her photographic images were often integrated into three-dimensional pieces.

4 In the late 1970s and 1980s, Chadwick and peers such as Barbara Kruger and Martha Rosler used photography as part of a rejoinder to the art-world dominance of male painters.

5 *Athenaeum* 1856, p. 46.

6 *The Intellectual Observer: Review of Natural History, Microscopic Research, and Recreative Science.* The IO was established in 1862 as a popular scientific periodical, and was very successful in the 1860s.

7 Slack 1867 (repr. 1890), p. 161.

8 '*Hagar in the Desert* (after a sketch by Francesco Mola)', Plate 23, part 6, in Talbot 1844–46 (repr. 1989), n.p.

9 Not all prints are based on line rendering; stipple engravings and mezzotints do, of course, present fine tonal reproduction.

10 Watts 1872.

11 *La Madonna Riposata*, like *Light and Love*, was based on *The Rest on the Flight into Egypt*, a familiar subject treated by among others Pier Francesco Mola in about 1630–35, acquired by The National Gallery in 1838.

12 In about 1869, Cameron's print dealers P & D Colnaghi sold 80 of her photographs to Cole. The museum's library, then part of the Government School of Design, also bought photographs of works of art.

13 Wright 2003, p. 86.

14 Members of the Arundel Society for Promoting the Knowledge of Art appear in Cameron's portraits, including Henry Liddell and Francis Charteris.

15 Hamber 1996, pp. 465–68. For the print processes, see the glossary under *photomechanical processes*.

16 The Royal Collection at Windsor has tracked the title's origins to an old story in which St. Gregory enquired about children being sold as slaves in Rome. Upon learning that they were English (*Angli*) he replied that the name was apt, for their beauty was reminiscent of angels (*Angeli*).

17 *Photographic Notes* 1857(c), p. 441.

18 Today, we take colour reproductions for granted, but full-colour photographic reproductions are a twentieth-century invention.

19 Levanto and Puranen 2007.

20 Eastlake 1848, pp. 389–90. Eastlake referred to volume one of Ruskin's *Modern Painters* (1843), suggesting a date of 1843–45 for his essay.

21 Levanto and Puranen 2007.

22 Until 1941, men of colour were barred from joining the RAF. Of almost 7000 West Indian servicemen in the RAF, just 400 became aircrew: With thanks to Laurent Philpot of the West Indian Ex-Servicemen's and Women's Association for this information.

23 See glossary under *daguerreotype* for information on hand-tinting.

24 Fenton's own notes from the Crimea describe exposure times of up to 20 seconds.

25 Burke and Norfolk 2011.

26 Whitacre 2009, p. 41.

27 Ibid, pp. 41–42.

CHAPTER 2

1 The muses included the writer Alice Walker as Thalia, the muse of comedy; and the singer and composer Dr Ysaye Maria Barnwell as Polyhymnia, the muse of sacred hymn. Richon 1989, pp. 8–9.

2 The works were first exhibited at the Rochdale Art Gallery in 1989. Sulter 1989, p. 10.

3 *Zabat* was the title of a collection of Sulter's poems about her Ghanaian heritage, published in 1985.

4 Sulter (date unknown).

5 Photographic exposures were initially too slow to make a portrait. It is documented that on 14 October 1840, William Henry Fox Talbot made a portrait of his footman standing by a carriage. Various prior claims have not been proven.

6 See glossary on *daguerreotype*.

7 Elizabeth Barrett, letter to Mary Russell Mitford, 7 December 1843, in *Collected Letters* (Betty Miller, ed.), London 1955, in Henisch and Henisch 1994, p. 166.

8 Ibid.

9 The tondo is a painting or sculpture in circular format. The term came into use in the Renaissance.

10 Alphonse-Eugène Disdéri introduced the *carte-de-visite* format in 1854.

11 Hamerton 1871 (rev. ed. 1889), p. 138.

12 Eastlake 1857, p. 460.

13 Ibid, p. 442.

14 Chiaroscuro combines the Italian words for 'light' and 'dark' and refers to the use of strong highlights and deep shadows for artistic effect.

15 Avery-Quash and Sheldon 2011, p. 69. In a number of Hill and Adamson portraits of Rigby (fig. 6, p. 14, Hill and Adamson, *Elizabeth Rigby with umbrella*), a replica of Étienne Maurice Falconet's eighteenth-century statuette portrays one cherub trying to stop the other from stamping on a heart.

16 *Photographic Journal* 1857, p. 193.

17 See glossary on *gold toning*.

18 William Henry Perkin's aniline mauve became fashionable when, in 1862, Queen Victoria wore a mauve dress to the International Exhibition.

19 *Photographic News* 1861, p. 42.

20 Smith 1858, p. 68.

21 Sixteenth-century Venetian art later inspired Rossetti.

22 While a student at the Royal Academy of Arts, London, Watts smoked a copy of a Van Dyck to subdue its colours and age its appearance. Bills and Bryant 2008, p. 21.

23 From the Italian *sfumare* (to evaporate in smoke), *sfumato* refers to a Renaissance painting technique whereby tones are blended to soften the outline of forms. Watts took the term literally, see footnote 22, above.

24 Letter from George Frederic Watts to Julia Margaret Cameron, Watts 1865. One of the photographs has been identified as *The Shunammite Woman & her Dead Son* (Mary Ryan and Percy Keown).

25 Jerrold, *London: A Pilgrimage*, with 180 engraved illustrations by Gustave Doré, London, 1872.

26 Cameron's *Little Girl in Prayer* (*Fillette en prière*) [Florence Anson], 1866, was inscribed 'd'après nature Photographe registré. Copyright Julia Margaret Cameron, 1871. Presenté à Gustave Doré par Julia Margaret Cameron'. The print is held at the Musée d'Orsay, Paris.

27 The print mount carries a blindstamp for P & D Colnaghi, Cameron's print dealers, suggesting that she intended it for sale as a celebrity portrait.

28 Cameron produced 245 studies but only three were published in 1875 as reduced-scale wood-engraved illustrations. In December 1874 and May 1875, the same publisher (Henry S. King) brought out two bound volumes of Cameron's actual (and splendid) photographs. Tennyson's poems were reproduced as lithographs of their transcription in Cameron's own hand.

29 *BJP Almanac* 1871, p. 123.

30 Kingsley 1886, pp. 141–42. Later in the novel, Claude would become a photographer, claiming that he was 'tired of painting nature clumsily, and then seeing a sun-picture out-do all my efforts', p. 251.

31 Balfour 1889, p. 74.

32 Conversation between Craigie Horsfield and Carol Armstrong, in Paris 2006, p. 322.

33 London 1991, p. 14.

34 Paris 2006, p. 223.

35 Colin Ford identified the sitter as Angelo Colarossi. Cox and Ford 2003, p. 315. Dr Barbara Bryant's work on Watts has identified an Italian model called 'Gennaro', and proposed that the photograph was intended to be an artist's study for Watts, although the only extant print is in an album that Cameron gave to Sir John Herschel.

36 Cameron, 'Annals of My Glass House', published posthumously by Henry Herschel Hay Cameron in the catalogue to the exhibition of J. M. Cameron's work at the Camera Club of London, April 1889. Reprinted in Claremont 1996, p. 15.

37 The word 'just' translates from the French 'juste' as in 'correct' or 'appropriate'. Disdéri 1862 (repr. 1863), p. 47.

38 Disdéri 1862 (repr. 1863), p. 45.

39 See glossary on *ink jet print*.

40 Bernardino Luini was a pupil of Leonardo. Patmore 1866, p. 231. Patmore's article reviewed Cameron's French Gallery exhibition of November 1865, at which she showed 158 photographs, all made within one year. Some of the prints were duplicates, but it was still a remarkable effort. London 1865.

41 Cameron had a beady eye for notable sitters, and was notorious for dragging the unwary into a prolonged 'sitting'. This involved holding a pose while she rushed off to coat the wet collodion plate (which had to be fresh to get a decent exposure). The camera exposure was followed by a wait while she processed the negative, followed by the next shot, and the next.

42 *The Studio* was published in fascicles of four photographs each, but the publication folded after four numbers. London 2000, p. 30. *The Studio* was available from Henry Hering, a self-described 'photographic printseller and publisher' whose stock in the mid-1850s included stereoscopic views and photographs by Gustave Le Gray. Jacobson 2001, p. 51, note 36.

43 *Photographic Notes* 1864, p. 97. There were few reviews of Wynfield's photographs, for they were shown just twice in the winter and spring of 1864.

44 The triplet portrait of Charles I is not part of the 'Iconographia' series, but reproduces the famous Van Dyck painting.

45 London 2000, p. 30.

46 Sharp focus across all the planes of the image makes the subject appear as if all the details are on the same plane. That distinctness flattens the view.

47 Hamerton 1871 (rev. ed. 1889), p. 64.

48 Hacking 1998, p. 44.

49 Only a few commercial photographic studios had solar enlargers before the 1880s introduction of gas light enlargers and enlarging papers.

50 Knorr 2009.

CHAPTER 3

1 Robinson 1896 (repr. 1973), p. 77.

2 London 1986.

3 The memento mori is an artistic and literary motif that communicates the inevitability of death through emblems of mortality.

4 Januszczak 1987.

5 Ibid.

6 Mulvey 1989.

7 Smith 1996, p. 8.

8 Watts warned: 'It is not possible to represent nudity with any attempt at realism without drifting perilously near vulgarity.… When the clothes are taken off the model, the creature is naked.' M. S. Watts 1912, p. 11, in Smith 1996, p. 4.

9 Daguerre's camera maker Nicolas Lerebours claimed to have produced a nude photograph in 1841.

10 This premium persists in today's market for nineteenth-century photographs of nudes.

11 See glossary on *stereoscopic photograph*.

12 In the 1850s, at least 15 Parisian photographic studios specialised in nude studies. McCauley 1994, pp. 153–56.

200

13 The first French photographic association, the Société héliographique, welcomed nude photographs at its private soirées. Its successor association, the Société française de photographie, barred nudes from its public exhibitions in 1855. McCauley 1994, p. 156.

14 The French spelling for the term may derive from the prevalence of drawing from the nude model at French art academies.

15 Constant Dutilleux recorded that Delacroix paid Durieu's photographic models three francs per session. Scharf 1968 (rev. ed. 1974), p. 123.

16 Delacroix was comparing daguerreotypes with engravings by Marcantonio Raimondi. Scharf 1968 (rev. ed. 1974), p. 122.

17 Ibid, p. 125.

18 Durieu's album incorporates photographs thought to have been made in collaboration with Delacroix. The album contains 31 photographs and is held at the Bibliothèque nationale de France.

19 'The Salon' refers to the annual exhibition of the Académie des Beaux-Arts in Paris. In the nineteenth century, there would have been far fewer nude studies at the Royal Academy's official summer exhibition.

20 My thanks to Dr Kathleen McLauchlan for her research on the submissions to the Salon.

21 McCauley 1994, p. 154. From 1852, the French government required that all photographs intended for public sale be registered at the *dépôt légal*, now at the Bibliothèque nationale de France. Apart from *académies*, most works were celebrity portraits.

22 Rejlander, 'An Apology for Art Photography', *Photographic News* 1863, in Spencer 1985, p. 24. Rejlander had few illusions about penny-pinching artists: 'When admiring a particular part of a figure, he asks you to cut that off, and put it on a card *i.e.* C.D.V. [*carte-de-visite*] size, and a card equals one shilling'. Rejlander 1871, p. 66.

23 Smith 1996, p. 56.

24 McCauley 1994, pp. 160–61.

25 Union cases were made from a composite of shellac, soot and sawdust, moulded into a bas-relief design. The motifs could be based on popular engravings. This design was 'The Faithful Hound', a favourite sentimental tale.

26 The Manchester Art Treasures Exhibition ran from 5 May to 17 October 1857.

27 Armstrong 1896, p. 75. Armstrong noted that in 1890, Velázquez's Venus was given a place of honour at the Old Master Exhibition at Burlington House.

28 *Photographic Notes* 1857(b), p. 202.

29 *Photographic Journal* 1858, p. 208.

30 Wall 1860, p. 112.

31 Rejlander 1858, pp. 191–93.

32 'Madame Wharton and Troupe' performed at the Theatre Royal in Wolverhampton, and it is known that Rejlander photographed one or two of her performers. Wharton modelled for William Etty and Ford Madox Brown. Smith 1996, pp. 25 and 61.

33 Sutton 1863, p. 203.

34 *Photographic Notes* 1857(c), p. 441.

35 After being barred in 1855, nude studies only reappeared in public photographic exhibitions in the 1890s.

36 According to contemporary accounts, Victoria hung one print in Albert's Balmoral dressing room. There are no extant prints of *The Two Ways of Life* in the Royal Collection. The poor condition of many Rejlander photographs suggests that if the albumen prints were hung on a wall, they would have faded and discoloured, and probably were simply discarded.

37 *Photographic News* 1886, p. 387.

38 Disdéri 1862 (repr. 1863), p. 54.

39 *Photographic Journal* 1858, p. 207.

40 Many of Fenton's photographs of statues were made out-of-doors (although 'Discobolus' was photographed in the museum, in situ).

41 Fenton's large prints and stereo cards were sold at a kiosk in the British Museum and distributed through associations such as the Art-Union of London.

42 Learoyd, email to the author, 3 June 2009.

43 Dijkstra quoted in Blank 2004, p. 81.

44 Learoyd, email to the author, 2 June 2009.

45 London 1991, p. 12.

46 Ibid, p. 11.

47 Learoyd, email to the author, 3 June 2009.

CHAPTER 4

1 Gersht in conversation with Michele Robecchi, in Santa Barbara 2011, p. 32.

2 Gersht, correspondence with Julie Joyce, in Joyce 2011, p. 18.

3 Talbot, 'Articles of Glass', Plate 4 in Talbot 1844–46 (repr. 1989), n.p.

4 Talbot, 'Articles of China', Plate 3 in Talbot 1844–46 (repr. 1989), n.p. Talbot explained that the photographs were proof should the items be stolen.

5 Price 1858 (repr. 1868), p. 187.

6 Ibid, p. 188.

7 One exception is Henri Le Secq, a painter and photographer who made table-top still lifes as artists' studies. The still lifes date from the 1850s, although most survive as later proof prints at the musée des Arts Decoratifs in Paris.

8 Quoted in Braun's 1855 portfolio, *Photographies de fleurs à l'usage des fabriques de toiles peintes, papiers peints, soieries, porcelains, etc.* (Mulhouse, 1855) in McCauley 1994, p. 242. This text may come from a review by H. V. Regnault, 'Photographic flowers from nature', *Journal des débats* 6 November 1854. See, Rosenblum 1979, p. 370, note 13.

9 Rosenblum 1979, p. 361. The portfolio was published in England as *Flowers from Nature* (1855).

10 The Musée d'Orsay holds Charles Aubry photographs of botanical specimens made as designs for plasterwork and other applied arts. He attempted to set up a school for the production of such studies for industry, but the venture was not a success.

11 See glossary on *carbon print*. Braun's '14 rue Cadet' studio stamp on the carbon print indicates that it was made between 1868 and 1871. My thanks to Ken Jacobson for this information.

12 Rosenblum 1979, p. 368.

13 From correspondence quoted in Rosenblum 1990, p. 195.

14 Jacobson 1996, p. 10.

15 Blakemore and Comino-James 2011, p. 178.

16 Ibid, p. 164.

17 Goldin 1986, p. 6.

18 Dye transfer is an additive print process, in which the print image is built up from coloured dyes sublimated into a gelatin layer on the print base. It derives from the earliest full-colour photographic processes and is still used today to produce highly stable images in both subtle and intense colour.

19 Fenton's photograph entitled Lance's work *Comus* but actually shows *The Golden Age*, a painting dated 1859, the year that Fenton photographed it. *The Golden Age* was exhibited at the British Institution and would be published as a coloured engraving in 1861. Fenton's photograph may in fact be from an engraved copy of the Lance painting.

20 Review in the *BJP*, 16 January 1861, in Roberts 2004, p. 97.

21 *Stereoscopic Magazine*, February 1863, quoted in Hannavy 1976, p. 89.

22 See glossary on *vignette*. The dark periphery would be more noticeable in the paler top of the print, so only the top needed to be arched.

23 Pam Roberts points out that the reflection of two cameras on tripods is visible on a silver goblet in one of Fenton's still lifes. Roberts 2004, p. 97.

24 Until the 1880s, most photographs were contact-printed from glass plate negatives, so the print size was determined by the plate size and, therefore, the camera size.

25 Stereographic cameras used a short-focus lens, which gave good deep focus across all the planes of the view, an important requirement for the resulting three-dimensional image.

26 Most extant Fenton still lifes are unique prints, suggesting that he did not print or sell them in quantity. Most of the 55 surviving prints are in the collection of the Royal Photographic Society, which received the entire still-life series from a member of Fenton's family.

27 The purchase was made in September 1860. Invoice listed in Baldwin and Taylor 2004, p. 238.

CHAPTER 5

1 Stillman 1872, p. 51. William James Stillman was a friend of John Ruskin and of Dante Gabriel Rossetti, both of whom influenced Stillman's American art journal *The Crayon* (1855–61). Stillman was acquainted with Julia Margaret Cameron and he married her model, the painter Marie Spartali, in 1871.

2 Smith 1863, p. 83.

3 *Photographic Journal* 1857, p. 193.

4 Jacobson 2001, p. 8 and p. 51, note 33.

5 *LMPJ* 1858, p. 83.

6 *Photographic Notes* 1857(a), p. 141.

7 *LMPJ* 1857, p. 170. The work may have been *Ships in a Breeze*, also known as the *Egremont Sea Piece*, a watercolour study from the oil painting *Ships Bearing up for Anchorage* (1802).

8 The Fontainebleau landscapes were taken between 1849 and 1852. Haworth Booth 1984, p. 17.

9 Townshend owned at least 16 paintings by Bocion, dated between 1848 and 1855. They had met at Lake Leman (now Lake Geneva), where Townshend had a villa.

10 At the Victoria and Albert Museum, this work is catalogued as *The Tugboat* and dated 1856. Townshend Bequest, 1868. Museum no. 68.000.

11 Muybridge's enduring legacy is his stop-action photography of the 1870s and 1880s; his sequential images of a running horse remain famous.

12 *Photographic Notes* 1857(c), p. 441.

13 See glossary on *actinic light*.

14 Eastlake 1857, p. 462.

15 Henry d'Audiger, *La Patrie*, 25 July 1858 in Aubenas 2002, p. 367.

16 While a number of photographers were achieving nearly instantaneous exposures in the 1850s, there were few – and rudimentary – options for instantaneous shutters. The best guess of Le Gray's own contemporaries was a perforated sliding cap shutter. Jacobson 2001, p. 22. This was based on the design used with the Daguerre-Giroux camera of 1839. Using the cap for a short exposure required a rapid dexterity.

17 Hunt 1858, p. 120.

18 Small catalogues listed the exhibits and prices. Print sellers bought stock from the shows, or direct from the photographers on consignment. Some firms lent works to the exhibitions. Ken Jacobson has tracked five print dealers offering Le Gray seascapes for sale in the late 1850s. Jacobson 2001, p. 51, notes 53 and 56.

19 The elm tree appeared in George Shadbolt's *Resting on the Stile*. *Athenaeum* 1856, p. 47.

20 *Bulletin de la Société française de photographie* September 1857, p. 281, in Kennel 2008, p. 160. Le Gray's artistic role model may have been Thèodore Rousseau, who in 1849 won a Salon medal for a Fontainebleau subject. Kennel 2008, p. 156.

21 Cynthia is a variant name for the Greek goddess of the moon. *Photographic Journal* 1857, p. 193.

22 Louis Blanquart-Evrard's portfolios, *Photographic Studies* and *Studies and Landscapes* 1853–54, included works by a number of Le Gray's contemporaries. See, Jammes 1981.

23 Kennel 2008, pp. 156–57.

24 The glass plate negative's greater transparency produced deeper shadows than a paper negative, while the more consistent density of the collodion coating gave bright, even highlights.

25 Le Gray was an expert, for in 1849 he had perfected a process for making waxed paper negatives.

26 Hughes 1861, p. 58.

27 The dark cloth blocks outside light, so that the rather faint image on the glass can be seen.

28 Southam uses 10 × 8 inch sheet film. Billingham works on 6 × 7 cm medium-format roll film.

29 Eastlake 1857, p. 463. For photosensitivity, see glossary under *collodion negative*.

30 Southam 2006, n.p.

31 Gersht, lecture at the Imperial War Museum, London, 28 January 2012.

32 In glass plate negatives, halation was amplified by the refraction of light through the thickness of the glass. See glossary on *halation*.

33 Ruskin 1857 (repr. 1903–12), p. 73.

34 Gersht, lecture at the Imperial War Museum, London, 28 January 2012.

35 Stonyhurst was a Jesuit school near a farm owned by Fenton and members of his family. Daniel 2004, p. 47.

36 Greenough 2004, p. 28.

37 Wall 1861, p. 310.

38 Ernest Chesneau, *Les nations rivales dans l'art* 1868, quoted in House 1995, p. 42.

39 Gütschow in Gefter 2004.

40 Martin 2007, p. 42.

41 Dean 2011, p. 104.

42 Goethe 1816–17 (repr. 1994), p. 147.

43 Dean 2011, p. 104.

44 Dean and Millar 2005, p. 47.

AFTERWORD

1 Broadhead, interview with Christopher Riopelle and Hope Kingsley, Room 41 in The National Gallery, 19 January 2012.

2 Sir Joshua Reynolds, *Discourse VI* 10 December 1774, quoted in Price 1860, pp. 37–38.

GLOSSARY

This glossary defines the photographic technologies and techniques illustrated in the book. Processes and materials are dated by their period of widest use, although a number of historical processes were revived in the late nineteenth and twentieth centuries.

ACTINIC LIGHT

Actinic light consists of blue, violet and ultraviolet light sources, which is the portion of the spectrum of light to which photographic materials are sensitive. Nineteenth-century photographic processes were not responsive to red or amber light, but later orthochromatic (1880s) and panchromatic (early 1900s) materials extended photosensitivity to the full spectrum of visible light.

ALBUMEN PRINT

Albumen paper (1852–1920) was coated with a binder layer of salted egg white. Silver nitrate was the light-sensitive constituent, added in a separate step before use. Louis Blanquart-Evrard introduced albumen paper in 1850, and, by 1855, his firm was selling coated and salted – but not sensitised – paper; the photographer or studio had to sensitise the paper prior to its use. Albumen paper had problems with stability; the prints were susceptible to sulphur in air pollution as well as sulphur in the egg white. Deterioration could be mitigated by *gold toning*, which also changed the warm brown image colour to a cooler aubergine brown. By the early twentieth century, albumen was largely supplanted by *gelatin silver* papers.

CALOTYPE

William Henry Fox Talbot coined the term calotype (1841–early 1860s) to describe a developed-out paper negative, produced with silver nitrate and potassium iodide. The negative was exposed for a short time (10 to 15 seconds in daylight) to obtain a faint or latent image, then intensified or 'developed' with silver nitrate and gallic acid, and fixed with sodium thiosulphate. Compared with the rival process – *daguerreotype* – Talbot's paper method was inexpensive and easy to use, with the great advantage of producing multiple prints.

CARBON PRINT

Developed by Alphonse Poitevin in 1855, carbon printing (1864–1940s) was perfected in 1864 and in general use by the early 1870s. Carbon prints are made with a thin paper 'tissue' coated with gelatin and iron oxide (carbon) pigment and sensitised with potassium bichromate, which causes the gelatin to harden upon exposure to daylight. Once exposed through a photographic negative, the carbon tissue is soaked in water, which dissolves the unexposed gelatin, leaving an image in pigmented gelatin.

Carbon prints can look like silver photographs; brown colours matched *albumen prints*, and when grey-black photographs became popular in the 1880s, equivalent pigments were introduced. In the early 1900s, cyan, magenta and yellow tissues were used to produce early colour prints.

CHROMOGENIC PRINT / C-TYPE PRINT

Chromogenic means 'derived from colour' and chromogenic papers (1941–present) are printed from a colour negative. The process exposes three layers of *silver halide*, chemically linking these to cyan, magenta and yellow dyes to produce a three-layer dye image that corresponds with the original metallic silver image. The term 'C-type' derives from Kodacolor Color Print Type C (1954), and is a generic term for any chromogenic print from a colour negative. Today, C-type paper is used for *laser direct prints*.

CIBACHROME AND ILFOCHROME

Cibachrome (1963–92) and Ilfochrome (1992–2011) are 'R-type' or reversal papers: positive prints printed from a positive transparency. The colours are produced by azo (diazonium) dyes, whose stability and intensity give high-quality images. The process is also called 'silver dye bleach' (SDB), from the sequence of bleaching out the *silver halide* after the dyes have been activated. The 'paper' is actually a photographic transparency on an opaque white polyester backing sheet. Cibachrome Transparent (1969) was adapted from this, and the stable azo dyes made it an ideal material for backlit photographs. Cibachrome was the brand name used by Ciba AG (later, Ciba-Geigy); Ilfochrome was adopted after Ciba-Geigy sold Ilford to International Paper (1989). The paper was discontinued at the end of 2011.

COLLODION NEGATIVE

Collodion negatives (1852–early 1880s) were glass plates coated with collodion (gun cotton dissolved in ether and alcohol) and halide salts (potassium and, later, cadmium bromide), and sensitised with silver nitrate. Invented in 1851 by Frederick Scott Archer, the process was widely used, remaining the standard plate technology until fast silver bromide plates were introduced in the late 1870s. Collodion negatives had to be coated and sensitised on the spot and developed directly after the exposure, requiring the whole apparatus of the darkroom to prepare and process the plates. Collodion negatives were primarily sensitive to the blue and ultraviolet parts of the spectrum of light. Thus, in early portraits, brown freckles would photograph as dark spots and a red nose might look black. Compensations included pale powder for hair and face.

COMBINATION PRINT

Also known as composition prints (about 1856 to early 1900s), combination prints were produced from a number of negatives, separately photographed and laboriously masked and contact-printed to create a single picture. The method was typically used for adding clouds to the blank white skies resulting from blue-sensitive photographic negatives.

COMPOSITE PHOTOGRAPH

Composite photography (later known as 'photo-montage') first appeared in the 1880s when gas-light enlargers and projection-speed printing paper made it possible to project and superimpose multiple negatives for a single photographic picture. The same effect can now be produced digitally.

CONTACT PRINTING

Most nineteenth-century photographic printing papers were only suitable for contact printing in daylight. To make a print, the negative was placed face down on a sheet of photosensitive paper and fitted into a wooden printing frame. A *paper negative* was held down under a glass cover sheet; a *glass plate negative* sat inside the frame without a cover glass. The frame was placed outdoors, often on the roof of the photographer's studio. *Salted paper* and *albumen* prints required about 20 minutes' exposure, although cloudy weather and cold temperatures lengthened the time, and many photographic studios gave up printing in the winter.

DAGUERREOTYPE

Daguerreotypes (1839–late 1850s) are images in finely divided grains of mercury-silver amalgam on the surface of a polished, silver-plated copper sheet. The image is monochrome grey and reads as a positive, although when viewed obliquely, the image appears to reverse itself. Hand-tinting of photographs began with daguerreotypes, whose livid grey colour and blue-sensitive bias did no favours to the sitter. Because daguerreotype surfaces are very fragile, dry pigment was mixed with powdered gum arabic and blown on to the plate through a small tube. Stencil forms kept the powder in the right place. This was photography's first commercial portrait process, and daguerreotypes were often cased like earlier painted miniatures. They were unique objects; one plate was produced for each exposure. The portraits were expensive, costing about one pound, which was the weekly wage for a skilled worker in the mid-nineteenth century.

DEFINITION

This term refers to the visual properties of a photographic image as characterised by its sharpness or

degree of focus. It is primarily applicable to an image produced by a lens. Ideal definition is recognised as a mathematical rather than a material principle, and in photography, image definition is mitigated by mechanical and atmospheric variables.

DEPTH OF FIELD

Depth of field specifies the range in the subject within which a lens is focused and provides acceptable image sharpness. It does not simply refer to perfect optical sharpness, which is only produced at one point on the lens axis. Depth of field is dependent on the aperture of the lens: as the aperture decreases, the depth of field increases. It is also determined by the *focal length* of the lens. When a photographic lens produces a shallow depth of field, the image shows only a narrow plane in focus.

DIGITAL PHOTOGRAPH

Digital cameras (1990s–present) use electrical sensors to record light levels. Those electrical signals are digitised; digital data is assigned to account for image hue, saturation and lightness or brightness. See *inkjet print* and *laser direct print*.

EMULSION

While this term is properly expressed as 'coating', emulsion is commonly used to describe a mixture of light-sensitive silver salts suspended in collodion or gelatin and coated on photographic plates, film or paper.

FIELD OF VIEW

Referring to the extent of the area of the scene visible through the lens, the term describes the lens's capacity to produce uniform illumination across the image plane. Outside of this field, the image will have poor definition and/or reduced illumination, the latter producing *vignetting*.

FOCAL LENGTH (OF LENS)

The focal length of a lens refers to its capacity to bend the rays of light to form an acceptable image at the focal plane, which should coincide with the surface of the negative plate or film. A short focal length lens, like a

landscape lens, focuses within a short distance between lens and image plane, giving a relatively wide angle of view and good depth of field. A long focal length lens, like a portrait lens, operates within a longer distance between lens and image plane, giving a narrow field of view and a shallow depth of field.

FOCUS

In photography, focus refers to the distinctness or resolution of an image produced by an optical device such as a lens. Soft focus describes an unsharp image; it can be introduced by opening up the lens aperture beyond the circumference for which the lens was designed.

GELATIN SILVER PRINT

Gelatin silver papers (mid-1880s–present) comprise printed-out or developed-out silver chloride or silver bromide, or a combination of the two. They can show a range of image colours from warm brown to grey-black, and a variety of surface finishes from a high gloss to a dull matt. Available in the early 1880s, gelatin silver printing papers did not supplant *albumen* paper until the 1890s, when silver chloride 'printing-out paper' was introduced as a contact-printing paper like *salted paper* and *albumen* paper. Silver bromide enlarging paper had limited uptake until the late 1890s, when manufacture was standardised and exposure times were calibrated. It became the standard photographic paper after 1910 and is still manufactured today.

GLASS PLATE NEGATIVE

From 1851 until the early 1920s, glass plates were the standard support for photographic negatives. In 1889, celluloid film negatives were introduced for snapshot cameras, but professional photographers did not switch to film negatives until the 1930s, and some studio photographers still used glass plates into the 1950s.

GOLD TONING

Gold toning (1840–present) was introduced by Hippolyte Fizeau in 1840, and is still used for toning

gelatin silver prints. Silver images can be 'toned' with metal halides to change image colour and increase stability. Gold toning preserves print highlights and shadow density, which enhance image contrast. The expense of gold meant that gold toning was used with economy and some nineteenth-century prints show deterioration from insufficient toning.

HALATION

Halation produces a halo around light objects and is particularly noticeable at the boundaries of very bright or dark imaged objects. It occurs when light penetrates the photosensitive coating of a *glass plate negative* and refracts back through the glass at a slightly different trajectory from that by which it entered. Between the 1870s and the 1890s, experiments with anti-halation coatings mitigated the effect.

INKJET PRINT

Inkjet prints (2000–present) are made from tiny dots of ink (dyes and/or archival pigments) sprayed on to a coated receiving paper. As with *digital C-type prints*, a digital signal is transmitted to a printer; in this case, the printer translates image pixels into dots of ink.

LASER DIRECT PRINT/DIGITAL C-TYPE PRINT

Digital C-type prints (2000–present) are high-resolution silver halide *chromogenic prints* on resin-coated paper (sealed with a top and bottom layer of polyethylene). The image data is downloaded as a digital file into a laser digital printer, which uses a scanning laser beam to record the image on the chromogenic paper. The paper is chemically developed and fixed as per standard C-type prints.

LENS

A lens is an optical device made of glass (silica and other materials such as quartz). Single or 'simple' lenses have a single lens element, whereas compound lenses have two or more elements. These could be cemented together, but the term usually refers to lenses whose elements are separated by an aperture or 'stop'.

LENS APERTURE (LENS DIAPHRAGM/LENS STOP)

The lens aperture largely determines the depth of focus produced by the lens. The smaller the aperture, the better the depth of focus. Early lenses had no integral aperture; instead, the photographer would insert a pierced metal disk (or 'stop') into a slot in the tube holding the lens elements. Bladed or iris diaphragm apertures were used in other optical equipment but not introduced to photography until the 1880s.

PAPER NEGATIVE

Paper negatives (1840s–1850s, with revivals in the 1890s and 1970s) are also known as *calotypes*. The paper was coated with light-sensitive *silver halides*. Once processed, the paper was waxed for printing (see *waxed paper negative*).

PHOTOGRAVURE

Photogravure (1886–present) is a fine photomechanical process perfected by Karel Klíč (Klietsch) in 1879. The process begins with a copper or zinc plate dusted with rosin (powdered pine resin) and coated with a layer of bichromated gelatin. The bichromated layer is selectively hardened by contact printing under a negative in daylight or a UV light source. The layer provides a 'resist' through which the plate is etched, while the rosin gives the image grain. Once inked, the plate is printed on to paper with an etching press.

PHOTOMECHANICAL PROCESSES

A photomechanical print is made as ink on plain paper and will usually show a grain structure. A random structure suggests *photogravure*, a pattern of fissures distinguishes collotype, a regular pattern of dots characterises half-tone printing and a mechanically ruled white grid indicates screened gravure (an offset process). An embossed line image may be produced by photo-engraving (termed photogalvanography from 1856 to the early 1870s, then photo-engraving from the 1870s to the 1930s), while photolithography shows no embossing. The woodburytype process (late 1860s–1890s) is a hybrid,

BIOGRAPHIES

using an intaglio printing plate to produce continuous-tone images in pigmented gelatin.

SALTED PAPER PRINT

By 1835, William Henry Fox Talbot was using silver nitrate and sodium chloride to produce a simple silver chloride paper that printed out in daylight, giving an image in metallic silver. The process was most used from the early 1840s through the 1850s with later revivals. Salted paper prints are on plain, matt paper and show the warm brown colour of a printed-out silver chloride image. They could be *gold-toned* for a purple-brown hue and improved stability.

SILVER HALIDE PROCESSES

Photographic processes typically use a compound of silver and a halogen such as chlorine, iodine or bromine. In the presence of *actinic light*, this produces a chemical reaction, apparent as a darkening of the sensitised area. Early experimental work with silver halides had begun in the 1700s and progressed in the 1830s. Silver halide materials are used in *albumen paper*, *calotype*, *daguerreotype*, *salted paper*, *gelatin silver print* and *paper negative*.

STEREOSCOPIC PHOTOGRAPH/STEREOCARD

In about 1841, William Henry Fox Talbot produced stereo photographs for Charles Wheatstone, the scientist who had established the principle of stereoscopy based on human binocular vision. Talbot made two exposures with a two-and-a-half inch separation between the points of view, using a single lens camera and moving it to make the exposures at the required distance of separation. When the pair of photographs was viewed with a twin lens viewer, the images appeared to converge, producing the effect of three-dimensionality.

At the 1851 Great Exhibition at the Crystal Palace, French optician Louis Jules Duboscq showed stereoscopic prints with a stereoscopic viewer designed by physicist Sir David Brewster. Within a year, more than one thousand stereoscopes were sold in the UK and Europe and stereo images were produced as *daguerreotypes*, glass positives and paper prints. From the mid-1850s, millions of stereo cards were marketed, presenting subjects such as landscapes, genre scenes and nudes.

TONE (INCLUDING TONAL RANGE)

The term is often used to describe the image colour of a photograph. However, it is more correctly used in reference to the relative degrees of light or dark in an image, as in shadows, mid-tones and highlights. The range of these densities is known as the tonal range of a photographic image. Continuous tone indicates an image in which the tonal gradation shows no perceptible grain or structure, as in an ordinary *silver halide* photograph.

VIGNETTE

Vignetting describes diffusion and loss of illumination at the edges of the photographic image. It can be produced by lens defects, but is appreciated for a pictorial effect whose antecedent was found in painted portrait miniatures.

WAXED PAPER NEGATIVE

In 1841, William Henry Fox Talbot began to wax his paper negatives, bettering their transparency and the resulting image resolution. In 1849, Gustave Le Gray improved the image resolution by waxing the paper first and incorporating the halide salts in a casein or rice binder layer. Waxed paper negatives were popular for travel and landscape photography; they were more portable than the heavy and fragile glass *collodion* plates, and could be sensitised ahead of time and processed later.

ANDERSON, JAMES
(BRITISH, BORN ISSAC [SIC] ATKINSON, 1813–1877)

Anderson began his career as a painter and initiated his photographic work on moving to Rome in 1838. His photographs of antique sculptures and monuments were sold to the tourists who visited the city, as were his photographic art reproductions, many of which were commissioned by museums. The business remained in the family until the 1960s when Fratelli Alinari acquired the Anderson archive.

BARNEY, TINA (AMERICAN, B. 1945)

Since the mid-1970s, Barney's large-format photographic portraits have depicted modern affluence. Her documentation of privileged domestic settings invokes nineteenth-century portraiture, resembling the commissioned family portraits of the past. Barney's most recent project records life in small towns.

BILLINGHAM, RICHARD (BRITISH, B. 1970)

As an art student in the late 1980s, Billingham began taking photographs as source material for painted portraits. That work dealt with his dysfunctional family and his father's alcoholism. In the late 1990s, Billingham turned away from that earlier subject matter and began to explore landscape photography. He teaches at the University of Gloucestershire.

BIRD, NICKY (BRITISH, B. 1960)

Trained as a painter, Bird took up photography in the late 1980s as part of her doctoral work. Her projects are built up from her own photographic images alongside found material such as vernacular photographs. Her published works explore the social role of photography, memory and genealogy. Her interest in different types of archives has led her to explore online media. She is a PhD coordinator at the Graduate School in the Glasgow School of Art.

BLAKEMORE, JOHN (BRITISH, B. 1936)

Self taught in photography, Blakemore has been working with the medium since 1956. He is best known for finely crafted black-and-white landscapes and still lifes, which encapsulate the richness of his extensive darkroom and printing experience. Blakemore is Emeritus Professor of Photography at the University of Derby.

BRAUN, ADOLPHE (ALSATIAN, 1811–1877)

In the early 1850s, Braun began to produce floral photographs as studies for his wallpaper and fabric designs. He established a photographic studio in Dornach; by the mid-1860s, he had expanded to premises in Paris. He became one of the most important publishers of photographic reproductions of works of art from major European museums. After his death, his family and friends sustained the business into the twentieth century.

BROADHEAD, MAISIE (BRITISH, B. 1980)

Using her family as models, Broadhead creates elaborate tableaux that echo the compositions and narratives of Old Master paintings. In her images, contemporary objects replace historical elements, interrupting the flow between past and present representations. Broadhead gained her Jewellery MA from the Royal College of Art in 2009.

CAMERON, JULIA MARGARET (BRITISH, 1815–1879)

Cameron's career began when her daughter gave her a camera in 1864. She learned photography from contemporaries including Oscar Gustav Rejlander and Henry Peach Robinson. Her vast series of dramatic portraits was inspired by Renaissance and Baroque painting, and portrayed illustrious Victorians such as Alfred Tennyson and George Frederic Watts. In 1875, Cameron and her husband moved to his plantation in Ceylon, where she continued to photograph until about 1877.

CHADWICK, HELEN (BRITISH, 1953–1996)

Chadwick's photographs formed part of her multi-disciplinary art studies in the late 1970s. Her sculptures, photographs and installations explored notions of gender, sexuality and the visceral nature of organic matter. Her provocative work inspired many young artists in the 1990s. Chadwick's last project, completed shortly before

her untimely death, dealt with human fertility.

DEAN, TACITA (BRITISH, B. 1965)

Dean received her art training in England and Greece during the late 1980s and early 1990s. She uses a variety of media – drawings, photographs, film and sound installations – to explore the literary and experiential potential of natural phenomena such as the sea. In recent years, Dean has become an outspoken advocate of analogue film, launching a public debate on its displacement by digital technology.

DELAHAYE, LUC (FRENCH, B. 1962)

Delahaye began his career as a photojournalist in the early 1980s. Dedicated to war reporting, he was a member of the photography collective Magnum. Delahaye moved away from photojournalism and started to work with large-format photography in 2001. While his photographic tableaux bear some of the characteristics of the documentary style, their pictoriality and narrative structures are reminiscent of shared cultural influences.

DIJKSTRA, RINEKE (DUTCH, B. 1959)

Dijkstra worked as a professional photographer for almost a decade before beginning her first non-commercial project, *Beach Portraits*, in the mid-1990s. This series of large-format colour portraits of adolescent bathers initiated a comprehensive examination of transitional stages of life, including motherhood. Dijkstra has extended her practice to film, yet maintains her early sources in seventeenth- and eighteenth-century Dutch and Flemish portrait masters.

DURIEU, EUGENE (FRENCH, 1800–1874)

Durieu established one of the earliest studios for the production of academic figure studies. He is best known for an album of nudes compiled in collaboration with the artist Ferdinand-Victor-Eugène Delacroix, who later used the figures in paintings. In 1854, Durieu was a founding member of the Société française de photographie, but left the society in 1856 after a problem with fake documents.

FENTON, ROGER (BRITISH, 1819–1869)

Fenton took up photography after art studies in London and Paris. His photographic still lifes, landscape views and architectural images were strongly influenced by fine-art models. His commissioned photographs of the Crimean War (1853–56) are among the earliest battlefield photographs. Fenton's career lasted until 1861, when he abandoned photography for reasons that may have included his disillusion with the cheapening and commercialisation of the medium.

GERSHT, ORI (ISRAELI, B. 1967)

Moving to London in the late 1980s, Gersht initiated his artistic career upon finishing photographic studies in the early 1990s. His work considers the tension between violence and beauty and the traces of war and exile. Through video and photography, Gersht also deals with optical perception and the limits of visual technology. He is a senior professor at the University for the Creative Arts in Kent.

GOLDIN, NAN (AMERICAN, B. 1953)

Goldin is best known for a diaristic documentary of her life in the counterculture of late-1970s Boston and 1980s New York. Her work has explored taboo issues, including drugs, sex, violence and AIDS, yet she also looks to the bonds that link classical painting and photography. More recently, Goldin has moved from darkly memorialising subjects to an optimistic chronicle of family.

GUTSCHOW, BEATE (GERMAN, B. 1970)

Since the late 1990s, Gütschow has developed a critical investigation of the landscape genre. By following the conventions of seventeenth- and eighteenth-century landscape painting, she questions historical and contemporary representation in still photographs and time-based pieces. Gütschow's most recent work is studio-based and analyses advertising photography.

HILL, DAVID OCTAVIUS (SCOTTISH, 1802–1870) AND ROBERT ADAMSON (SCOTTISH, 1821–1848)

Establishing a studio in Edinburgh, Hill and Adamson began their photographic partnership in 1843. They used William Henry Fox Talbot's calotype process for work that is best known for a fine series of portraits and an inspired study of local fishing communities. Their collaboration ended with Adamson's death.

HOFER, EVELYN (GERMAN, 1922–2009)

In a career spanning more than four decades, Hofer created a prolific body of work that included fashion imagery, portraiture, still life and landscape in black and white and colour. Hofer's polychromatic images are fundamental to the understanding of colour in post-war photography.

HORSFIELD, CRAIGIE (BRITISH, B. 1949)

From 1968 to 1972, Horsfield studied painting and photography in London. His work investigates photography's material and philosophical intersections with painting and literature. Horsfield's multidisciplinary practice includes film and sound; and, in recent years, he has created monumental tapestries in collaboration with a Flemish textile company.

HUNTER, TOM (BRITISH, B. 1965)

Hunter lives and works in Hackney, London, where, since the mid-1990s, he has undertaken a critique of historical art practice within social commentary. His subjects portray East London's diverse community through a range of art-historical models, from Renaissance allegory through seventeenth-century Dutch genre scenes and Pre-Raphaelite painting.

IGOUT, LOUIS-JEAN-BAPTISTE (FRENCH, 1837–ABOUT 1882)

In 1860s Paris, Igout started his career by making photographic art reproductions. In the 1870s, he began a large series of photographic nudes, which were published as artists' studies in France and Germany. The photographs were later used by students at l'École des Beaux-Arts in Paris.

JONES, SARAH (BRITISH, B. 1959)

Jones began exhibiting in the late 1980s, deploying visual narratives that blur the line between the factual and the constructed. Her photographic portraits of female figures juxtapose social identity and art-historical representation, elements that are further explored in still life. Jones is a research fellow at the University of Derby and a tutor at the Royal College of Art in London.

KNORR, KAREN (GERMAN, B. 1954)

From the late 1970s, Knorr's work developed visual and textual strategies on the subjects of colonialism, feminism and class identity. Investigating several centuries of philosophy, her work reflects the complexity of high art culture and its many interpretations, as well as the relationship between art's production and its institutional dissemination.

LEAROYD, RICHARD (BRITISH, B. 1966)

A former teacher of fine-art photography, Learoyd moved to London in 2000, where he began his career as a commercial photographer. Learoyd's images are made with a camera obscura, producing large-scale colour portraits, nudes and still lifes by the direct exposure of the image on to positive photographic paper. The results are minutely detailed and uncannily realistic.

LE GRAY, JEAN BAPTISTE GUSTAVE (FRENCH, 1820–1884)

Trained as a painter, Le Gray took up photography in the late 1840s, becoming an influential landscape photographer. His contributions to the medium included the improvement of paper negatives in 1849. Le Gray's work was influenced by the painters of the Barbizon School, and he in turn trained many mid-century French photographers. In the late 1850s, financial troubles instigated his emigration from Paris to the Mediterranean, and he ended his days in Egypt.

LEWIS, DAVE (BRITISH, B. 1962)

From the early 1980s, Lewis's photographic and filmic investigations have dealt with identity, religion, politics and social and racial discrimination. He works as a

commercial photographer and is a visiting research fellow at Goldsmiths, University of London.

MUYBRIDGE, EADWEARD (BRITISH, 1830–1904)
Muybridge began his photographic career in the late 1860s after his immigration to the USA. For ten years, he photographed architectural subjects and landscapes, including an extensive series on the Yosemite Valley. Muybridge's fame came during the 1880s, when he expanded earlier motion studies into a formal documentation of human and animal locomotion at the University of Pennsylvania. Muybridge returned to England in 1894.

NADAR (GASPARD-FELIX TOURNACHON) (FRENCH, 1820–1910)
Nadar was a central figure of mid-nineteenth-century photography; his spare, beautifully modelled portraits of sitters such as Charles Baudelaire and Alexandre Dumas captured the cultural life of Paris. His pioneering aerial photography and use of artificial lighting brought him fame, but his ambitions left him in debt. By the 1870s, Nadar was no longer involved in photography, and his son, Paul, took over the photographic studio.

NORFOLK, SIMON (BRITISH, B. 1963)
With a degree in philosophy and sociology, Norfolk began to work as a photojournalist in the late 1980s. He abandoned that work during the early 1990s in favour of large-scale landscapes of war zones. Treading a delicate line between war photography and artistic practice, Norfolk's images show the aftermath of conflict and the psychological and physical residue of violence.

PARR, MARTIN (BRITISH, B. 1952)
As much anthropologist as photographer, Parr began his investigation of modern Britain in the mid-1970s, in a black-and-white project on everyday life in the north of England. In the early 1980s, he used colour to create a vibrant and satirical study of the Thatcher era. Parr joined Magnum in 2004, and his work now encompasses Western commodity culture. He is also known as an avid collector of photobooks and photographic ephemera.

PARSONS, JOHN R. (BRITISH, UNKNOWN)
Active during the 1860s, Parsons is known for his portraits of Jane Morris, the wife of artist and designer William Morris. The work was commissioned and directed by the Pre-Raphaelite artist Dante Gabriel Rossetti, who used the photographs as studies for his paintings.

PURANEN, JORMA (FINNISH, B. 1951)
One of Finland's most important photographers, Puranen began his photographic career in the early 1970s. His work has been diverse, from poetic ethnography to experimentation with painterly reflections of light. His interest in historical painting has led him to conceptual projects with portraiture and landscape. He lives and works in Helsinki, where his teaching inspired a generation of young practitioners, now called the Helsinki School.

REJLANDER, OSCAR GUSTAV (SWEDISH, 1813–1875)
Rejlander trained as a painter in Rome in the 1830s, and, by the 1840s, he had settled in England. In the early 1850s, he set up a photographic portrait studio in Wolverhampton, moving to London after 1857, where his business benefited from friendships with cultural notables like the then Poet Laureate Alfred Tennyson. Rejlander's artistic work was revolutionary, yet his career and finances were precarious, and real success eluded him.

SOUTHAM, JEM (BRITISH, B. 1950)
Exploring Britain's topography since the 1970s, Southam is considered one of the country's leading landscape photographers. He works in series, chronicling the same location through months and years of seasonal and geological change. His large-format colour photographs combine rigorous analogue technique with a poetic sensibility. Southam teaches at the University of Plymouth.

STRUTH, THOMAS (GERMAN, B. 1954)
Struth studied painting with Gerhard Richter at the Düsseldorf Kunstakademie in the early 1970s. Under the tutelage of Bernd Becher from 1976, he adopted a large-format camera and began to photograph the social landscapes of twentieth-century cities. Struth has since built an extensive practice that examines the role of photography as a tool of social documentation.

SULTER, MAUD (SCOTTISH, 1960–2008)
Sulter's artistic practice began in the 1970s, deploying poetry, theatre, video and photography to critique the conventions of representation. In the late 1980s, her background in photographic theory and art history informed the complex social and racial histories of her portraiture. Over the next twenty years, her multifaceted works energetically questioned British heritage and culture.

TALBOT, WILLIAM HENRY FOX (BRITISH, 1800–1877)
Talbot was the British inventor of photography. His photographic experiments began in the early 1830s, and he announced his work soon after Louis Daguerre, the French pioneer of the medium. Between 1844 and 1846, he published the summation of his aspirations for photography as *The Pencil of Nature*, one of the first photographically illustrated books. His subsequent investigations produced the first photoengraving process in 1852.

TAYLOR-WOOD, SAM (BRITISH, B. 1967)
Trained as a sculptor, Taylor-Wood adopted photography, film and video to document performances and installations in the early 1990s. These lens-based media became her primary access to themes of mortality, psychological tension and intimacy through the intricacies of art history and popular culture. Taylor-Wood now works primarily as a film-maker.

WALL, JEFF (CANADIAN, B. 1946)
From 1978, Wall's large-scale backlit transparencies marked a new type of staged photography, inspired by nineteenth-century paintings and updated with lighting and compositions influenced by the cinema. Wall studied art history, and writes extensively about art theory and contemporary art and culture. He is a professor at the University of British Columbia.

WYNFIELD, DAVID WILKIE (BRITISH, 1837–1887)
Wynfield, a London painter, made just one photographic series in the 1860s comprising costumed portraits of contemporary artists such as Frederic Leighton and George Frederic Watts. Wynfield's innovative techniques of soft focus and close-up framing inspired Julia Margaret Cameron, who was introduced to his work by G. F. Watts in 1864.

ZWEHL, BETTINA VON (GERMAN, B. 1971)
Born in Munich, Von Zwehl studied photography in London during the mid-1990s. Her large-format portraits use defenceless states of being (such as sudden awakening) to uncover the inner subjectivity that often remains invisible in photographs. Other portraits draw on the paintings of the Italian Renaissance. She is a visiting lecturer at the University of the Arts, London.

Biographies written by José Luís Neves with Hope Kingsley.

LIST OF LENDERS

And Her Majesty Queen Elizabeth II,
Tina Barney, Richard Billingham,
Nicky Bird, John Blakemore, Maisie
Broadhead, Mehmet Dalman Collection,
Luc Delahaye and Galerie Nathalie
Obadia, Eric and Louise Franck
Collection, The Gere Collection, Jane
Hamlyn and James Lingwood, Craigie
Horsfield, K & J Jacobson, Sarah Jones,
Karen Knorr, Richard Learoyd, Dave
Lewis, the Personal Representatives
of Sir Denis Mahon CH CBE FBA,
Martin Parr, Jorma Puranen, Corinna
Schnitt, Jem Southam, Thomas Struth,
Uziyel Collection, Gregg Wilson,
Wilson Centre for Photography,
Bettina von Zwehl and all those
lenders and private collectors who
wish to remain anonymous.

LIST OF EXHIBITED WORKS

ROOM 1

Francesco Faraone Aquila (after Raphael), fig. 80
The School of Athens (Picturae Raphaelis Sanctij Urbinatis: Plate 11), published in Rome 1722
Etching and engraving on paper, 51·8 × 70·7 cm
The British Museum, London (1925,0605.9)

Thomas Couture, not illustrated
Study for Romains de la Décadence, before 1847
Oil on canvas, 52 × 84 cm
Musée d'Orsay, Paris (RF1937-117)

Eugène Durieu, fig. 75
Artist's study from an album made for Eugène Delacroix, about 1853
Gold-toned albumen print from collodion negative, 20·9 × 12·7 cm
Wilson Centre for Photography

Tom Hunter, fig. 10
Death of Coltelli, 2009
C-type print, 122 cm × 152 cm
Wilson Centre for Photography

Sarah Jones, fig. 11
The Drawing Studio (I), 2008
C-type print mounted on aluminium, 122 × 152 cm
Courtesy the Artist and Maureen Paley, London

Karen Knorr, fig. 136
The Work of Art in the Age of Mechanical Reproduction, 1988
Cibachrome print mounted on aluminium, 92 × 92 cm
Collection of the Artist, courtesy Eric Franck Fine Art

Oscar Gustav Rejlander, fig. 79
Penitence (Study for The Two Ways of Life), about 1857
Modern gelatin silver print, about 1987, 18·2 × 23 cm
The Royal Photographic Society Collection at the National Media Museum, Bradford (2003-5001/2/24125)

Oscar Gustav Rejlander, see fig. 78
The Two Ways of Life, 1857
Digital print facsimile from carbon print of 1925 (2003-5001/2/20758), 2012, 41 × 79 cm
The Royal Photographic Society Collection at the National Media Museum, Bradford

Frédéric Villot (after Delacroix), not illustrated
The Death of Sardanapalus, 1844
Oil on canvas, 73 × 92 cm
Musée du Louvre, Département des Peintures (RF1962-26)

Jeff Wall, fig. 8
The Destroyed Room, 1978, printed 1987
Cibachrome transparency in fluorescent lightbox, 158·8 × 229 cm
National Gallery of Canada, Ottawa. Purchased 1988 (29997)

ROOM 2

Tina Barney, fig. 66
The Ancestor, 2001
C-type print, 120 × 150 cm (framed)
Courtesy Janet Borden, Inc., and the Artist

Nicky Bird, fig. 55
Jasmin, Ryde, Isle of Wight, July 2000–January 2001, from the series 'Tracing Echoes', 2001
Colour Iris print, 29 × 23·8 cm
Collection of the Artist (NCB/TE2001)

Maisie Broadhead and Jack Cole, fig. 46
An Ode to Hill and Adamson, 2012
Film; 3 minutes
Lent by Artist

Julia Margaret Cameron, fig. 52
Kate Keown, about 1866
Gold-toned albumen print from collodion negative, 29cm (diameter)
Gregg Wilson, Wilson Centre for Photography

Julia Margaret Cameron, fig. 57
Iago (Study from an Italian), 1867
Unique albumen print from collodion
negative, 33·4 × 24·8 cm
National Media Museum, Bradford
(1984-5017)

Anthony van Dyck, fig. 58
Portrait of Giovanni Battista Cattaneo,
about 1625–27
Oil on canvas, 73·5 × 60·5 cm
The National Gallery, London.
Bought, 1907 (NG 2127)

Thomas Gainsborough, fig. 67
Mr and Mrs Andrews, about 1750
Oil on canvas, 69·8 × 119·4 cm
The National Gallery, London. Bought
with contributions from The Pilgrim
Trust, The Art Fund, Associated
Television Ltd, and Mr and Mrs
W. W. Spooner, 1960 (NG 6301)

Richard Gibson, fig. 41
*Unknown woman, perhaps Elizabeth
Capell, Countess of Carnarvon*, 1653–57
Watercolour on vellum put down on
pasteboard, 7·4 × 6 cm (oval)
Victoria and Albert Museum
(P.15-1926)

**David Octavius Hill and Robert
Adamson**, fig. 43
Elizabeth Rigby (later, Elizabeth, Lady
Eastlake), about 1845
Salted paper print from paper negative,
21 × 15·2 cm
Wilson Centre for Photography

**David Octavius Hill and Robert
Adamson**, fig. 6
Elizabeth Rigby (later, Elizabeth, Lady
Eastlake) *with umbrella*, about 1843–47
Salted paper print, 19·5 × 14 cm
National Gallery of Canada, Ottawa.
Purchased 1977 (31246)

Craigie Horsfield, fig. 56
*Hernando Gómez, Calle Serrano,
Madrid, Diciembre 2006*, 2007
Dry pigment print on Arches paper,
131 × 95 cm
Courtesy of the Artist

Karen Knorr, fig. 64
Belgravia, ('Security'), 1988
Gelatin silver print, 50·8 × 40·6 cm
Eric and Louise Franck Collection,
London (EFLC1017)

Jan Lievens, fig. 37
Portrait of Anna Maria van Schurman,
1649
Oil on canvas, 87 × 68·6 cm
The National Gallery, London.
Presented by the Trustees of the British
Museum, 1880 (NG 1095)

Martin Parr, fig. 68
Signs of the Times, England, 1991
C-type print, 51 × 61 cm
Martin Parr/Magnum Photos/Rocket
Gallery (PAM 1991 010z00232-18)

Oscar Gustav Rejlander, fig. 42
Mary Rejlander, early 1860s
Albumen print from collodion negative
as *carte-de-visite* mounted on card
and inserted into album page with
hand-painted surround, 14 × 9 cm
(including surround)
K & J Jacobson, UK

**William Sharp (after Anthony van
Dyck)**, fig. 60
King Charles I, published 1815
Line engraving, 46·8 × 37 cm
Lent by the National Portrait Gallery,
London (NPG D26546)

Thomas Struth, not illustrated
*The Lingwood & Hamlyn Family,
London, 2001*, 2001
C-type print on Perspex support,
95·3 × 112·7 cm
Jane Hamlyn and James Lingwood,
London

Maud Sulter, fig. 36
Calliope, 1989, from the series 'Zabat',
1989
Cibachrome, 140 × 116 × 4·5 cm
(framed)
Victoria and Albert Museum
(E.1796-1991)

Unknown photographer, fig. 38
Portrait of a woman, 1854
Daguerreotype plate in glass surround,
18·2 × 14·8 cm
Wilson Centre for Photography

Unknown photographer, fig. 63
Family portrait, Lübeck, Germany,
about 1845
Daguerreotype, 9·2 × 13·3 cm (image);
21 × 25·5 cm (framed)
Wilson Centre for Photography

George Frederic Watts, fig. 47
Julia Margaret Cameron, 1850–52
Oil on canvas, 61 × 50·8 cm
Lent by the National Portrait Gallery,
London (NPG 5046)

David Wilkie Wynfield, fig. 59
John Dawson Watson, 1862/63
Later carbon print, after 1864 and
before 1911, 21·1 × 16·1 cm
Lent by the Royal Academy of Arts,
London (03/6714)

Bettina von Zwehl, fig. 40
Irini I, 2011
C-type print, 5·8cm (diameter);
16·3 × 16·3 cm (framed)
Bettina von Zwehl, courtesy Purdy
Hicks Gallery, London

Bettina von Zwehl, fig. 39
Irini II, 2011
C-type print, 5·8cm (diameter);
16·3 × 16·3 cm (framed)
Bettina von Zwehl, courtesy Purdy
Hicks Gallery, London

ROOM 3

Studio of James Anderson, fig. 85
*'Venus of Praxiteles' in The Vatican,
Rome*, about 1860
Two albumen prints as stereo view
mounted on card, 8·1 × 17·2 cm
Wilson Centre for Photography

James Anderson (?), fig. 86
The Laocoön Group, about 1855–65
Gold-toned albumen print from
collodion negative, 42 × 29·4 cm
Wilson Centre for Photography

Helen Chadwick, fig. 72
Ruin, 1986
Cibachrome, 93 × 49 × 4·5 cm
(framed)
Mehmet Dalman Collection

Rineke Dijkstra, fig. 90
Kolobrzeg, Poland, July 26 1992, 1992
C-type print, 137 × 107 cm
Tate. Purchased with assistance from
the American Fund for the Tate
Gallery, courtesy of Mr and Mrs Robert
Bransten 1999 (P78330)

Louis-Jean-Baptiste Igout, fig. 74
Académie No. E791, 1870s
Albumen print from glass plate
negative, 14·2 × 9·8 cm
Wilson Centre for Photography

Louis-Jean-Baptiste Igout,
not illustrated
Académie No. E795, 1870s
Albumen print from glass plate
negative, 14·2 × 9·8 cm
Wilson Centre for Photography

Louis-Jean-Baptiste Igout, fig. 76
Académies, page from a sample
album, 1870s
Albumen print from glass plate
negative, 27·8 × 21 cm (sheet)
Wilson Centre for Photography

Louis-Jean-Baptiste Igout,
not illustrated
Académies, page from a sample
album, 1870s
Albumen print from glass plate
negative, 27·8 × 21 cm (sheet)
Wilson Centre for Photography

Jean-Auguste-Dominique Ingres,
fig. 73
Angelica saved by Ruggiero, 1819–39
Oil on canvas, 47·6 × 39·4 cm
The National Gallery, London. Bought,
1918 (NG 3292)

Richard Learoyd, fig. 88
Man with Octopus Tattoo II, 2011
Unique Ilfochrome photograph,
148·6 × 125·7 cm
Courtesy of McKee Gallery, New York

Oscar Gustav Rejlander, fig. 71
Artist's study (self portrait), about
1856–57
Modern gelatin silver print, about 1987,
23 × 18 cm
The Royal Photographic Society
Collection at the National Media
Museum, Bradford
(2003-5001/2/21387)

Oscar Gustav Rejlander, fig. 83
Reclining female draped, artist's study, dorsal, about 1856–57
Modern gelatin silver print, about 1987, 18·3 × 23·2 cm
The Royal Photographic Society Collection at the National Media Museum, Bradford (2003-5001/2/4)

Oscar Gustav Rejlander, fig. 82
Reclining female nude, artist's study, late 1850s
Modern gelatin silver print, about 1987, 18·3 × 23·2 cm
The Royal Photographic Society Collection at the National Media Museum, Bradford (2003-5001/2/2)

Unknown French photographer, fig. 77
Four nude studies, about 1855
Hand-tinted and pin-pricked daguerreotypes mounted within gilt surrounds and set into thermoplastic 'union' case, 19·6 × 16 cm (open)
Wilson Centre for Photography

ROOM 4

Maisie Broadhead, fig. 2
Keep Them Sweet, 2010
Digital C-type print, 145 × 106·5 cm
Represented by Sarah Myerscough Fine Art, London

Julia Margaret Cameron, fig. 3
A Study of the Cenci, 1868
Albumen print from collodion negative, 35·2 × 27 cm
Wilson Centre for Photography

Julia Margaret Cameron, fig. 22
I Wait, 1872
Gold-toned albumen print from collodion negative, 26·7 × 21·6 cm
Wilson Centre for Photography

Julia Margaret Cameron, fig. 15
Light and Love, 1865
Albumen print from collodion negative, 26 × 21·6 cm
Wilson Centre for Photography

Helen Chadwick, fig. 13
One Flesh, 1985
Collage of photocopies on paper, 160 × 107 cm
Victoria and Albert Museum, London (PH.146-1986)

Luc Delahaye, fig. 31
US Bombing on Taliban Positions, 2001
C-type print, 112·2 × 238·6 cm
Courtesy Luc Delahaye and Galerie Nathalie Obadia

Luc Delahaye, fig. 32
132nd Ordinary Meeting of the Conference, 2004
Digital C-type print, 138·7 × 300 cm
Wilson Centre for Photography

Roger Fenton (after Raphael), fig. 19
Madonna and Child, 1854–58
Photographic art reproduction as albumen print from collodion negative, 36·3 × 26·5 cm
The Royal Photographic Society Collection at the National Media Museum, Bradford (2003-5001/2/23069)

Roger Fenton, fig. 27
Cooking House of the 8th Hussars, about 1855
Gold-toned salted paper print from collodion negative, 15·5 × 20 cm
Wilson Centre for Photography

Roger Fenton, fig. 29
Lieutenant-General Sir John Campbell and the remains of the Light Company of the 38th (1st Staffordshire) Regiment of Foot, 1855
Gold-toned salted paper print from collodion negative, 14·6 × 24·7 cm
Wilson Centre for Photography

William Holl the Younger (after Raphael), fig. 21
The Sistine Madonna (Madonna di San Sisto), 1822–71
Engraving on paper, 30·5 × 23 cm
The British Museum, London (1872,1012.2388)

Louis Legoux (after Guido Reni), fig. 5
Maria Anna [Beatrice] *Cenci*, 1794
Engraving, 20 × 14·5 cm
Private collection

Dave Lewis, fig. 25
Mr. Hector Stanley Watson, 1994, from the series 'West Indian Ex-Servicemen's and Women's Association', 1994–95
C-type Lambda print, 50·8 × 40·6 cm
Collection of the Artist

Simon Norfolk, fig. 28
British Army Media Operations Team including a Combat Camera Unit, Camp Bastion, Helmand, 2011
Digital archival pigment print, 36·7 × 48·8 cm
Wilson Centre for Photography

Jorma Puranen, fig. 24
Shadows and Reflections (after Goya) 2011
C-type print mounted on Plexiglas, 98 × 78 cm
Jorma Puranen, courtesy Purdy Hicks Gallery, London

Oscar Gustav Rejlander, fig. 20
Non Angeli sed Angli, 1857
Albumen print from collodion negative, 16·2 × 19·3 cm (oval)
Lent by Her Majesty Queen Elizabeth II (RCIN 2906215)

Oscar Gustav Rejlander, fig. 7
Untitled (allegorical study), about 1857
Gold-toned albumen print from collodion negative, 18·5 × 12·5 cm
Wilson Centre for Photography

Bartolomeo Schedoni, fig. 14
The Holy Family with the Virgin teaching the Child to Read, about 1613–15
Oil on wood, 33·6 × 28·2 cm
On loan from the Personal Representatives of Sir Denis Mahon CH CBE FBA

Thomas Struth, fig. 12
National Gallery 1, London, 1989, 1989
C-type print on Perspex support, 183·5 × 199·5 × 4·9 cm (framed)
Tate. Purchased 1994 (P77661)

Unknown photographer, fig. 26
Portrait of a junior naval officer of the Second French Empire, after 1852
Daguerreotype plate with applied gilt and hand-tinting, 9·2 × 7 cm
Wilson Centre for Photography

Emile-Jean-Horace Vernet, fig. 30
Battle of Jemappes, 1821, from the group 'Four Battle Scenes', 1821–26.
Oil on canvas, 177·2 × 288·3 cm
The National Gallery, London.
Bequeathed by Sir John Murray Scott, 1914 (NG 2963)

ROOM 5

Balthasar van der Ast, fig. 103
Flowers in a Vase with Shells and Insects, about 1630
Oil on oak, 47 × 36·8 cm
The National Gallery, London.
Accepted by H. M. Government in lieu of Inheritance Tax and allocated to The National Gallery, 2003 (NG 6593)

John Blakemore, fig. 104
Tulipa – 'The Generations' No. 14, 1994
Selenium-toned gelatin silver print, 39·7 × 29·5 cm
John Blakemore

Adolphe Braun, fig. 101
Bouquet with Hollyhocks (Étude de Fleurs), about 1857
Coated gold-toned salted paper print from collodion negative, 23·4 × 22·5 cm (corners rounded)
Private collection courtesy of Hans P. Kraus Jr., New York (300624.1)

Adolphe Braun, fig. 102
Study of Tulips, late 1860s
Carbon print from collodion negative, 36·9 × 44 cm
K & J Jacobson, UK

Ignace-Henri-Théodore Fantin-Latour, fig. 96
The Rosy Wealth of June, 1886
Oil on canvas, 70·5 × 61·6 cm
The National Gallery, London.
Presented by Mrs Edwin Edwards, 1899 (NG 1686)

Roger Fenton, fig. 112
'Comus'. A Painting by George Lance,
1859
Photographic art reproduction as
albumen print, 20·9 × 42·3 cm
The Royal Photographic Society
Collection at the National Media
Museum, Bradford
(2003-5001/2/21130)

Roger Fenton, fig. 113
Flowers and Fruit. A Study, 1860
Two albumen prints as stereo view
mounted on card, 8·4 × 17·4 cm
K & J Jacobson, UK

Roger Fenton, fig. 110
*Still life with fruit, flowers, vase and
putti*, 1860
Gold-toned albumen print from
collodion negative, 27·8 × 29 cm
The Royal Photographic Society
Collection at the National Media
Museum, Bradford
(2003-5001/2/24445)

Ori Gersht, fig. 97
Blow Up: Untitled 5, 2007
LightJet print mounted on aluminium,
248 × 188 × 6 cm (framed)
Mummery + Schnelle, London

Nan Goldin, fig. 107
My Bed, Hotel La Louisiane, Paris,
1996
Cibachrome, 76·2 × 76·2 cm
Courtesy of Sprovieri Gallery, London

Evelyn Hofer, fig. 109
*Oaxaca Vase with Aubergine, New York
[Still Life No. 2]*, 1997
Dye transfer print, 40·1 × 52·3 cm
Wilson Centre for Photography

Sarah Jones, fig. 115
The Rose Gardens (display: II) (I),
2007
C-type print mounted on aluminium,
152 × 122 cm
Government Art Collection (18171)

Sarah Jones, fig. 116
The Rose Gardens (display: II) (III),
2007
C-type print mounted on aluminium,
152 × 122 cm
Courtesy the Artist and Maureen Paley,
London

George Lance, fig. 111
Fruit ('The Autumn Gift'),
exhibited 1834
Oil on mahogany, 46 × 52·1 cm
Tate. Presented by Robert Vernon 1847
(N00441)

Luis Meléndez, fig. 108
Still Life with Lemons and Oranges,
1760s
Oil on canvas, 48 × 35·5 cm
The National Gallery, London.
Accepted by H. M. Government in lieu
of Inheritance Tax and allocated to
The National Gallery, 2005 (NG 6602)

Sam Taylor-Wood, fig. 105
Still life, 2001
35mm film/DVD; 3 minutes 44 seconds
Uziyel Collection (JJ5567)

ROOM 6

Peder Balke, fig. 122
The Tempest, about 1862
Oil on wood panel, 12 × 16·5 cm
The National Gallery, London.
Presented by Danny and Gry Katz,
2010 (NG 6614)

Richard Billingham, fig. 117
Storm at Sea, 2002, from the series
'Landscapes'
LightJet print mounted on aluminium,
111 × 130·5 cm
Courtesy Anthony Reynolds Gallery,
London

François Bocion, fig. 119
*Steamer on Lake Geneva: Evening
Effect*, 1863
Oil on canvas, 33·6 × 75·5 cm
Victoria and Albert Museum, London,
bequeathed by Rev. Chauncy Hare
Townshend (1591–1869)

Tacita Dean, fig. 135
Fernweh, 2009
Photogravure in eight parts on
Somerset 400g paper, 228 × 500 cm
Collection of Contemporary Art
Fundación "la Caixa"

Roger Fenton, fig. 130
*Paradise, View down the Hodder,
Stonyhurst*, 1859
Gold-toned albumen print from
collodion negative, 28 × 28·2 cm
Wilson Centre for Photography

Ori Gersht, fig. 129
Ghost: Olive 7, 2004
C-type print mounted on aluminium,
100 × 80 × 4 cm (framed)
Mummery + Schnelle, London

Beate Gütschow, fig. 133
LS#13, 2001
C-type print, 108 × 85 cm
Eric and Louise Franck Collection,
London

Gustave Le Gray, fig. 121
*The Great Wave, Sète (La Grande
Vague, Sète)*, about 1856–59
Gold-toned albumen print from several
collodion negatives, 33·5 × 42 cm
Gregg Wilson, Wilson Centre for
Photography

Gustave Le Gray, fig. 118
*Seascape, The Steamer (Marine, Le
Vapeur)*, about 1856
Gold-toned albumen print from
collodion negative, 30·4 × 40·7 cm
Gregg Wilson, Wilson Centre for
Photography

Gustave Le Gray, fig. 124
*Knotty Oak near the Carrefour de
l'Epine (Forêt de Fontainebleau)*,
about 1853
Albumen print from waxed paper
negative, 24·5 × 36·4 cm
Wilson Centre for Photography

Achille-Etna Michallon, fig. 123
A Tree, about 1816
Oil on paper, 30·5 × 24 cm
The Gere Collection, on long-term loan
to the National Gallery

Eadweard Muybridge, fig. 120
*No. 328. Moonlight Effect. Steamer El
Capitan, San Francisco*, 1868
Two gold-toned albumen prints from
collodion negative as stereo view
mounted on card, 8·7 × 17·6 cm
Wilson Centre for Photography

Jem Southam, fig. 125
The Painter's Pool, 9 January 2003,
2003
Chromogenic dye coupler contact print
dry mounted on museum board,
18·5 × 24 cm
Jem Southam, courtesy James Hyman
Photography, London (8830)

Jem Southam, fig. 126
The Painter's Pool, 28 May 2003, 2003
Chromogenic dye coupler contact print
dry mounted on museum board,
18·5 × 24 cm
Jem Southam, courtesy James Hyman
Photography, London (9038)

Jem Southam, fig. 127
The Painter's Pool, 9 November 2003,
2003
Chromogenic dye coupler contact print
dry mounted on museum board,
18·5 × 24 cm
Jem Southam, courtesy James Hyman
Photography, London (8834)

Jem Southam, fig. 128
The Painter's Pool, 4 January 2004,
2004
Chromogenic dye coupler contact print
dry mounted on museum board,
18·5 × 24 cm
Jem Southam, courtesy James Hyman
Photography, London (9039)

INTERVENTIONS

Richard Billingham, fig. 132
Hedgerow (New Forest), 2003
LightJet print mounted on aluminium,
122 × 155 cm
Southampton City Art Gallery
(11/2004)

John Constable, fig. 131
The Cornfield, 1826
Oil on canvas, 143 × 122 cm
The National Gallery, London.
Presented by subscribers, including
Wordsworth, Faraday and Sir William
Beechey, 1837 (NG 130)

ACKNOWLEDGEMENTS

Hilaire-Germain-Edgar Degas, fig. 95
After the Bath, Woman drying herself,
about 1890–95
Pastel on woven paper laid on
millboard, 103·5 × 98·5 cm
The National Gallery, London.
Bought, 1959 (NG 6295)

Craigie Horsfield, fig. 94
E. Horsfield, Well Street, East London,
February 1987, 1988
Photographic paper mounted on
aluminium, 141·5 × 141·5 cm
Depósito de la Colección Ordóñez-
Falcón de Fotografía. Colección TEA
Tenerife Espacio de las Artes. Cabildo
Insular de Tenerife

Jean-Auguste-Dominique Ingres,
fig. 69
Madame Moitessier, 1856
Oil on canvas, 120 × 92·1 cm
The National Gallery, London.
Bought, 1936 (NG 4821)

Richard Learoyd, fig. 70
Jasmijn in Mary Quant, 2008
Unique Ilfochrome photograph,
148·6 × 125·7 cm
Courtesy of McKee Gallery, New York

CINEMA

Maisie Broadhead and Jack Cole,
fig. 46
An Ode to Hill and Adamson, 2012
Film; 3 minutes
Lent by Artist

Ori Gersht, fig. 98
Big Bang 2, 2007
HD film; 5 minutes 33 seconds
Mummery + Schnelle, London

Corinna Schnitt, not illustrated
The Sleeping Girl/Das schlafende
Mädchen, 2001
Film; 8 minutes 30 seconds
Corinna Schnitt, courtesy Figge von
Rosen Galerie, Cologne

This book and the accompanying
exhibition were developed at the
instigation of Nicholas Penny, Director
of the National Gallery, Colin Wiggins,
Curator of Special Projects at the
National Gallery, and Michael Wilson
of the Wilson Centre for Photography.
I am grateful to Nick Penny for taking
a leap of scholarly faith into new
territory, to Colin Wiggins for his
enthusiastic and productive lateral
thinking and to Michael and Jane
Wilson for their moral support and
great generosity.

Christopher Riopelle, Curator of
Post-1800 Paintings at the National
Gallery, is the co-curator of the
exhibition, and he has been a
rigorously smart confederate. His
contributions to the book have been
marked by energy, wit and art-
historical insights.

Catherine Putz, Exhibitions
Curator at the National Gallery,
brought a pragmatic and thoughtful
overview that informed the exhibition
proposal and the first manuscript drafts.
She marshalled the initial ideas into a
real project, along with the estimable
Jo Kent, Exhibitions Organiser, and
Stephen Dunn, Senior Registrar.

Rachel Giles, Project Editor at
the National Gallery Company, was
proverbially calm and focused, and
I am in her debt for her editorial
guidance and kind patience. The same
virtues – and my appreciation – apply
to Catherine Hooper, the editor.
Rosalind McKever was the resourceful
and intelligent picture researcher.
Sophie Wright ably transcribed the
interviews and was a great help in
many aspects of the publication. The
book looks magnificent thanks to the
designer, Adam Hooper.

This project draws on rich material
from the Wilson Centre of Photography,
where Kathryn Del Boccio, Polly
Fleury, Ella Naef, José Luís Neves and
Stephanie Smith are valued colleagues
and a tremendous help in myriad ways.
Artists and private lenders have
generously made this project a reality,
and my gratitude extends to all, with
especial thanks to Gregg Wilson,
Martin Barnes of the Victoria and
Albert Museum, Pat Eaton of the Royal
Academy of Arts and Sophie Gordon at

the Royal Collection. Maria Escalé,
Mireia Gubern and Isabel Salgado of
Fundación "la Caixa" have been
marvellous collaborators. At the
National Media Museum, Brian Liddy,
Philippa Wright and Ruth Kitchin
patiently sourced photographs, and
Brian and Philippa kindly read and
commented on the manuscript of this
book. Other readers merit thanks: Pete
Massingham and Yuka Yamaji took a
long view of the key ideas; and Marta
Braun read a number of drafts in detail
– her sharp insights made this a better
and more robust book.

Finally, for various, sundry and
immeasurable help, I want to thank
Susan Blackaby, Barbara Bryant, Zelda
Cheatle, Jane Hamlyn, Dennis
Letbetter, Anne Lyden, Kathleen
McLauchlan, Sandra Phillips, Michael
Pritchard, Chris Roberts, Prudence
Roberts Toedtemeier, Per Rumberg,
Lindsey Stewart and Valérie Whitacre.

DEDICATION

This project has been a mere three
years, or more than twenty-five years,
in the making. In the mid-1980s, the
late Brian W. Coe, then Curator of the
Royal Photographic Society, introduced
me to the role of technology in art
photography. In the early 1990s, my
doctoral supervisor, the late Professor
John House of the Courtauld Institute
of Art, insisted on a scrupulous
approach to the art-historical context
for nineteenth-century photography.
Twenty years later, over a large glass of
wine, John looked at Rineke Dijkstra's
Polish bather and came up with
Amaury-Duval's *The Birth of Venus*.
I raise a metaphorical glass to those
two remarkable historians.

PHOTOGRAPHIC CREDITS

INDEX

This book was published to mark the exhibition

SEDUCED BY ART
PHOTOGRAPHY PAST AND PRESENT

Held at the National Gallery, London, 31 October 2012–20 January 2013
CaixaForum Barcelona, 21 February–19 May 2013
CaixaForum Madrid, 19 June–15 September 2013

With support from The John Kobal Foundation, Walter and Barbara Marais, David M. McKee, Outset Contemporary Art Fund, The Priestley Family and those who wish to remain anonymous.

This exhibition has been made possible by the provision of insurance through the Government Indemnity Scheme. The National Gallery would like to thank HM Government for providing Government Indemnity and the Department for Culture, Media and Sport and Arts Council England for arranging the indemnity.

National Gallery publications generate valuable revenue for the Gallery, to ensure that future generations are able to enjoy the paintings as we do today.

First published in Great Britain in 2012 by National Gallery Company Limited
St Vincent House, 30 Orange Street, London WC2H 7HH
www.nationalgallery.co.uk

HB ISBN: 978 1 85709 545 6
1033703

PB ISBN: 978 1 85709 568 5
1035294

British Library Cataloguing-in-Publication Data.
A catalogue record is available from the British Library.
Library of Congress Control Number: 2012936404

Managing Editor Jan Green
Project Editor Rachel Giles
Editor Catherine Hooper
Picture Researcher Rosalind McKever
Production Jane Hyne and Penny Le Tissier
Designed by hoopdesign.co.uk
Printed and bound in Italy by Conti Tipocolor

All measurements give height before width

FRONT COVER Ori Gersht, *Blow Up: Untitled 5*, 2007 (detail) fig. 97
BACK COVER Ignace-Henri-Théodore Fantin-Latour, *The Rosy Wealth of June*, 1886, fig. 96